Information is Beautiful

Information is Beautiful

David McCandless

WILLIAM
COLLINS

William Collins
An imprint of HarperCollinsPublishers
1 London Bridge Street
London
SE1 9GF

www.WilliamCollinsBooks.com

First published in 2009 by Collins
This edition published in 2012

10 9 8 7

Text & Design © David McCandless

www.davidmccandless.com

The author asserts his right to be identified as the author of this work

A catalogue record for this book is available from the British Library

ISBN: 9780007492893

Printed and bound in Hong Kong by Printing Express

to the beautiful internet

Introduction

This book started out as an exploration. Swamped by information, I was searching for a better way to see it all and understand it. Why not visually?

In a way, we're all visual now. Every day, every hour, maybe even every minute, we're seeing and absorbing information via the web. We're steeped in it. Maybe even lost in it. So perhaps what we need are well-designed, colourful and — hopefully — useful charts to help us navigate. A modern-day map book.

But can a book with the minimum of text, crammed with diagrams, maps and charts, still be exciting and readable? Can it still be fun? Can you make jokes in graphs? Are you even allowed to?

So I started experimenting with visualizing information and ideas in both new and old ways. I went for subjects that sprang from my own curiosity and ignorance — the questions I wanted answering. I avoided straightforward facts and dry statistics. Instead, I focused on the relationship between facts, the context, the connections that make information meaningful.

So, that's what this book is. Miscellaneous facts and ideas, interconnected visually. A visual miscellaneum. A series of experiments in making information approachable and beautiful. See what you think.

David McCandless

POP

WEB

THOUGHT

NATURE

SCIENCE

HEALTH

FOOD

POWER

LIFE

FILM

MEDIA

MUSIC

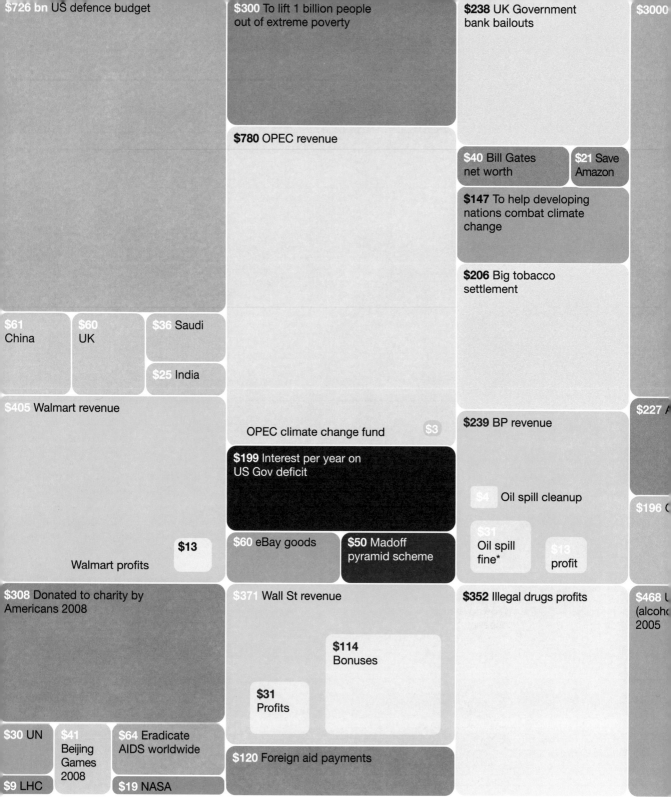

$726 bn US defence budget

$300 To lift 1 billion people out of extreme poverty

$238 UK Government bank bailouts

$3000

$780 OPEC revenue

$40 Bill Gates net worth

$21 Save Amazon

$147 To help developing nations combat climate change

$206 Big tobacco settlement

$61 China

$60 UK

$36 Saudi

$25 India

$405 Walmart revenue

OPEC climate change fund

$3

$199 Interest per year on US Gov deficit

$239 BP revenue

$227 A

$4 Oil spill cleanup

$196 C

$13

Walmart profits

$60 eBay goods

$50 Madoff pyramid scheme

$31 Oil spill fine*

$13 profit

$308 Donated to charity by Americans 2008

$371 Wall St revenue

$352 Illegal drugs profits

$468 U (alcoho 2005

$114 Bonuses

$31 Profits

$30 UN

$41 Beijing Games 2008

$64 Eradicate AIDS worldwide

$120 Foreign aid payments

$9 LHC

$19 NASA

Billion-Dollar-O-Gram

Billions spent on this. Billions spent on that. It's all relative, right?

Afghanistan Wars total eventual cost*

$60
Iraq War
predicted
cost 2003

market value

$226 Microsoft
market value

$742 Medicare & Medicaid per year

market value

for drug abuse
otics & smoking)

$148 Cost of
obesity-related
diseases

$825 Global pharmaceutical market

$36
Video
games

$34
Alternative
medicine

Erectile dysfunction

$6

$69
War on Drugs

$40 World-wide
porn industry

Anti-depressants

$19

Gifts to doctors

$21

* estimated

source: MSNBC, Guardian, Washington Post, Forbes, UNODC, BBC News. All figures 2009 unless otherwise stated.

$12,700bn Worldwide cost of the financial crisis

Left

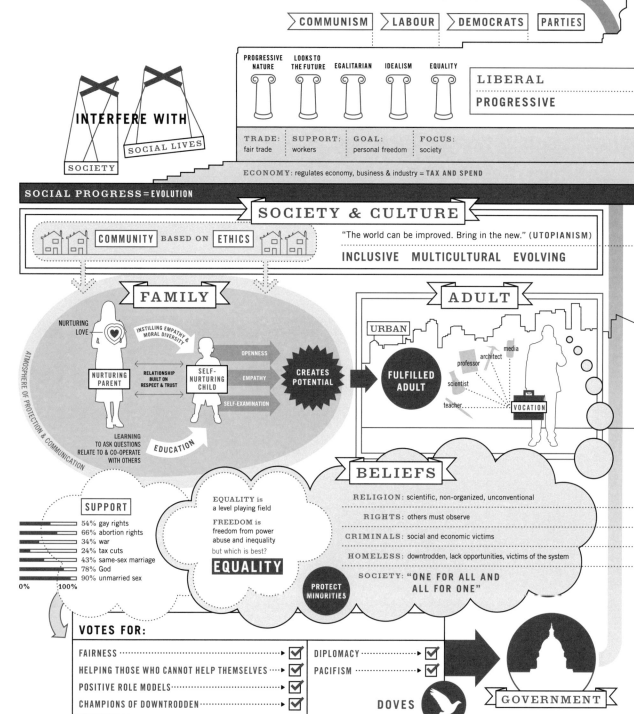

COMMUNISM LABOUR DEMOCRATS PARTIES

PROGRESSIVE NATURE	LOOKS TO THE FUTURE	EGALITARIAN	IDEALISM	EQUALITY

LIBERAL

PROGRESSIVE

TRADE:	SUPPORT:	GOAL:	FOCUS:
fair trade	workers	personal freedom	society

INTERFERE WITH
SOCIAL LIVES
SOCIETY

ECONOMY: regulates economy, business & industry = TAX AND SPEND

SOCIAL PROGRESS = EVOLUTION

SOCIETY & CULTURE

COMMUNITY BASED ON ETHICS

"The world can be improved. Bring in the new." (UTOPIANISM)

INCLUSIVE MULTICULTURAL EVOLVING

FAMILY

ATMOSPHERE OF PROTECTION & COMMUNICATION

NURTURING LOVE

INSTILLING EMPATHY & MORAL DIVERSITY

NURTURING PARENT

RELATIONSHIP BUILT ON RESPECT & TRUST

SELF-NURTURING CHILD

OPENNESS

EMPATHY

SELF-EXAMINATION

CREATES POTENTIAL

LEARNING TO ASK QUESTIONS RELATE TO & CO-OPERATE WITH OTHERS

EDUCATION

ADULT

URBAN

FULFILLED ADULT

media
architect
professor
scientist
teacher

VOCATION

BELIEFS

RELIGION: scientific, non-organized, unconventional

RIGHTS: others must observe

CRIMINALS: social and economic victims

HOMELESS: downtrodden, lack opportunities, victims of the system

SOCIETY: "ONE FOR ALL AND ALL FOR ONE"

EQUALITY is a level playing field

FREEDOM is freedom from power abuse and inequality
but which is best?
EQUALITY

PROTECT MINORITIES

SUPPORT

- 54% gay rights
- 66% abortion rights
- 34% war
- 24% tax cuts
- 43% same-sex marriage
- 78% God
- 90% unmarried sex

0% 100%

VOTES FOR:

FAIRNESS ································▶ ☑
HELPING THOSE WHO CANNOT HELP THEMSELVES ···▶ ☑
POSITIVE ROLE MODELS ····················▶ ☑
CHAMPIONS OF DOWNTRODDEN ···············▶ ☑

DIPLOMACY ·············▶ ☑
PACIFISM ···············▶ ☑

DOVES

GOVERNMENT

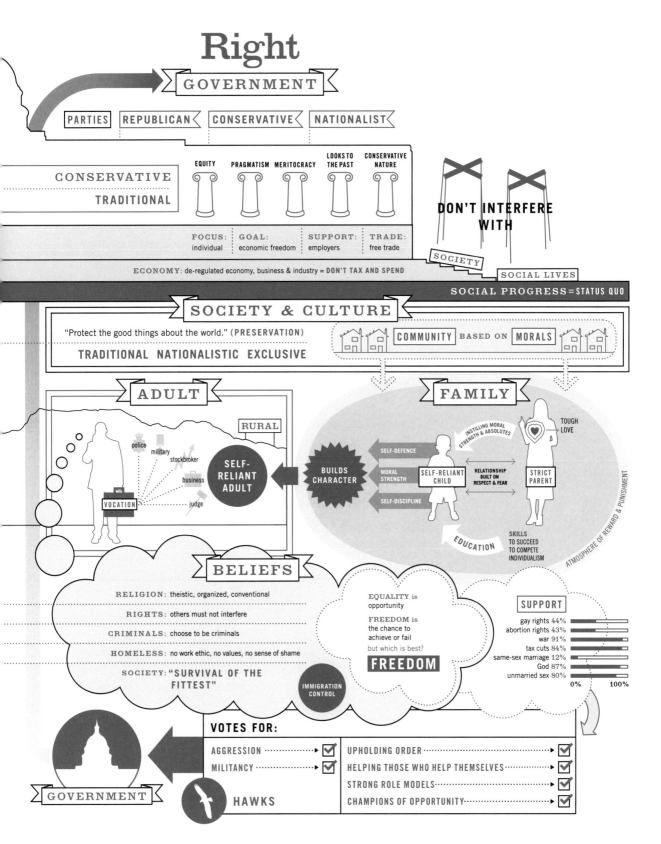

Right

GOVERNMENT

PARTIES | REPUBLICAN | CONSERVATIVE | NATIONALIST

CONSERVATIVE / TRADITIONAL

EQUITY | PRAGMATISM | MERITOCRACY | LOOKS TO THE PAST | CONSERVATIVE NATURE

FOCUS: individual | GOAL: economic freedom | SUPPORT: employers | TRADE: free trade

ECONOMY: de-regulated economy, business & industry = DON'T TAX AND SPEND

DON'T INTERFERE WITH
SOCIETY
SOCIAL LIVES
SOCIAL PROGRESS = STATUS QUO

SOCIETY & CULTURE

"Protect the good things about the world." (PRESERVATION)

TRADITIONAL NATIONALISTIC EXCLUSIVE

COMMUNITY BASED ON MORALS

ADULT

RURAL

police | military | stockbroker | business | judge

VOCATION

SELF-RELIANT ADULT

BUILDS CHARACTER

FAMILY

TOUGH LOVE

INSTILLING MORAL STRENGTH & ABSOLUTES

SELF-DEFENCE
MORAL STRENGTH
SELF-DISCIPLINE

SELF-RELIANT CHILD

RELATIONSHIP BUILT ON RESPECT & FEAR

STRICT PARENT

EDUCATION

SKILLS TO SUCCEED TO COMPETE INDIVIDUALISM

ATMOSPHERE OF REWARD & PUNISHMENT

BELIEFS

RELIGION: theistic, organized, conventional

RIGHTS: others must not interfere

CRIMINALS: choose to be criminals

HOMELESS: no work ethic, no values, no sense of shame

SOCIETY: "SURVIVAL OF THE FITTEST"

IMMIGRATION CONTROL

EQUALITY is opportunity

FREEDOM is the chance to achieve or fail

but which is best?

FREEDOM

SUPPORT

gay rights 44%
abortion rights 43%
war 91%
tax cuts 84%
same-sex marriage 12%
God 87%
unmarried sex 80%

0% — 100%

VOTES FOR:

AGGRESSION ✓ | UPHOLDING ORDER ✓
MILITANCY ✓ | HELPING THOSE WHO HELP THEMSELVES ✓
| STRONG ROLE MODELS ✓
HAWKS | CHAMPIONS OF OPPORTUNITY ✓

GOVERNMENT

source: Wikipedia, Britannica.com, New Scientist, Conservative-resources.com

ULTRA PARADOX!
The Terminatrix
encounters Evan
from *Butterfly
Effect* pursued by
Timecop Max Walker

2500

3000

2400

4000

Austin Powers: The Spy Wl

Star Trek (TOS) Assignment Earth

Austin Powers in Goldmember

Buck Rogers in the 25th Century

Star Trek (TOS) Tomorrow is Yesterday

Planet of the Apes

2300

2200

2100

2050

Star Trek: First Contact

Sleeper

1990

2000

The Time Machine (802,701)

The Time Machine (30,000,000)

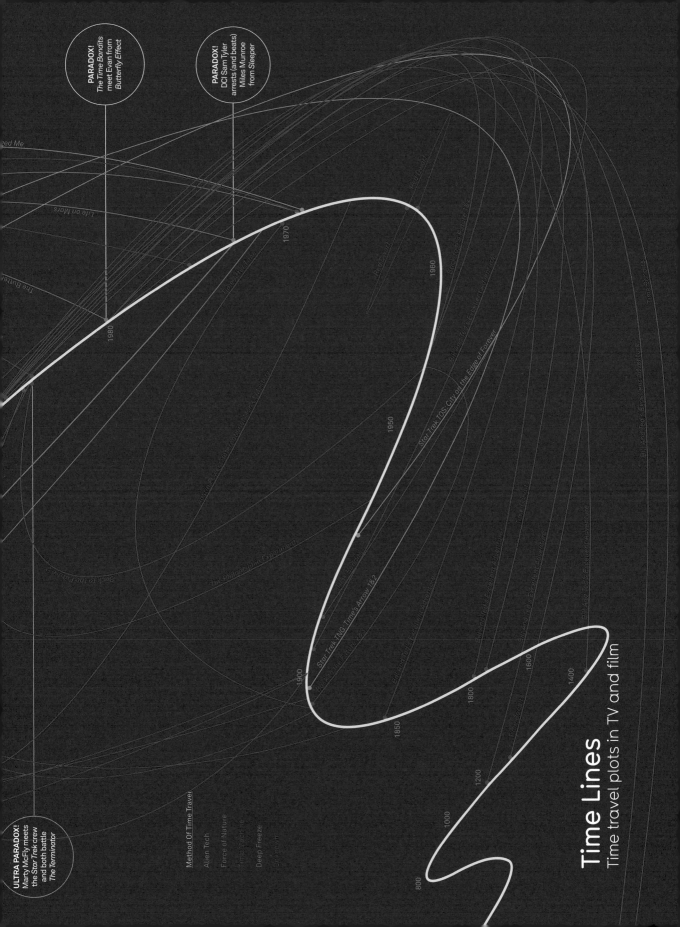

Time Lines
Time travel plots in TV and film

PARADOX! *The Time Bandits* meet Evan from *Butterfly Effect*

PARADOX! DCI Sam Tyler arrests (and beats) Miles Munroe from *Sleeper*

ULTRA PARADOX! Marty McFly meets the *Star Trek* crew and both battle *The Terminator*

Method Of Time Travel

Alien Tech

Force of Nature

Time Machine

Deep Freeze

Unknown

Star Trek TOS: City on the Edge of Forever

Star Trek TNG Time's Arrow 182

Life on Mars

The Butterfly Effect

1980

1970

1960

1950

1900

1850

1800

1600

1400

1200

1000

800

Snake Oil?

Scientific evidence for popular dietary supplements showing tangible health benefits when taken orally by an adult with a healthy diet.

Popularity
(Google hits)

One to Watch
(Few studies but promising results)

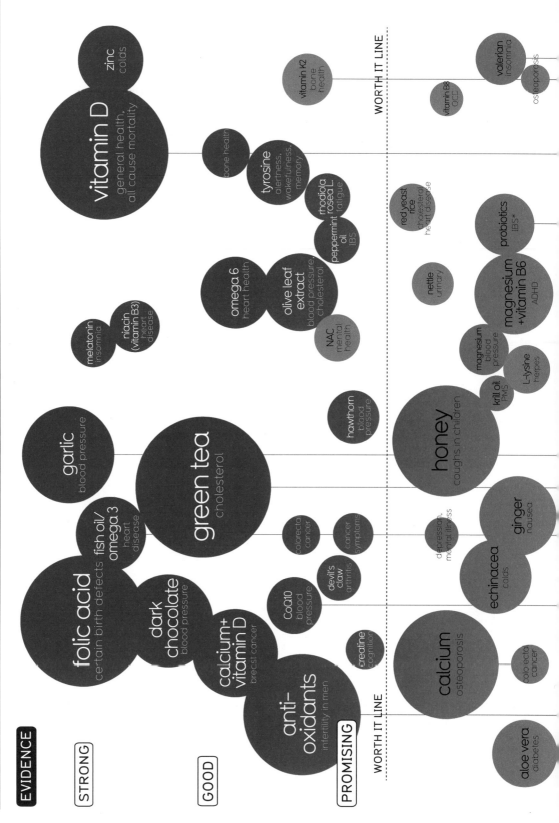

EVIDENCE

STRONG

GOOD

PROMISING

WORTH IT LINE

WORTH IT LINE

vitamin D
general health, all cause mortality

zinc
colds

bone health

tyrosine
alertness, wakefulness, memory

rhodiola rosea L.
fatigue

peppermint oil
IBS

omega 6
heart health

olive leaf extract
blood pressure, cholesterol

NAC
mental health

melatonin
insomnia

niacin (vitamin B3)
heart disease

vitamin K2
bone health

vitamin B8
OCD

valerian
insomnia

osteoporosis

red yeast rice
cholesterol, heart disease

nettle
urinary

probiotics
IBS*

magnesium
+vitamin B6
ADHD

magnesium
blood pressure

krill oil
PMS

L-lysine
herpes

garlic
blood pressure

green tea
cholesterol

hawthorn
blood pressure

honey
coughs in children

folic acid
certain birth defects

fish oil/
omega 3
heart disease

dark chocolate
blood pressure

calcium+
vitamin D
breast cancer

anti-oxidants
infertility in men

CoQ10
blood pressure

colorectal cancer

cancer symptoms

devil's claw
arthritis

depression, mental illness

creatine
cognition

calcium
osteoporosis

colorectal cancer

echinacea
colds

ginger
nausea

aloe vera
diabetes

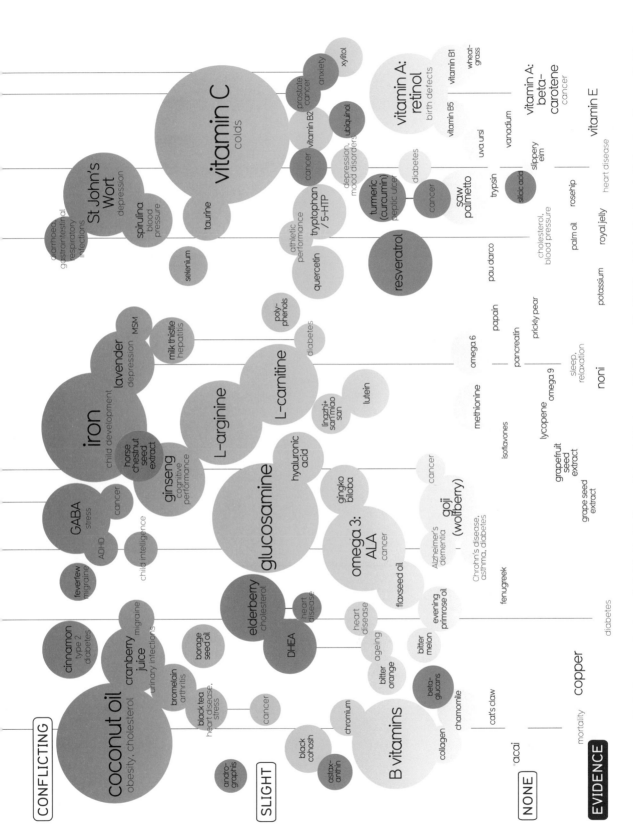

CONFLICTING

coconut oil
obesity, cholesterol

cinnamon
type 2
diabetes

cranberry
juice
urinary infections

migraine

bromelain
arthritis

black tea
heart disease,
stress

borage
seed oil

cancer

andro-
graphis

SLICHT

black
cohosh

astax-
anthin

chromium

B vitamins

collagen

chamomile

beta-
glucans

cat's claw

NONE

acai

mortality

copper

diabetes

EVIDENCE

elderberry
cholesterol

DHEA

heart
disease

heart
disease

bitter
melon

bitter
orange

ageing

evening
primrose oil

omega 3:
ALA

cancer

flaxseed oil

Alzheimer's
dementia

goji
(wolfberry)

cancer

Chrohn's disease,
asthma, diabetes

fenugreek

grape seed
extract

grapefruit
seed
extract

isoflavones

glucosamine

hyaluronic
acid

gingko
biloba

lycopene omega 9

sleep,
relaxation

pancreatin

papain

prickly pear

noni

potassium

royal jelly

iron
child development

lavender
depression

MSM

horse
chestnut
seed
extract

ginseng
cognitive
performance

GABA
stress

cancer

ADHD

child intelligence

feverfew
migraine

L-arginine

L-carnitine

milk thistle
hepatitis

poly-
phenols

diabetes

lingzhi+
san miao
san

lutein

methionine

omega 6

St John's
Wort
depression

diarrhoea,
gastrointestinal,
respiratory
infections

spirulina
blood
pressure

selenium

vitamin C
colds

taurine

athletic
performance

quercetin

tryptophan
/ 5-HTP

resveratrol

prostate
cancer

cancer vitamin B2

depression,
mood disorders

turmeric
(curcumin)
peptic ulcer

pau darco

cholesterol,
blood pressure

palm oil

anxiety

xylitol

ubiquinol

diabetes

cancer

saw
palmetto

trypsin

silicic acid

slippery
elm

rosehip

heart disease

vitamin A:
retinol
birth defects

vitamin B5

uva ursi

vanadium

vitamin B1

wheat-
grass

vitamin A:
beta-
carotene
cancer

vitamin E

source: English language placebo-controlled double-blind human trials on PubMed.org and Cochrane.org, Herbmed.org, European Medicines Agency, The US Office of Dietary Supplements

International Number Ones

Because every country is the best at something

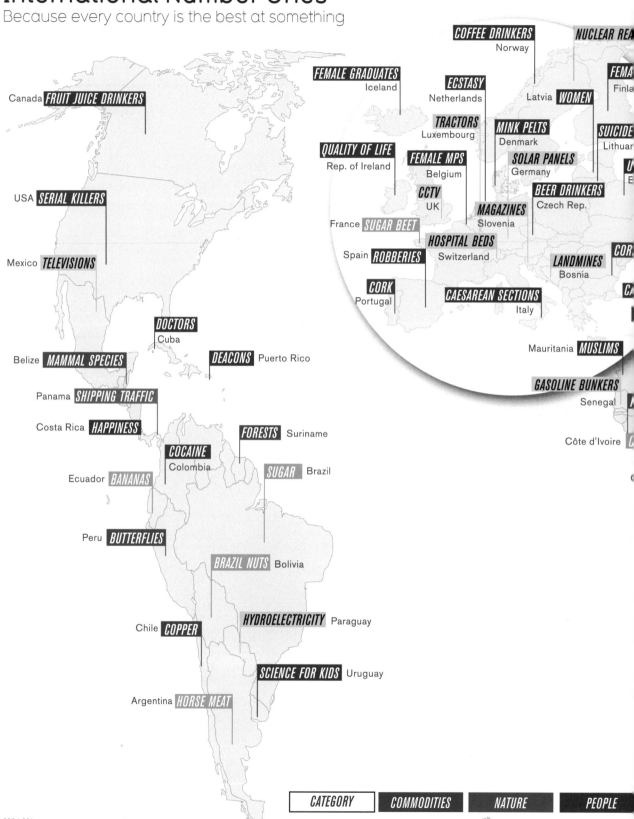

Canada **FRUIT JUICE DRINKERS**

USA **SERIAL KILLERS**

Mexico **TELEVISIONS**

DOCTORS
Cuba

DEACONS Puerto Rico

Belize **MAMMAL SPECIES**

Panama **SHIPPING TRAFFIC**

Costa Rica **HAPPINESS**

FORESTS Suriname

COCAINE
Colombia

Ecuador **BANANAS**

SUGAR Brazil

Peru **BUTTERFLIES**

BRAZIL NUTS Bolivia

Chile **COPPER**

HYDROELECTRICITY Paraguay

SCIENCE FOR KIDS Uruguay

Argentina **HORSE MEAT**

COFFEE DRINKERS
Norway

NUCLEAR REA

FEMALE GRADUATES
Iceland

ECSTASY
Netherlands

Latvia **WOMEN**

FEMA
Finla

TRACTORS
Luxembourg

MINK PELTS
Denmark

SUICIDE
Lithuar

QUALITY OF LIFE
Rep. of Ireland

FEMALE MPS
Belgium

SOLAR PANELS
Germany

U
B

CCTV
UK

MAGAZINES
Slovenia

BEER DRINKERS
Czech Rep.

France **SUGAR BEET**

HOSPITAL BEDS
Switzerland

Spain **ROBBERIES**

LANDMINES
Bosnia

COR

CORK
Portugal

CAESAREAN SECTIONS
Italy

CA

Mauritania **MUSLIMS**

GASOLINE BUNKERS
Senegal

Côte d'Ivoire

| CATEGORY | COMMODITIES | NATURE | PEOPLE |

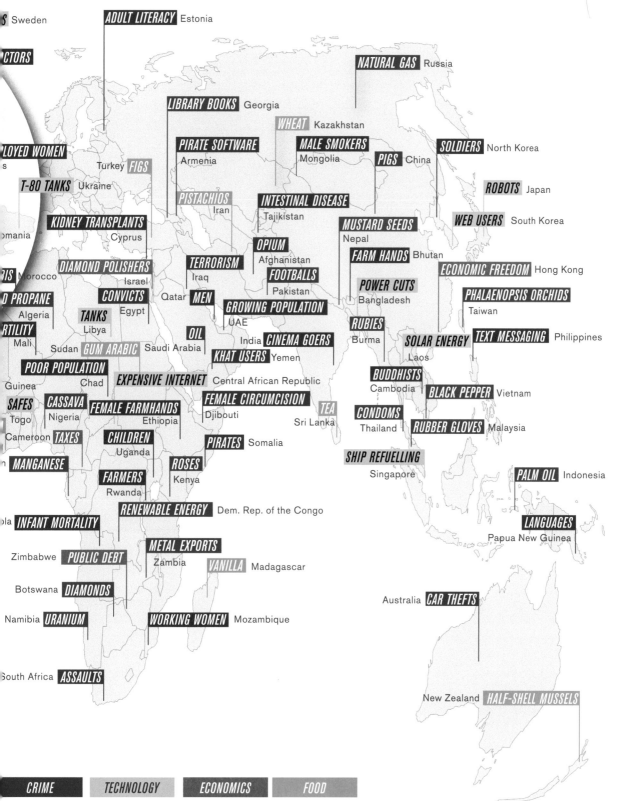

S Sweden

ADULT LITERACY Estonia

CTORS

NATURAL GAS Russia

LIBRARY BOOKS Georgia

WHEAT Kazakhstan

LOYED WOMEN
s

PIRATE SOFTWARE

MALE SMOKERS

SOLDIERS North Korea

Turkey FIGS

Armenia

Mongolia

PIGS China

T-80 TANKS Ukraine

PISTACHIOS

INTESTINAL DISEASE

ROBOTS Japan

Iran

Tajikistan

WEB USERS South Korea

KIDNEY TRANSPLANTS

MUSTARD SEEDS

omania

Cyprus

OPIUM

Nepal

Afghanistan

FARM HANDS Bhutan

DIAMOND POLISHERS

TERRORISM

FOOTBALLS

ECONOMIC FREEDOM Hong Kong

RIS Morocco

Israel

Iraq

Pakistan

POWER CUTS

D PROPANE

CONVICTS

MEN

Bangladesh

PHALAENOPSIS ORCHIDS

Algeria

Qatar

Egypt

GROWING POPULATION

Taiwan

RTILITY

TANKS

UAE

RUBIES

Mali

Libya

OIL

Burma

SOLAR ENERGY

TEXT MESSAGING Philippines

Sudan GUM ARABIC Saudi Arabia

India CINEMA GOERS

Laos

KHAT USERS Yemen

POOR POPULATION

EXPENSIVE INTERNET Central African Republic

BUDDHISTS

Guinea

Chad

Cambodia

BLACK PEPPER Vietnam

SAFES

CASSAVA

FEMALE FARMHANDS

FEMALE CIRCUMCISION

CONDOMS

Togo

Nigeria

Ethiopia

Djibouti

TEA

Thailand

RUBBER GLOVES Malaysia

Cameroon TAXES

CHILDREN

Sri Lanka

n

MANGANESE

Uganda

ROSES

PIRATES Somalia

SHIP REFUELLING

PALM OIL Indonesia

FARMERS

Kenya

Singapore

Rwanda

INFANT MORTALITY

RENEWABLE ENERGY Dem. Rep. of the Congo

LANGUAGES

METAL EXPORTS

Papua New Guinea

Zimbabwe PUBLIC DEBT

Zambia

VANILLA Madagascar

Botswana DIAMONDS

Australia CAR THEFTS

Namibia URANIUM

WORKING WOMEN Mozambique

South Africa ASSAULTS

New Zealand HALF-SHELL MUSSELS

CRIME TECHNOLOGY ECONOMICS FOOD

source: per capita data from Newscientist.com, Unstats.un.org, NationMaster.com

INTENSITY (Number of stories)

"Y2K APOCALYPSE"

"SARS QUARANTINE IN CHINA"

"BATTLE OVER VIOLENT VIDEO GAMES HEATS UP"

2000 2001 2002 2003 2004 2005

Story (approximate worldwide deaths)

▲ Killer Wasps (1000)
▲ Killer Wifi (0)
▲ Mobile Phones & Tumours (0)

▲ Autism Vaccinations (0)
▲ Asteroid Collision (0)
▲ Millennium Bug (0)

▲ Mad Cow Disease (204)
▲ Violent Video Games (Unknown)
▲ SARS (774)

▲ Bird Flu (262)
▲ Swine Flu (702)

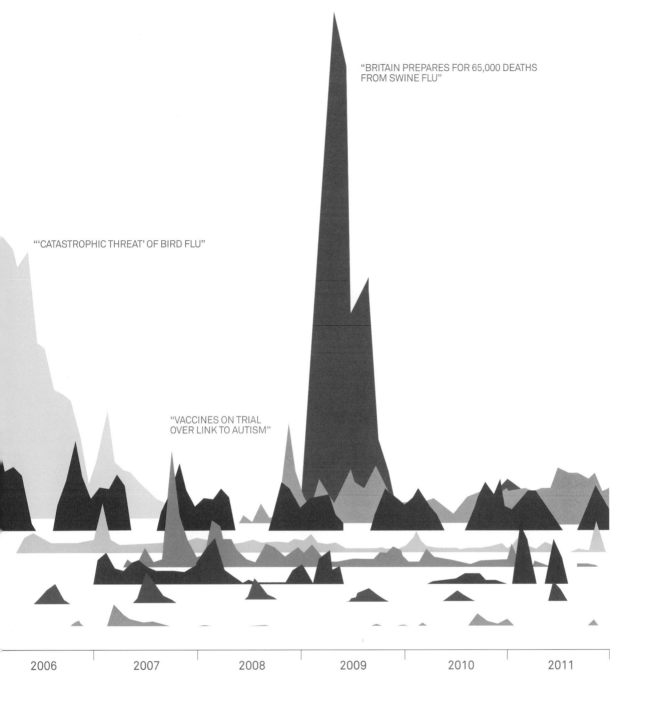

"BRITAIN PREPARES FOR 65,000 DEATHS
FROM SWINE FLU"

"'CATASTROPHIC THREAT' OF BIRD FLU"

"VACCINES ON TRIAL
OVER LINK TO AUTISM"

2006 2007 2008 2009 2010 2011

Mountains out of Molehills
A timeline of global media scare stories

source: Google News and Insights for Search (worldwide deaths at time of print)

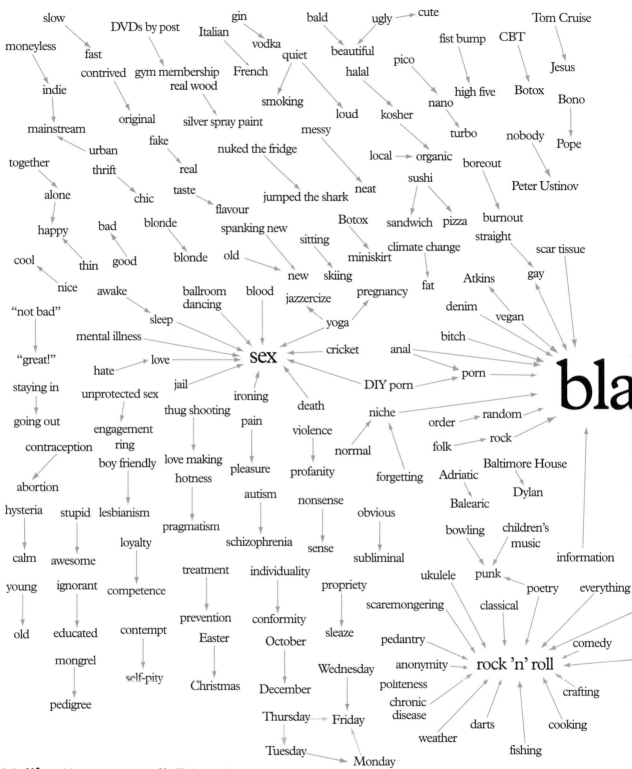

X "is the new" Black

A map of clichés

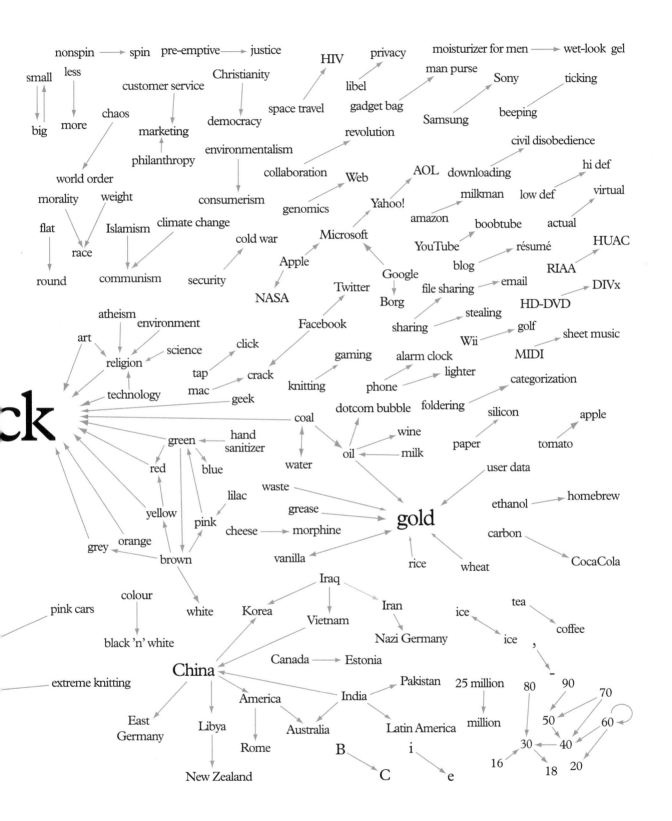

Searches for the phrase "is the new" on various media websites.

idea: Randall Szott // source: Google, Guardian.co.uk, NewScientist.com, Wired.com, Nytimes.com

Kilograms of Carbon

Emissions per year

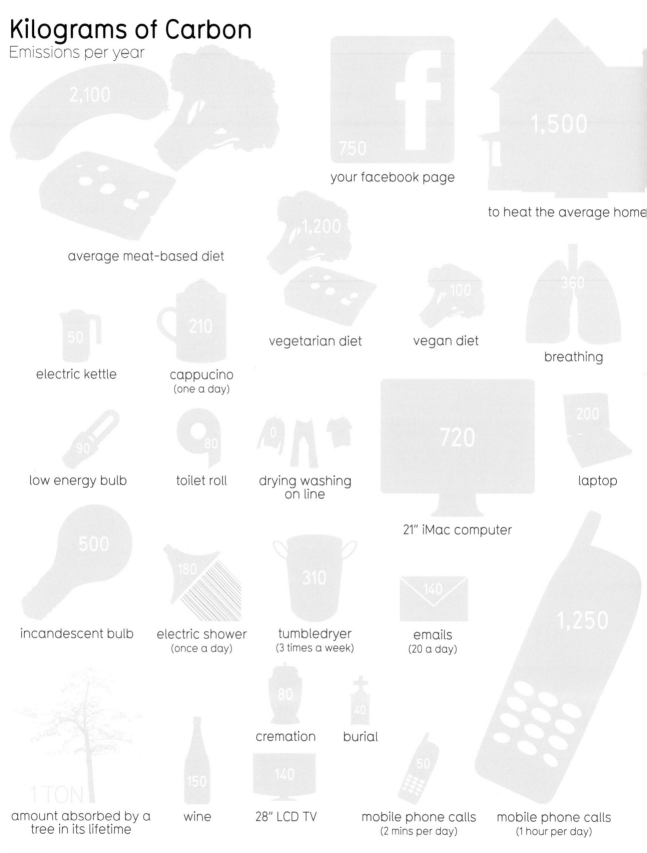

2,100

average meat-based diet

750

your facebook page

1,500

to heat the average home

1,200

vegetarian diet

100

vegan diet

360

breathing

50

electric kettle

210

cappucino
(one a day)

90

low energy bulb

80

toilet roll

0

drying washing
on line

720

21" iMac computer

200

laptop

500

incandescent bulb

180

electric shower
(once a day)

310

tumbledryer
(3 times a week)

140

emails
(20 a day)

1,250

80

cremation

40

burial

1 TON

amount absorbed by a
tree in its lifetime

150

wine

140

28" LCD TV

50

mobile phone calls
(2 mins per day)

mobile phone calls
(1 hour per day)

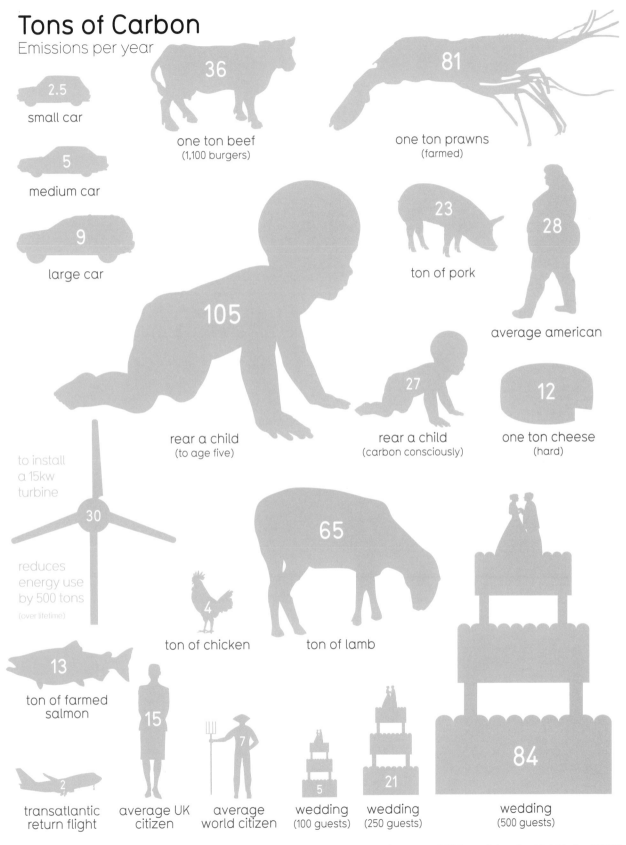

Tons of Carbon
Emissions per year

2.5
small car

5
medium car

9
large car

36
one ton beef
(1,100 burgers)

81
one ton prawns
(farmed)

23
ton of pork

28
average american

105
rear a child
(to age five)

27
rear a child
(carbon consciously)

12
one ton cheese
(hard)

30
to install a 15kw turbine

reduces energy use by 500 tons
(over lifetime)

4
ton of chicken

65
ton of lamb

13
ton of farmed salmon

2
transatlantic return flight

15
average UK citizen

7
average world citizen

5
wedding
(100 guests)

21
wedding
(250 guests)

84
wedding
(500 guests)

source: New York Times, Environmental Protection Agency, IPCC, Energy Information Administration, UNESCO

Books Everyone Should Read

A consensus cloud

All Quiet on the

Anne of Green Gables Emma The

Of Mice and Men Life of Pi

The Jungle Lonesome Dove

Midnight's Children The Time Traveler's Wife

The Da Vinci Code Persuasion Remembrance

The Stranger Sense and Sensibility Mid

The Fountainhead Lord of th

Underworld Love in the Time of Cholera One Hu

The Remains of the Day The Handmaid's Tale

Invisible Man Scoop His Dark Materials The Name of th

Watership Down The Leopard Winnie the Pooh The Sound and the Fury

A Thousand Splendid Suns The Adventures of Huckleb

The Three Musketeers

The Lord of the Rings To Kill a

The Life and Opinions of Tristram Shandy, Gentleman

The Scarlet Letter The Hitchhiker's Guide

Blood Meridian

The Color Purple The Chronicles of Narnia Lolita

A Prayer for Owen Meany Harry Potter Crash Vanity Fair B

Siddhartha Tess of the D'Urbervilles Crime and P

A Farewell to Arms Pride and Prejudice Les M

Don Quixote The Hobbit Jane Eyre David C

The Tin Drum Gone with the Wind Great Expe

Alice's Adventures in Wonderland Heart of Dark

The Brothers Karamazov The Grapes

Middlemarch

The Unbearable Lightness of B

Western Front

ture of Dorian Gray Atonement

Madame Bovary A Clockwork Orange

Wuthering Heights Of Human Bondage

of Things Past The Road East of Eden Fahrenheit 451

The Little Prince

sex Disgrace The Curious Incident of the Dog in the Night-Time

e Flies On the Road The Kite Runner The Bell Jar

ndred Years of Solitude Dracula

Rose One Flew Over the Cuckoo's Nest Little Women

erry Finn Beloved 1984 Stranger in a Strange Land

Mockingbird Moby-Dick The Old Man and the Sea

The Master and Margarita Frankenstein

to the Galaxy War and Peace

une The Glass Bead Game Twilight Do Androids Dream of Electric Sheep?

ave New World A Confederacy of Dunces Foundation

unishment Catch-22 A Tale of Two Cities Possession

Cold Comfort Farm Memoirs of a Geisha

isérables Anna Karenina The Wind in the Willows

opperfield Atlas Shrugged

tions Ulysses Slaughterhouse-Five Ender's Game

The Amazing Adventures of Kavalier and Clay

ess Animal Farm Rebecca

of Wrath For Whom the Bell Tolls

g The Good Earth Oscar and Lucinda

source: Desert Island Discs, Pulitzer Prize, AskMetafilter.com, World Day Book Poll, Booker Prize, BBC Big Reads, Oprah's Book Club List & the author's own top five

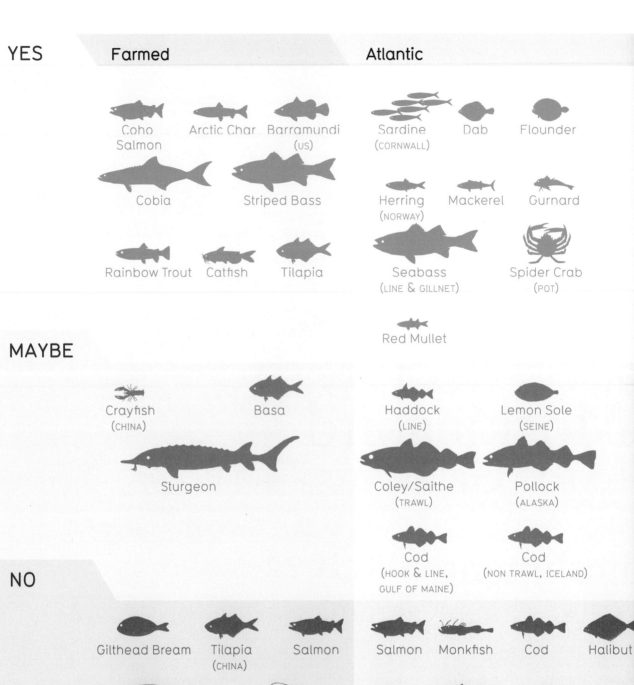

YES

Farmed

Coho Salmon

Arctic Char

Barramundi (US)

Cobia

Striped Bass

Rainbow Trout

Catfish

Tilapia

Atlantic

Sardine (CORNWALL)

Dab

Flounder

Herring (NORWAY)

Mackerel

Gurnard

Seabass (LINE & GILLNET)

Spider Crab (POT)

Red Mullet

MAYBE

Crayfish (CHINA)

Basa

Sturgeon

Haddock (LINE)

Lemon Sole (SEINE)

Coley/Saithe (TRAWL)

Pollock (ALASKA)

Cod (HOOK & LINE, GULF OF MAINE)

Cod (NON TRAWL, ICELAND)

NO

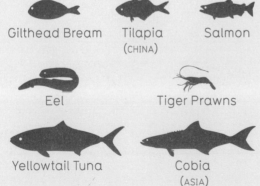

Gilthead Bream

Tilapia (CHINA)

Salmon

Eel

Tiger Prawns

Yellowtail Tuna

Cobia (ASIA)

Salmon

Monkfish

Cod

Halibut

Herring (W. ATLANTIC)

Sea Trout

Spiny Dogfish

Hake (LINE)

Chilean Seabass

Plaice

Anchovy (MEDITERRANEAN)

Seabass

Yellowfin Tuna

Haddock

Which Fish are Okay to Eat?

Crashing fish stocks. Pollution. Near-extinction.

Atlantic/Pacific

Black Bream

Albacore Tuna
(POLE)

Longfin Squid
(SEINE)

Big Eye Tuna
(POLE)

Squid
(JIG)

Spiny Lobster

Skipjack Tuna
(POLE & LINE)

Pacific

Anchovy
(PERU & CHILE)

Blackcod/Sablefish

Halibut

Crimson Snapper
(AUSTRALIA, TRAP)

Salmon
(ALASKA)

Cod
(LONGLINE, JIG, TRAP)

Dungeness Crab
(TRAP)

Pink Shrimp
(OREGON)

Sardine

Striped Bass

White Seabass

Lingcod

Flounder

Californian Halibut
(HOOK & LINE)

American Lobster
(TRAP)

Pomfret

Sole

Mahi Mahi
(LONGLINE)

Squid

Turbot

Yellowfin Tuna

Dover Sole

Shark

Blue Marlin

Spiny Lobster

Grenadier

Red Snapper

Swordfish

Hoki

King Crab

Californian Halibut

Orange Roughy

Any Tuna
(LONGLINE)

Mahi Mahi

Cod
(IMPORTED)

Rockfish
(TRAWL)

Skate

Toothfish

Salmon

source: Marine Conservation Society, Greenpeace, Seafood Watch // data:bit.ly/whichfish

SUMMER | WINTER

The "In" Colours
Women's fashion colours

2007

2008

2009

2010

2011

source: pantone.com

The "Interesting" Colours
Selected women's fashion colours

SUMMER

2002

			03
pinkle	lily green	poppy red	

			04
tigerlily	cadmium	plaza taupe	

			05
coral reef	kelp	begonia pink	

			06
french vanilla	melon	clove	

			07
silver peony	tarragon	golden apricot	

			08
golden olive	croissant	snorkel blue	

			09
lucite green	dark citron	rose dust	

			10
roccoco red	deep ultramarine	cameo pink	

			11
blue curaçao	peapod	russet	

2002

gypsy lavender turkish coffee peacock

03

hollyhock cognac dull gold

04

tango red norse blue elderberry

05

moroccan blue rattan moss

06

simple taupe apple cinnamon red mahogany

07

carafe chilli pepper lemon curry

08

royal lilac shiitake withered rose

09

split pea dark plum raspberry

10

rose dust purple orchid woodbine

11

honeysuckle deep teal quarry

WINTER

Three's a Magic Number

BIZARRE LOVE TRIANGLES

hmmmmm

leia

han luke

70s

cough

diana

charles camilla

80s

wha–?

woody

mia soon-yi

90s

THREE THINKING

dialectics

synthesis

thesis antithesis

HEGEL

types of thinking

analytic

creative practical

APPARENTLY

journalistic

lies damned lies statistics

MARK TWAIN

THE THREE DOMAINS OF LIFE

the domains

the good

the beautiful the true

PLATO

their disciplines

ethics

art science

their types of truth

justness

integrity fact

CHRISTIAN TRINITIES

God is a happy family

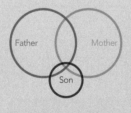

Father Mother

Son

GNOSTIC (100 AD)

1 god, 3 persons

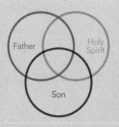

Father Holy Spirit

Son

EARLY (200 AD)

all separate

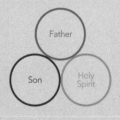

Father

Son Holy Spirit

NICENE (325 AD)

HEALTHREE

life essentials

exercise diet

sleep

COMMON SENSE

types of fitness

stamina flexibility

strength

SHAWN PHILLIPS

relationship essentials

passion intimacy

commitment

GOOD LUCK!

3-part mind

ego
the "I"

super ego
above "I" id
 the "it"

FREUD

3-part brain

neocortex limbic

 reptilian

thought emotion impulse

PAUL D MACLEAN

3 voices in the mind

top dog

adult

underdog

FRITZ PERLS

THREEDOM

pre-modern values

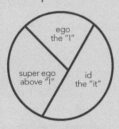

faith

instinct belief

PRE 1700

modern values

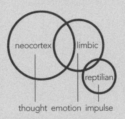

rationality

secularism science

1700–1945

post-modern values

choice

diversity tolerance

1945+

no, son both human & divine

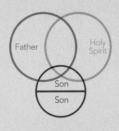

Father Holy
 Spirit

Son
Son

CALCEDON (451 AD)

er, son created by union

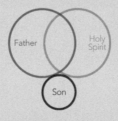

Father Holy
 Spirit

Son

ORIENTAL ORTHODOXY (451 AD)

I know! Father creates *both*

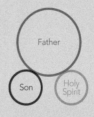

Father

Son Holy
 Spirit

EASTERN ORTHODOXY (1054 AD)

source: Wikipedia, The Gale Encyclopedia of Religion

Who Runs the World?

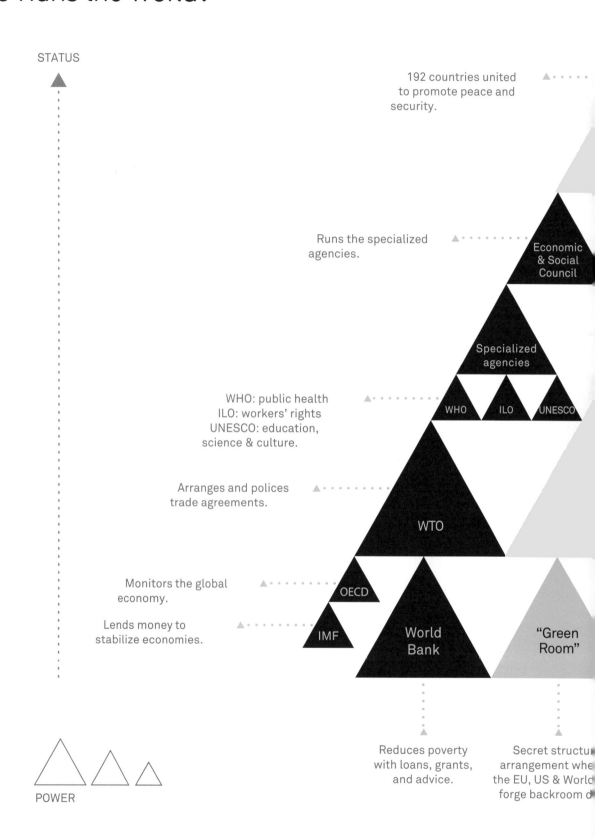

STATUS

192 countries united to promote peace and security.

Runs the specialized agencies.

Economic & Social Council

Specialized agencies

WHO: public health
ILO: workers' rights
UNESCO: education, science & culture.

WHO ILO UNESCO

Arranges and polices trade agreements.

WTO

Monitors the global economy.

OECD

Lends money to stabilize economies.

IMF World Bank "Green Room"

Reduces poverty with loans, grants, and advice.

Secret structu
arrangement whe
the EU, US & World
forge backroom d

POWER

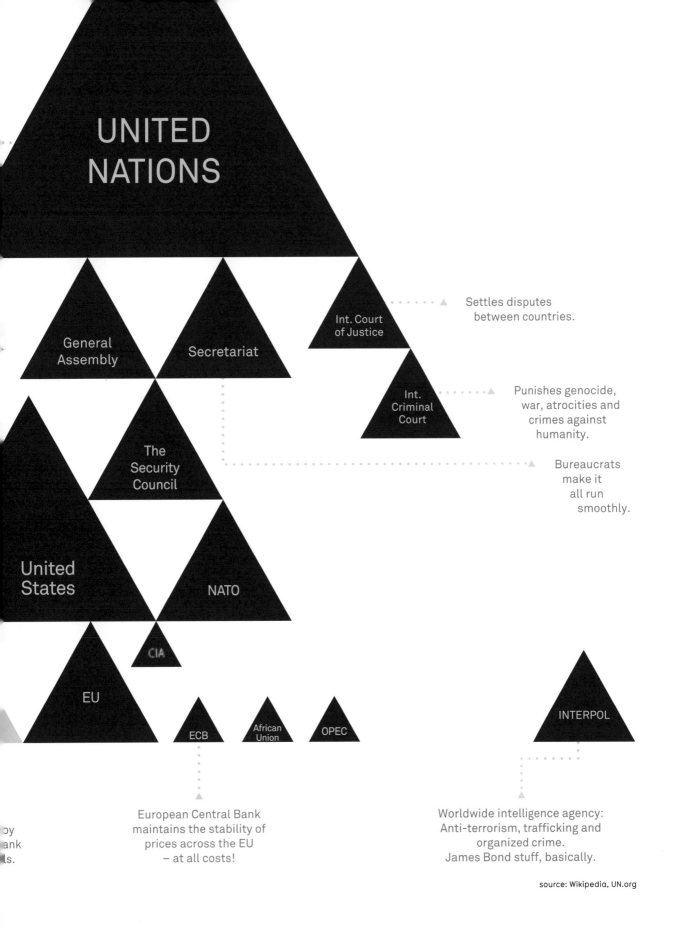

UNITED NATIONS

General Assembly

Secretariat

Int. Court of Justice

············ ▲ Settles disputes between countries.

Int. Criminal Court

············ ▲ Punishes genocide, war, atrocities and crimes against humanity.

The Security Council

············ ▲ Bureaucrats make it all run smoothly.

United States

NATO

CIA

EU

ECB

African Union

OPEC

INTERPOL

European Central Bank maintains the stability of prices across the EU – at all costs!

Worldwide intelligence agency: Anti-terrorism, trafficking and organized crime. James Bond stuff, basically.

source: Wikipedia, UN.org

Who *Really* Runs the World?
Conspiracy theory

STATUS

Secret group similar to Freemasons, which masterminds world events and controls governments for its own purposes.

Unofficial invite-only club comprised of world leaders. Their goal: to create an international government to rule a New World Order. Staged 9/11 attacks to trigger world war and destroy incriminating tax records.

Bilderberg Group

New World Order

A Jewish cabal that secretly controls Wall Street. And the entire world's financial markets. Oh, and Hollywood too. And the world.

The Zionists

World Trade Organization, oversees global trade and controls the world.

WTO

Corporations

The U

International economic body, controls the world.

Trilateral Commission

IMF

WHO

The Media

Invents disorders like ADHD to market drugs.

POWER

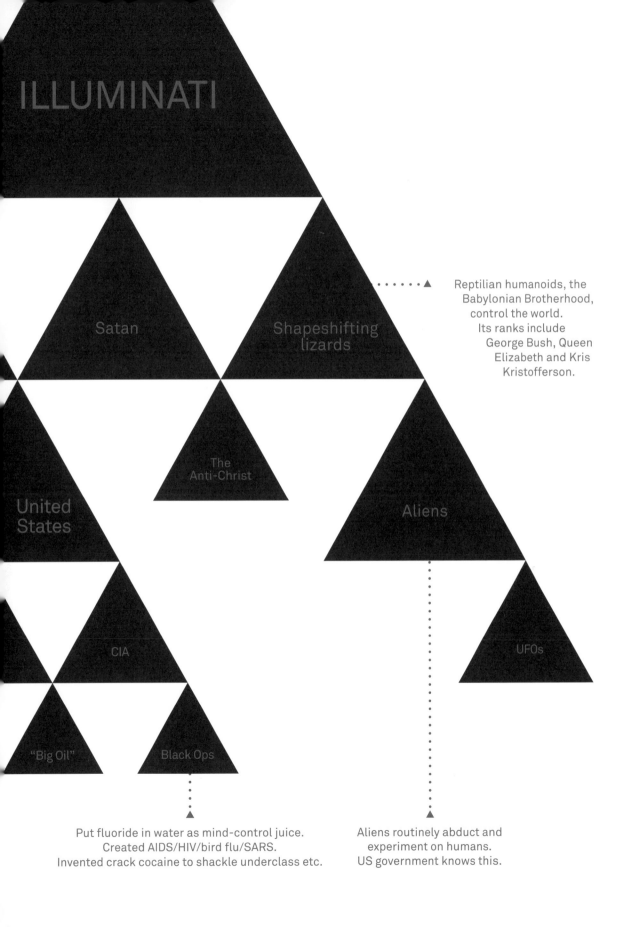

ILLUMINATI

Satan

Shapeshifting lizards

Reptilian humanoids, the Babylonian Brotherhood, control the world. Its ranks include George Bush, Queen Elizabeth and Kris Kristofferson.

The Anti-Christ

United States

Aliens

CIA

UFOs

"Big Oil"

Black Ops

Put fluoride in water as mind-control juice. Created AIDS/HIV/bird flu/SARS. Invented crack cocaine to shackle underclass etc.

Aliens routinely abduct and experiment on humans. US government knows this.

Stock Check

Estimated remaining world supplies of non-renewable resources

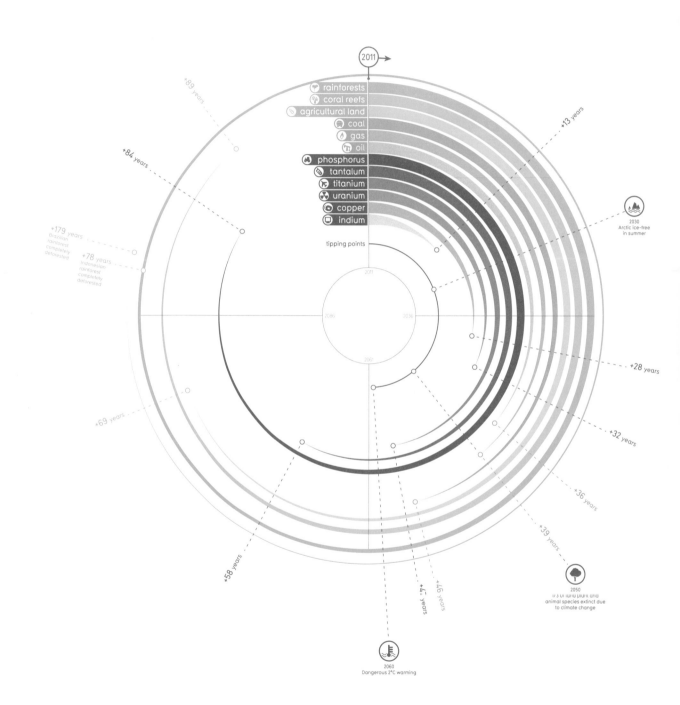

2011

rainforests
coral reefs
agricultural land
coal
gas
oil
phosphorus
tantalum
titanium
uranium
copper
indium

tipping points

+89 years
+84 years
+179 years
Brazilian rainforest completely deforested
+78 years
Indonesian rainforest completely deforested
+69 years
+58 years
+47 years
+46 years
+39 years
+36 years
+32 years
+28 years
+13 years

2011
2086
2036
2061

2030
Arctic ice-free in summer

2050
1/3 of land plant and animal species extinct due to climate change

2060
Dangerous 2°C warming

note: worst-case based on published estimates, assuming fixed % yearly consumption rate

source: UN TEEB, US Geological Survey, BP, Worm et al (2006), London Metal Exchange

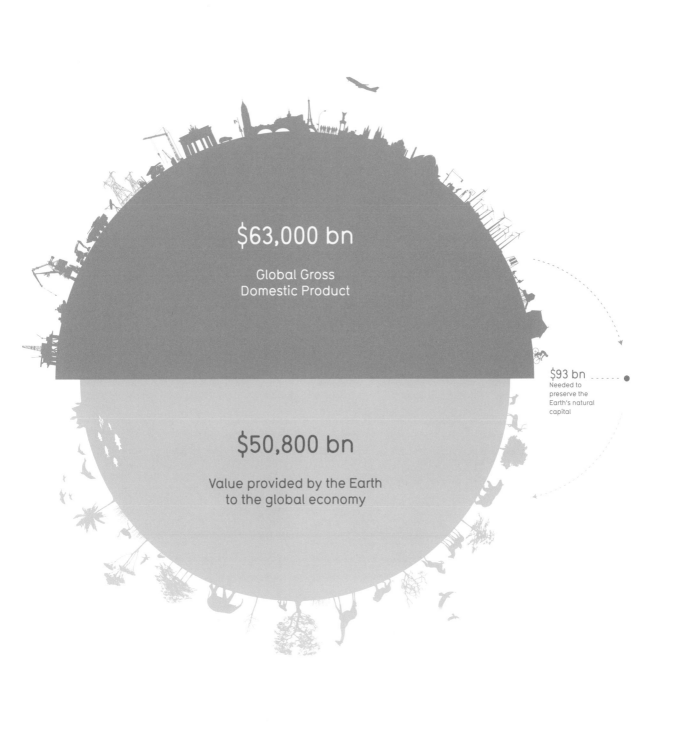

$63,000 bn

Global Gross
Domestic Product

$93 bn
Needed to
preserve the
Earth's natural
capital

$50,800 bn

Value provided by the Earth
to the global economy

source: Costanza et al, World Bank (2010)

Amazon

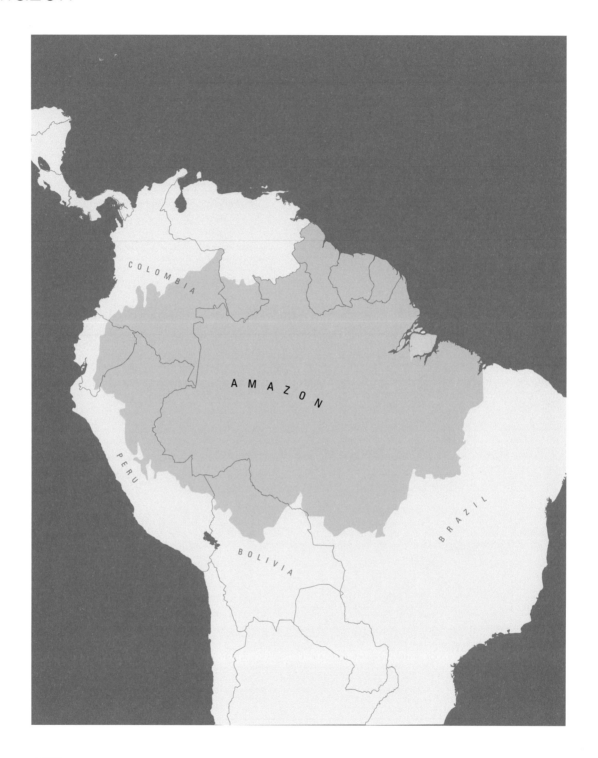

1979

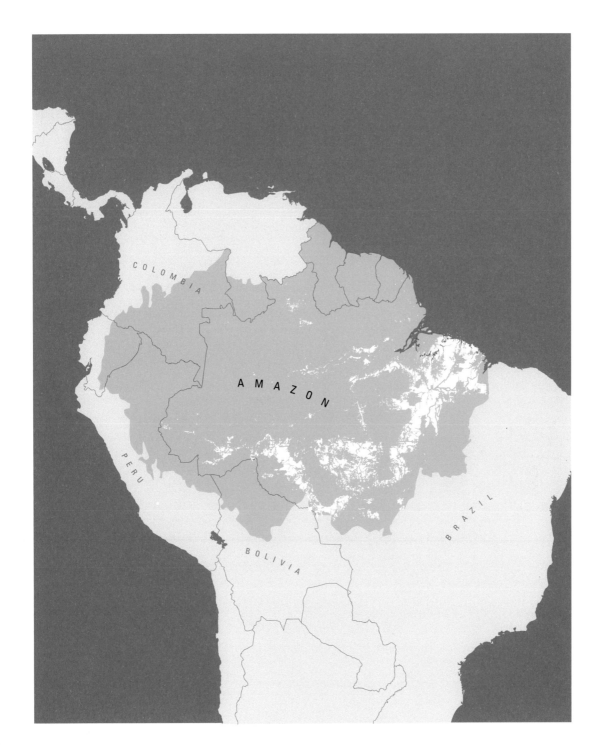

COLOMBIA

AMAZON

PERU

BRAZIL

BOLIVIA

2009

source: Global Forest Watch

Creation Myths
How did it all start?

Ex Nihilo (Out of Nothing)

Abrahamic (Christianity / Judaism / Islam)
Day 1. God created light and darkness.
Day 2. He created water and sky.
Day 3. Separated dry ground from oceans, created all vegetation.
Day 4. Created sun, moon and stars.
Day 5. Created all water-dwelling creatures and birds.
Day 6. Created all creatures of the world.
Day 7. Had a nice rest.

The Big Bang
1. 15,000 million years ago all the matter in the Universe bursts out from single point. **2.** Inflates from the size of an atom to the size of a grapefruit in a microsecond. **3.** Three minutes in, the universe is a superhot fog, too hot for even light to shine. **4.** 300,000 years later, everything is cool enough to form the first atoms. Light shines! **5.** After a billion years, clouds of gas collapse. Gravity pulls them in to form the first galaxies and stars.

Primordial "Soup"

Hinduism
In a dark vast ocean, Lord Vishnu sleeps. A humming noise trembles. With a vast "OM!" Vishnu awakes. From his stomach blossoms a lotus flower containing Brahma, who splits the lotus flower into heaven, earth and sky.

Chinese (Taoist)
There was a mist of chaos. The mist separated and the light rose to heaven and the heavy sank and formed the earth. From heaven and earth came yin and yang, masculine and feminine. Together they keep the world in harmony.

Infinite Universe / Continuous Creation

Steady State Theory
Matter is generated constantly as the universe expands. No beginning, no end.

Buddhism
The universe is not fixed in a state of "being", but of "becoming". At any moment some stars and galaxies are born while others die.

Infinite Universe / Cyclical

Big Bangs, Big Crunches
Endless cycles of big bangs and big crunches, with each cycle lasting about a trillion years. All matter and radiation is reset, but the cosmological constant is not. It gradually diminishes over many cycles to the small value observed in today's universe.

Involution / Evolution (Hinduism, Theosophy)
Infinite number of universes in an infinite cycle of births, deaths and rebirths. Each cycle lasts 8.4 billion years. The universe involves (in breath), gathers all the material, then 'evolves' (out breath) and expands. This cycle repeats infinitely.

Quasi Steady State (QSS) Theory
The cosmos has always existed. Explosions, of all different sizes, occur continuously, giving the impression of a big bang in our locality.

Bubble Universe
Our universe is a bubble spawned off a larger "foam" of other universes. Each bubble is different. Ours is finely tuned to support life.

source: Wikipedia, NewScientist.com

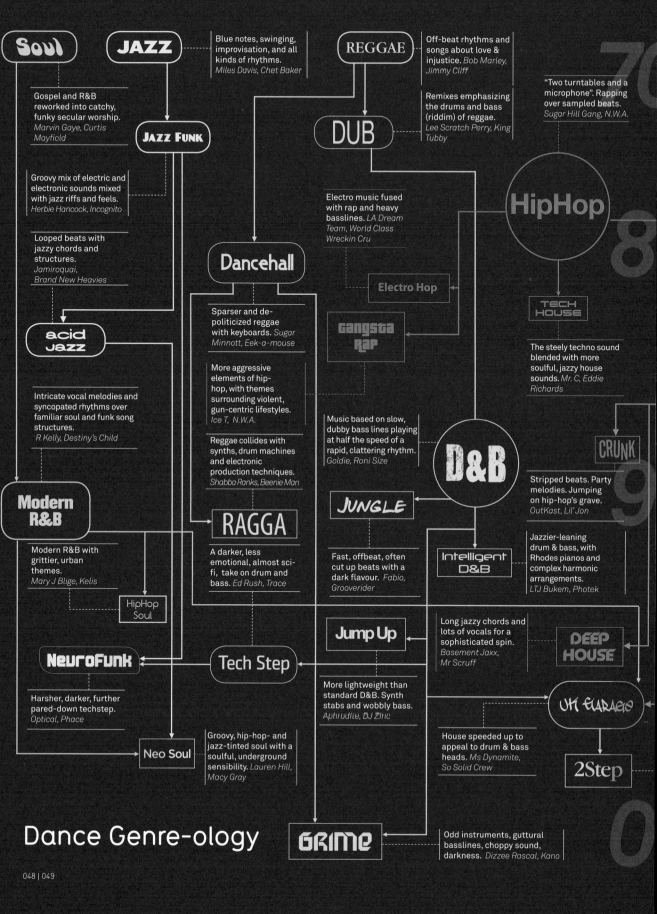

Soul

JAZZ — Blue notes, swinging, improvisation, and all kinds of rhythms. *Miles Davis, Chet Baker*

REGGAE — Off-beat rhythms and songs about love & injustice. *Bob Marley, Jimmy Cliff*

Gospel and R&B reworked into catchy, funky secular worship. *Marvin Gaye, Curtis Mayfield*

JAZZ FUNK

DUB — Remixes emphasizing the drums and bass (riddim) of reggae. *Lee Scratch Perry, King Tubby*

"Two turntables and a microphone". Rapping over sampled beats. *Sugar Hill Gang, N.W.A.*

Groovy mix of electric and electronic sounds mixed with jazz riffs and feels. *Herbie Hancock, Incognito*

Electro music fused with rap and heavy basslines. *LA Dream Team, World Class Wreckin Cru*

HipHop

Looped beats with jazzy chords and structures. *Jamiroquai, Brand New Heavies*

Dancehall

Electro Hop

acid jazz

TECH HOUSE

The steely techno sound blended with more soulful, jazzy house sounds. *Mr. C, Eddie Richards*

Intricate vocal melodies and syncopated rhythms over familiar soul and funk song structures. *R Kelly, Destiny's Child*

Sparser and de-politicized reggae with keyboards. *Sugar Minnott, Eek-a-mouse*

Gangsta Rap

More aggressive elements of hip-hop, with themes surrounding violent, gun-centric lifestyles. *Ice T, N.W.A.*

Music based on slow, dubby bass lines playing at half the speed of a rapid, clattering rhythm. *Goldie, Roni Size*

D&B

CRUNK

Reggae collides with synths, drum machines and electronic production techniques. *Shabba Ranks, Beenie Man*

Stripped beats. Party melodies. Jumping on hip-hop's grave. *OutKast, Lil' Jon*

Modern R&B

RAGGA

JUNGLE

Intelligent D&B

Jazzier-leaning drum & bass, with Rhodes pianos and complex harmonic arrangements. *LTJ Bukem, Photek*

Modern R&B with grittier, urban themes. *Mary J Blige, Kelis*

A darker, less emotional, almost sci-fi, take on drum and bass. *Ed Rush, Trace*

Fast, offbeat, often cut up beats with a dark flavour. *Fabio, Grooverider*

HipHop Soul

Jump Up

Long jazzy chords and lots of vocals for a sophisticated spin. *Basement Jaxx, Mr Scruff*

DEEP HOUSE

NeuroFunk

Tech Step

UK Garage

More lightweight than standard D&B. Synth stabs and wobbly bass. *Aphrodite, DJ Zinc*

Harsher, darker, further pared-down techstep. *Optical, Phace*

House speeded up to appeal to drum & bass heads. *Ms Dynamite, So Solid Crew*

2Step

Neo Soul

Groovy, hip-hop- and jazz-tinted soul with a soulful, underground sensibility. *Lauren Hill, Macy Gray*

Dance Genre-ology

GRIME — Odd instruments, guttural basslines, choppy sound, darkness. *Dizzee Rascal, Kano*

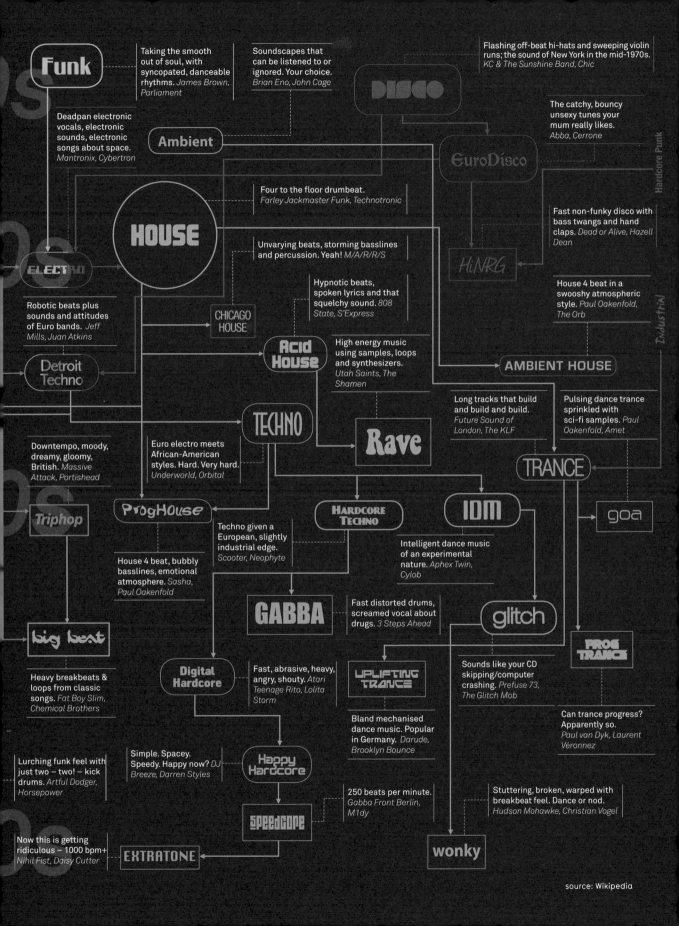

Funk — Taking the smooth out of soul, with syncopated, danceable rhythms. *James Brown, Parliament*

Soundscapes that can be listened to or ignored. Your choice. *Brian Eno, John Cage*

DISCO — Flashing off-beat hi-hats and sweeping violin runs; the sound of New York in the mid-1970s. *KC & The Sunshine Band, Chic*

The catchy, bouncy unsexy tunes your mum really likes. *Abba, Cerrone*

Ambient

EuroDisco

Deadpan electronic vocals, electronic sounds, electronic songs about space. *Mantronix, Cybertron*

HOUSE — Four to the floor drumbeat. *Farley Jackmaster Funk, Technotronic*

Fast non-funky disco with bass twangs and hand claps. *Dead or Alive, Hazell Dean*

HiNRG

Unvarying beats, storming basslines and percussion. Yeah! *M/A/R/R/S*

ELECTRO

Robotic beats plus sounds and attitudes of Euro bands. *Jeff Mills, Juan Atkins*

CHICAGO HOUSE

Hypnotic beats, spoken lyrics and that squelchy sound. *808 State, S'Express*

House 4 beat in a swooshy atmospheric style. *Paul Oakenfold, The Orb*

Acid House

High energy music using samples, loops and synthesizers. *Utah Saints, The Shamen*

AMBIENT HOUSE

Detroit Techno

TECHNO

Long tracks that build and build and build. *Future Sound of London, The KLF*

Pulsing dance trance sprinkled with sci-fi samples. *Paul Oakenfold, Amet*

Downtempo, moody, dreamy, gloomy, British. *Massive Attack, Portishead*

Euro electro meets African-American styles. Hard. Very hard. *Underworld, Orbital*

Rave

TRANCE

Triphop

ProgHouse

HARDCORE TECHNO

IDM

goa

Techno given a European, slightly industrial edge. *Scooter, Neophyte*

Intelligent dance music of an experimental nature. *Aphex Twin, Cylob*

House 4 beat, bubbly basslines, emotional atmosphere. *Sasha, Paul Oakenfold*

GABBA

Fast distorted drums, screamed vocal about drugs. *3 Steps Ahead*

glitch

big beat

Heavy breakbeats & loops from classic songs. *Fat Boy Slim, Chemical Brothers*

Digital Hardcore

Fast, abrasive, heavy, angry, shouty. *Atari Teenage Rito, Lolita Storm*

UPLIFTING TRANCE

Sounds like your CD skipping/computer crashing. *Prefuse 73, The Glitch Mob*

PROG TRANCE

Can trance progress? Apparently so. *Paul van Dyk, Laurent Véronnez*

Lurching funk feel with just two – two! – kick drums. *Artful Dodger, Horsepower*

Simple. Spacey. Speedy. Happy now? *DJ Breeze, Darren Styles*

Happy Hardcore

Bland mechanised dance music. Popular in Germany. *Darude, Brooklyn Bounce*

Stuttering, broken, warped with breakbeat feel. Dance or nod. *Hudson Mohawke, Christian Vogel*

Speedcore

250 beats per minute. *Gabba Front Berlin, M1dy*

Now this is getting ridiculous – 1000 bpm+ *Nihil Fist, Daisy Cutter*

EXTRATONE

wonky

Hardcore Punk

Industrial

source: Wikipedia

The Book of You

A copy in every one of your 10,000,000,000 cells

The Book Your complete DNA (or "genome") – 3.2 billion words

Your Page
The only part
that varies from
person to person
("genotype")
0.06%

The Chapters
Organized sections inside the book ("chromosomes"). Made of genes
23 pairs

The Paragraphs

Genes are clumps of DNA
made up of base pairs
20 – 25,000

The Words

Individual two letter
"words" of DNA
2 million

The Letters

Letters made of
just four
individual molecules

A C
G T

Responsible for all your physical characteristics, susceptibility to certain diseases, and even earwax
We have identified the effects of around 5000 out of 2,000,000 (0.25%)

source: Decodeme.com, Wikipedia

folate metabolism & several cancers

The Book of Me
My chromosomes sequenced (2 million letter combinations)

restless legs syndrome (5)

type 1 diabe

psoriasis (4)

Cr

obesity (10)

gallstones

prostate cancer (11)

rheumatoid arthri

coeliac disease (8)

venous thromboembolism

heart attack (4)

lactose intolerance

basal cell carcinoma (3)

parts of other sequences

Some conditions are influenced by several
"letters" (DNA base pairs). Only the first letters
of a sequence are labelled here with the
number of base pairs in the sequence (brackets).

age-related macular degeneration (3)

breast cancer (

disease (11)

type 2 diabetes (17)

multiple sclerosis (4)

atrial fibrillation

makes alcohol cravings stronger

bitter taste perception

haemochromatosis

intercranial aneurysm

sensitivity to pleasure

endurance athletics

warfarin metabolism (3)

bladder cancer

colorectal cancer (6)

nicotine dependence

determines earw

alcoholic flush reaction

exfoliation glaucoma
green eye colour

blue eye colour

asthma

increased Alzheimer's risk (3)

baldness

source: Decodeme.com / programming : Mattias Gunnerås

varied cognitive effects

Baroque Pop
Classical instruments – horns, strings – odd structures and conceptual, often dark, lyrics.
Beach Boys, Phil Spector

Art Rock
Intellectual rock, complex textures, many keyboards and philosophic lyrics.
ELO, Roxy Music

Power Metal
Themes of fantasy, war and death, and a few stacks of keyboards for maximum symphonic effect.
Helloween, Manowar

Prog Rock
Strange structures, odd sounds, concept albums and indulgence.
Pink Floyd, King Crimson

Indie Rock
Jangly guitars, bleak kitchen-sink lyrics, and lots and lots of daffodils.
Stone Roses, The Smiths

Glam Rock
Hard rock sound with campy costumes, big hair and ballads about space, myth and goblins.
T. Rex, David Bowie

Post Punk
Electronic keyboards, dubby basslines and even punchy disco drums plus PUNK!
PiL, Gang of Four

Rock
Distorted guitars, lengthy solos, colossal drum kits, very loud.
Judas Priest, Deep Purple

Speed Metal
Metal, but markedly faster: staccato riffs, double kick drums, complex solos.
Venom, Motörhead

Glam Metal
Catchy hooks, lengthy shredding guitar solos, spandex and hair. Big hair.
AC/DC, Kiss

Thrash Metal
Low-register, palm-muted riffs, shredding guitars,anti-authoritarian stance. Yeah!
Slayer, Anthrax

Gothic Rock
Post punk with eyeliner, flanged guitars and an increasing obsession with the futility of existence.
Siouxsie and the Banshees, The Cure

Symphonic Prog Rock
Huge rock songs composed on classical lines. Epic, complex and extra synthy.
Yes, Genesis

Metal
Roots in blues-rock and psychedelia. Distorted guitars, lengthy solos, colossal drum kits, very loud.
Judas Priest, Deep Purple

Black Metal
Heavy and dark plus songs about the evil of religion, satanic practices, and lots of white facepaint.
Mayhem, Dark Throne

Krautrock
Jamming and moody rock mixed with classical and electrionic free-forming.
Tangerine Dream, Kraftwek

Anarcho Punk
Extend punk as far to the left of the political spectrum as you can. You got it.
Crass, Conflict

Classical

Punk
Raw rebellion , pared-down songs, and shorter, punky songs.
Sex Pistols, The Damned

Hardcore Punk
Raw, direct and political. Fast, short, brutish.
Black Flag, Minor Threat

Doom Metal
Metal slowed right down, for maximum doom-laden effect. Also the despairing lyrics help.
Saint Vitus, Pagan Altar

Industrial
Experimental, dehumanized, mechanical, often using non-musical objects (like bins).
Einstürzende Neubauten, SPK

Death Metal
Fast, complex, heavy. Growling vocals and violent drumming. Don't even think about dancing.
Sepultura, Cannibal Corpse

Rock Genre-ology

Ambient Industrial
Gongs, tapeloops, swishes. Uneasy and disorientating musical concrete.
Coil, Nocturnal Emissions

POST ROCK
Often purely instrumental. Uses rock instruments to create textures, tones and atmospheres.
Tortoise, Mogwai

Mathrock
Complex, difficult, lopsided time signatures and bizarre arrangements to not quite tap your foot to.
Battles, Dirty Projectors

Symphonic Post Rock
Ambient soundscapes. Orchestras. Walls of sound.
Godspeed You! Black Emperor, Sigur Rós

GRUNGE
The distortion and ferocity of hardcore punk and metal with angsty lyrics and more accessible tune-ship.
Mudhoney, Nirvana

Mathcore
Offshoot of doom metal.
The DIllinger Escape Plan

post grunge
Distorted guitar, angsty lyrics but easier on the ear.
Silverchair, Puddle of Mudd

INDIE POP
Indie rock fused with 60s influences for a more pop-oriented sound.
The Wedding Present, Orange Juice

britpop
Fusing the rock and pop elements of indie music and sold back to the major labels in the 1990s.
Oasis, Blur

RAP ROCK
White-style shouted rap, hardcore guitars over live hip-hop style beats.
Rage Against the Machine, Red Hot Chili Peppers

Melodic Black Metal
Reining in the distortion, a few more tunes, but no let-up on the obsession with death and destruction.
Satyricon, Dark Fortress

DEATH DOOM
Growling, incomprehensible vocals, double kick drum and sheets of guitars.
Paradise Lost, Anathema

DEATHCORE
Heavy muted riffing, dissonance, growling and screaming. Melodic riffs in there somewhere.
Abscess, Unseen Terrrors

College Rock
Poppy but edgy guitar rock with artsy, poignant and jangly qualities.
REM, They Might Be Giants

Symphonic Black Metal
The addition of orchestral instruments and classical influences to the black metal.
Dimmu Borgir, Antestor

GOTH METAL
Aggressive guitar mushed with melancholic vibes, dark atmospheres & epic lyrics.
Evanescence, Paradise Lost

Melodic Death Metal
Reining in the distortion, a few more tunes, but no let-up on the obsession with death and destruction.
In Flames, Dark Tranquillity

METAL CORE
All the ferocity of metal, with all the political posturing of hardcore punk.
Biohazard, Suicidal Tendencies

Gothic Black Metal
Operatic female vocals, ambient keyboards and dark guitaring.
Cradle of Filth, Moonspell

Technical Death Metal
Noise, plus prog-style tempo changes and bizarre time signatures.
Meshuggah, Suffocation

Drone Doom
Heavy, heavy, repetitive, slow. "Not unlike listening to an Indian raga in the middle of an earthquake".
Sunn O))), Earth

THRASH CORE
Incredibly fast punk songs with blasting beats and rebellious shouty lyrics.
Septic Death, Nuclear Assault

iNDUSTRIAL METAL
Lots of drum machines. Lots of guitars. Lots of bleak lyrics. All with a tight computerized edge.
Ministry, Nine Inch Nails

MARTIAL INDUSTRIAL
Orchestral elements of classical music fused with rock music, parading and military uniforms.
Laibach, Death in June

GRINDCORE
Very heavy guitars, very fast rhythms, very short songs (sometimes only seconds).
Napalm Death, Carcass

BRUTAL DEATH METAL
Absurdly fast drumming, plus growling, shrieking and shredding guitars.
Spawn of Posession, Devourment

Simple Part I

Think of the Children
% of children living in poverty

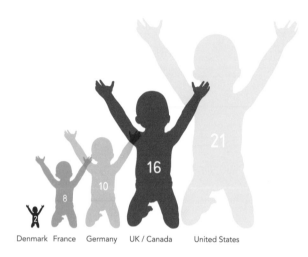

Denmark France Germany UK / Canada United States

2 8 10 16 21

source UNICEF 2007. Numbers rounded up.

Farty Animals
Annual methane emissions in equivalent CO_2

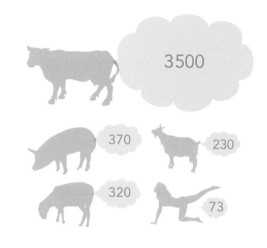

3500

370 230

320 73

source: UN Environmental Programme, theregister.co.uk

Who Reads the Most?
Amazon book stock as % of population size

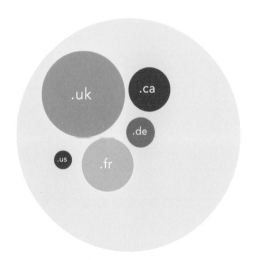

.uk .ca .de .us .fr

source: Data scraped from Amazon websites.

Wave of Generosity
% of promised tsunami aid money actually paid

Greece 100%
New Zealand
Iceland UK Norway
Japan 90%
Australia Canada 75%
Portugal Netherlands
Italy France 50%
USA 35%
Germany 26%

source: OECD

Celebrities with Issues
Number of celebs behind each cause

Mostly male celebs

Equal men & women

Mostly female celebs

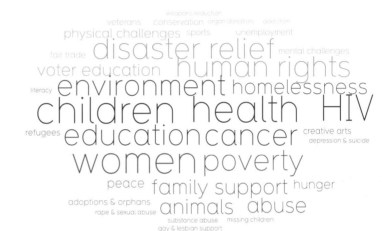

weapons reduction
veterans conservation organ donation addiction
physical challenges sports unemployment
disaster relief mental challenges
fair trade
voter education human rights
environment homelessness
literacy
children health HIV
refugees education cancer creative arts
depression & suicide
women poverty
peace family support hunger
adoptions & orphans
rape & sexual abuse animals abuse
substance abuse missing children
gay & lesbian support

idea: Richard Rogers @ govcom.org // source: looktothestars.org

How Rich?
Yearly earnings of world's wealthiest nations as combined earnings of US states

2007

Japan
$4,300bn

UK
$2,800bn

China
$3,200bn

Germany
$3,300bn

2010

Germany
$3,200bn

China
$5,900bn

Japan
$5,500bn

source: WorldBank, ASecondHandConjecture.com

Sex Education

% virgin students by university subject

0% 50% 100%

Studio Art

Anthropology

Neuroscience

Art History

Computer Science

Spanish

English

French

Philosophy

History

Economics

Undecided

Psychology

International Relations

Biology

Political Science

Biochemistry

Mathematics

0% 50% 100%

source: MIT/Wellesley College magazine, Counterpoint (2001)

Godless Swedes

% of atheists, agnostics & non-believers

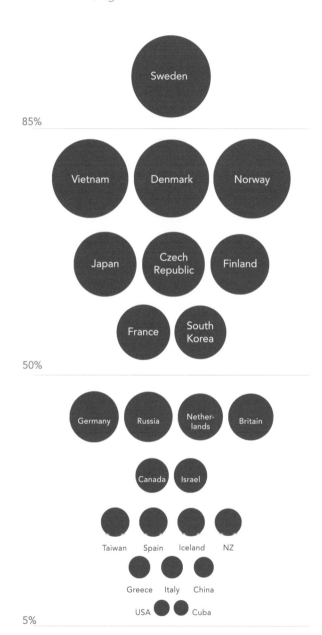

85%

50%

5%

Sweden

Vietnam Denmark Norway

Japan Czech Republic Finland

France South Korea

Germany Russia Netherlands Britain

Canada Israel

Taiwan Spain Iceland NZ

Greece Italy China

USA Cuba

source: Adherents.com

Net Increase
Internet traffic growth

Entire internet per year
1993

Internet per second
2008

Internet per year, 2000

YouTube per month, 2008

source: Cisco

Left-Hand Path
Increased wealth of left-handed men

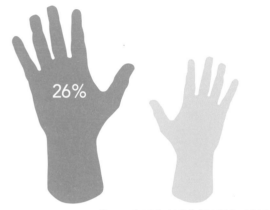

26%

Does not apply to left-handed women.

source: Lafayette College and Johns Hopkins University study

Goggle Box
The cognitive surplus...

200 billion hours
per year spent watching TV by US adults

100 million hours
to create
Wikipedia

source: Cognitive Surplus. Clay Shirky (Allen Lane, 2010)

Clear Cut
Drop in HIV transmission in circumcised males

55%

source: University of Melbourne, BBC News

Excuse Us

Reasons for divorce

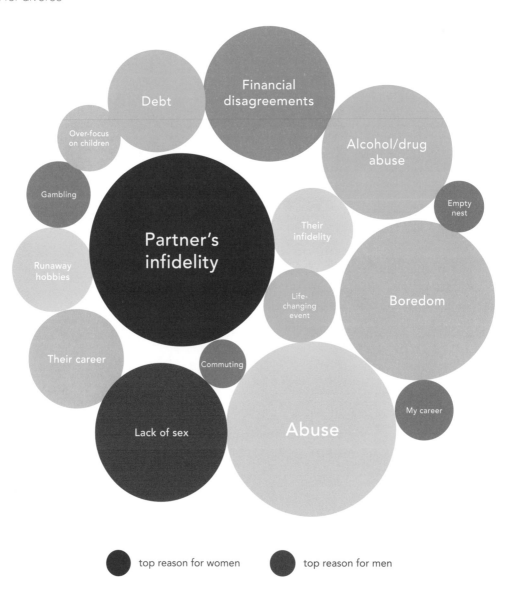

- top reason for women
- top reason for men

Debt

Financial disagreements

Over-focus on children

Alcohol/drug abuse

Gambling

Empty nest

Partner's infidelity

Their infidelity

Runaway hobbies

Life-changing event

Boredom

Their career

Commuting

My career

Lack of sex

Abuse

source: Insidedivorce.com

National Hypochondriacs Service
Top health searches

UK

Sciatica Shingles
IBS Thyroid Back pain
Pregnancy
Kidney Infection Ringworm
Chickenpox
Thrush Anaemia
Glandular Fever
Diabetes

source: NHS Direct

USA

Flu Stroke Asthma
ADHD Hepatitis
Pregnancy
Headache Arthritis
Cancer
Herpes HIV
HPV

source: About.com

Germany

Cancer
Arthritis Stroke
Anorexia Flu Spots
Diarrhea Hemorrhoids
Diabetes
HIV MS
Hypertension

source: Google Insights

For Cod's Sake
Stocks of cod in the North Atlantic (100,000 tons)

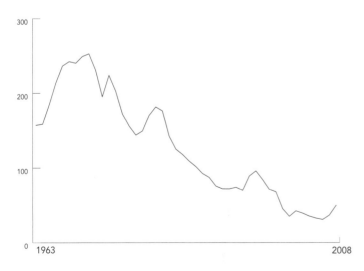

source: Fisheries Research Service

Ups and Downs
Cover vs coverage

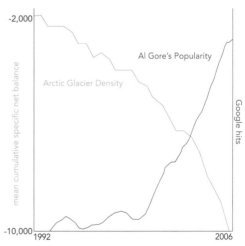

Al Gore's Popularity

Arctic Glacier Density

mean cumulative specific net balance

Google hits

source: Google Insights

What is Consciousness?
Make up your own mind

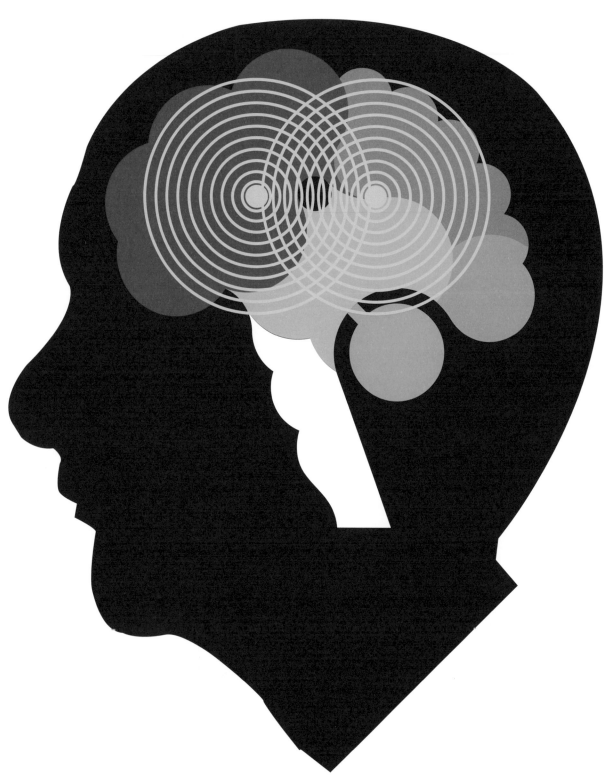

A field that exists in its own parallel "realm" of existence outside reality, so can't be seen.
(Substance Dualism)

A sensation that "grows" inevitably out of complicated brain states.
(Emergent Dualism)

A physical property of all matter, like electromagnetism, just not one scientists know about.
(Property Dualism)

All matter has a psychic part. Consciousness is just the psychic part of our brain.
(Panpsychism)

Mental states are simply physical events that we can see in brain scans.
(Identity Theory)

Consciousness and its states (belief, desire, pain) are simply functions the brain performs.
(Functionalism)

Literally just behaviour. When we behave in a certain way, we appear conscious.
(Behaviourism)

An accidental side-effect of complex physical processes in the brain.
(Epiphenomenalism)

Not sure. But quantum physics, over classical physics, can better explain it.
(Quantum Consciousness)

The sensation of your most significant thoughts being highlighted.
(Cognitivism)

Consciousness is just higher-order thoughts (thoughts about other thoughts).
(Higher-Order Theory)

A continuous stream of ever-recurring phenomena, pinched like eddies into isolated minds.
(Buddhism)

source: Wikipedia

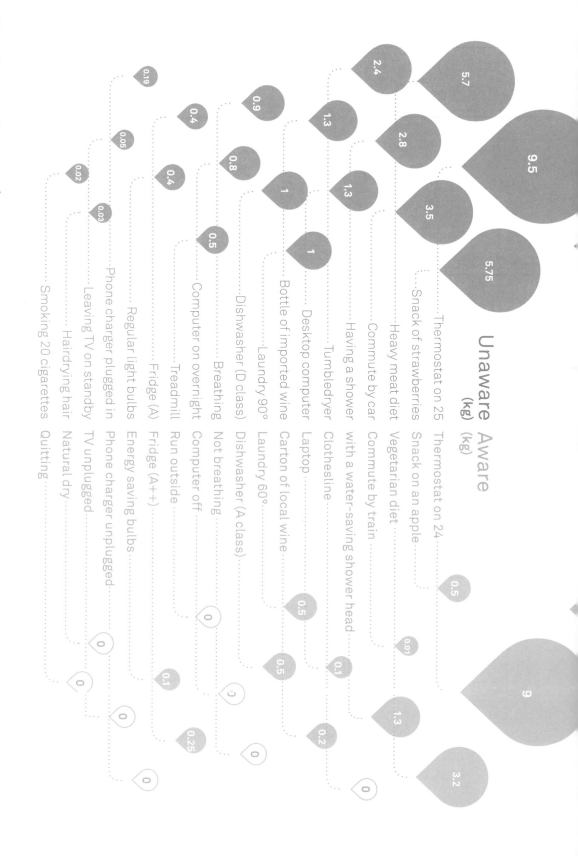

Unaware (kg)

Aware (kg)

Unaware	Item	Aware
5.7	Thermostat on 25 — Thermostat on 24	0.5
2.4	Snack of strawberries — Snack on an apple	0.01
9.5	Heavy meat diet — Vegetarian diet	9
2.8	Commute by car — Commute by train	
3.5	Having a shower with a water-saving shower head	0.1
5.75	Clothesline	
1.3	Tumbledryer	1.3
1.3	Desktop computer — Laptop	0.5
1	Bottle of imported wine — Carton of local wine	0.5
0.9	Laundry 90° — Laundry 60°	
0.8	Dishwasher (D class) — Dishwasher (A class)	0.25
0.4	Breathing — Not breathing	0
0.5	Computer on overnight — Computer off	0
0.4	Treadmill — Run outside	0.1
0.19	Regular light bulbs — Energy saving bulbs	0
0.05	Phone charger plugged in — Phone charger unplugged	0
0.03	Leaving TV on standby — TV unplugged	0
0.02	Hairdrying hair — Natural dry	0
	Smoking 20 cigarettes — Quitting	3.2

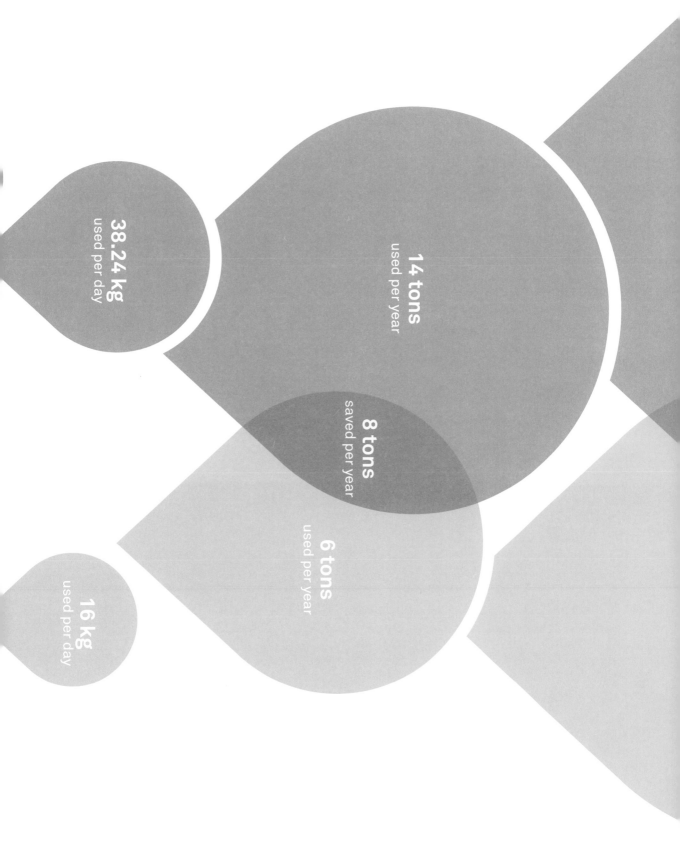

38.24 kg
used per day

14 tons
used per year

8 tons
saved per year

6 tons
used per year

16 kg
used per day

source: UNESCO, Environmental Protection Agency, Energy Information Administration

including everyone in the UK & USA
4,187,280,000 tons

including everyone in the UK
907,244,000 tons
used per year

527,644,000
tons saved

including everyone in the UK & USA
1,752,000,000 tons
(Equivalent to Japan's annual
CO_2 emissions)

including everyone in the UK
379,600,000 tons
used per year

2,435,280,000 tons
saved
(equivalent to Russia & India's total
combined CO_2 emissions per year)

Reduce Your Chances of Dying in a Plane Crash
A pre-flight check

49% 56% 56% 69%

Aisle seat
within 5 rows of an emergency exit

Seating Plan
Survival rate relative to seat position

source: Popular Mechanics [via FlowingData.com], University of Greenwich study

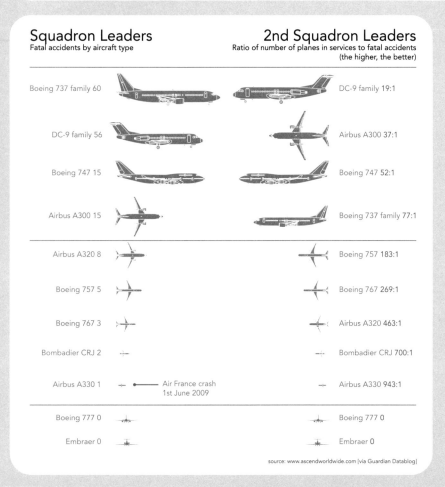

Squadron Leaders
Fatal accidents by aircraft type

Boeing 737 family	60
DC-9 family	56
Boeing 747	15
Airbus A300	15
Airbus A320	8
Boeing 757	5
Boeing 767	3
Bombadier CRJ	2
Airbus A330	1
Boeing 777	0
Embraer	0

Air France crash
1st June 2009

2nd Squadron Leaders
Ratio of number of planes in services to fatal accidents
(the higher, the better)

DC-9 family	19:1
Airbus A300	37:1
Boeing 747	52:1
Boeing 737 family	77:1
Boeing 757	183:1
Boeing 767	269:1
Airbus A320	463:1
Bombadier CRJ	700:1
Airbus A330	943:1
Boeing 777	0
Embraer	0

source: www.ascendworldwide.com [via Guardian Datablog]

Bad Month
Months with the most fatal airline accidents
1942–2009

Jan 39	Feb
Mar	Apr
May 27	June
July	Aug 48
Sep	Oct
Nov	Dec

source: Wikipedia/List_of_air_disasters

Safety Record
Fatal accidents by airline (7 or more) 1950–2008

AIR FRANCE
AIR INDIA
KOREAN AIR
CUBANA
PIA Pakistan International
AmericanAirlines®
TURKISH AIRLINES
AEROFLOT
UNITED
Garuda Indonesia
Air Philippines
CHINA AIRLINES
U·S AIRWAYS

source: airdisaster.com

Final Destination
Density of fatal accidents 1942–2009

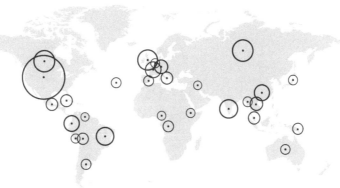

USA (2613 accidents), Russia (626), UK, India, Canada, Brazil, France, China, Colombia, Germany, Vietnam, Indonesia,
Mexico, Italy, Cuba, Bolivia, Philippines, Congo (former Zaire), Spain, Argentina, Atlantic Ocean (and associated seas
like Mediterranean, Caribbean), Myanmar, Australia, Japan, Venezuela, Netherlands, Sudan, Nigeria, Iran, Peru,
Angola, Papua New Guinea, Afghanistan, Poland, Egypt, Pakistan, Thailand, Turkey, Ecuador (75)

source: www.aviation-safety.net/database/country

The Odds
Chances of actually dying in a plane crash

Falling down	Heat stroke	Lightning	Nuclear accident	Plane crash	Bee sting	Mountain lion attack	Blogging
20,666:1	950,000:1	2,320,000:1	10,000,000:1	11,000,000:1	15,000,000:1	32,000,000:1	35,000,000:1

source: Google

Rising Sea Levels

How long have we got?

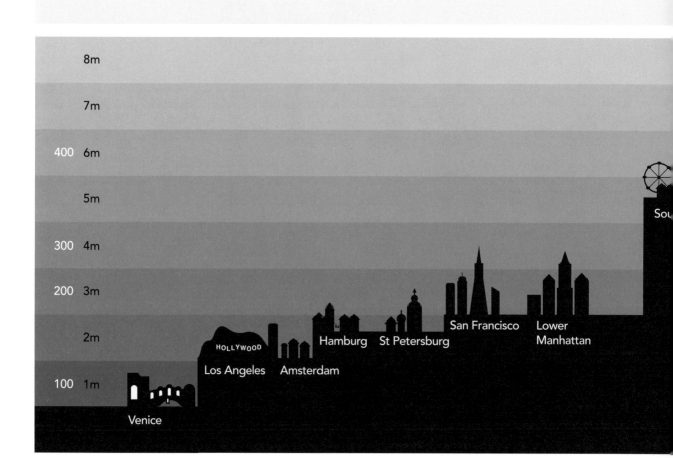

8000 years

TOTAL CONTRIBUTIONS

Antarctic ice sheet
(South Pole)
61m

Greenland ice sheet
7m

West Arctic ice sheet
6m

Heating ocean expanding
1m per century

Already happened
20cm

New York London Taipei

New Orleans

Shanghai Edinburgh

London

800 years

80 years

source: IPCC, UN Sea Levels Report, Realclimate.org, Telegraph.co.uk

Colours and Culture
The meanings of colours around the world

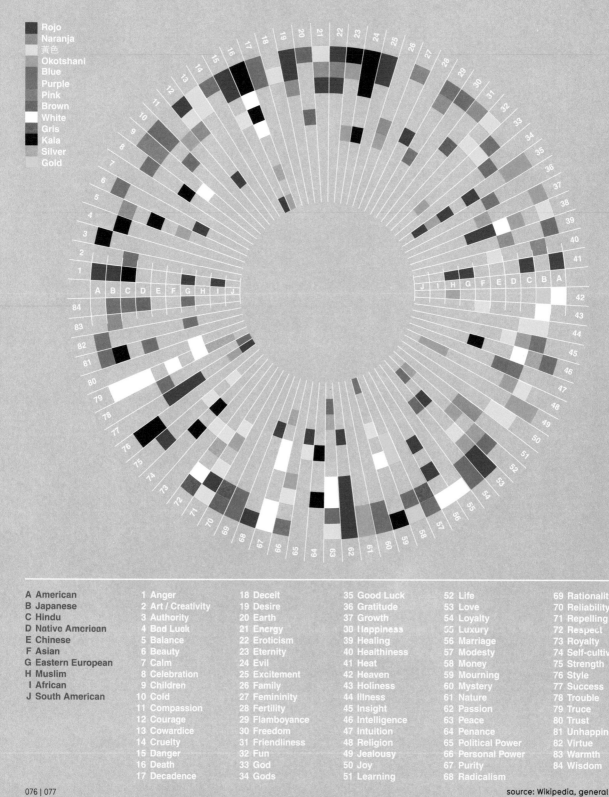

Legend (colours):
- Rojo
- Naranja
- 黄色
- Okotshani
- Blue
- Purple
- Pink
- Brown
- White
- Gris
- Kala
- Silver
- Gold

A American
B Japanese
C Hindu
D Native American
E Chinese
F Asian
G Eastern European
H Muslim
I African
J South American

1 Anger	18 Deceit	35 Good Luck	52 Life	69 Rationality
2 Art / Creativity	19 Desire	36 Gratitude	53 Love	70 Reliability
3 Authority	20 Earth	37 Growth	54 Loyalty	71 Repelling Evil
4 Bad Luck	21 Energy	38 Happiness	55 Luxury	72 Respect
5 Balance	22 Eroticism	39 Healing	56 Marriage	73 Royalty
6 Beauty	23 Eternity	40 Healthiness	57 Modesty	74 Self-cultivation
7 Calm	24 Evil	41 Heat	58 Money	75 Strength
8 Celebration	25 Excitement	42 Heaven	59 Mourning	76 Style
9 Children	26 Family	43 Holiness	60 Mystery	77 Success
10 Cold	27 Femininity	44 Illness	61 Nature	78 Trouble
11 Compassion	28 Fertility	45 Insight	62 Passion	79 Truce
12 Courage	29 Flamboyance	46 Intelligence	63 Peace	80 Trust
13 Cowardice	30 Freedom	47 Intuition	64 Penance	81 Unhappiness
14 Cruelty	31 Friendliness	48 Religion	65 Political Power	82 Virtue
15 Danger	32 Fun	49 Jealousy	66 Personal Power	83 Warmth
16 Death	33 God	50 Joy	67 Purity	84 Wisdom
17 Decadence	34 Gods	51 Learning	68 Radicalism	

source: Wikipedia, general web

Stages of You
Children grow in phases. Do adults too? If so, what are the stages? Some theories...

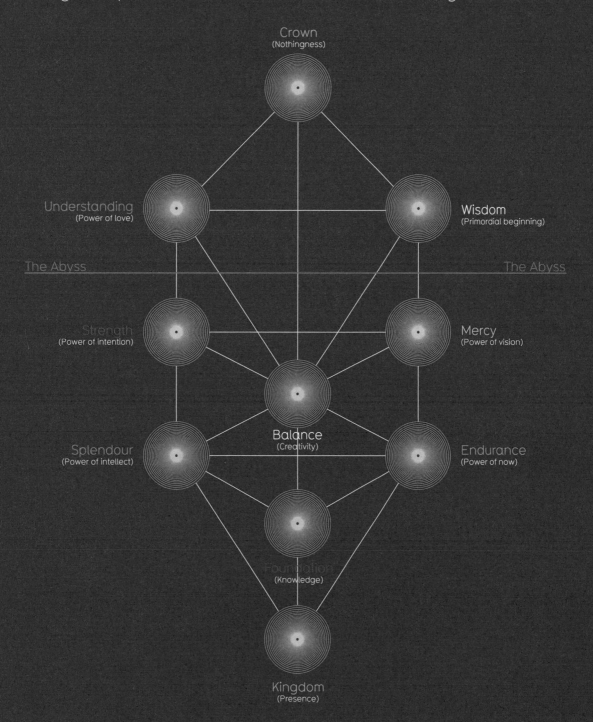

Crown
(Nothingness)

Understanding
(Power of love)

Wisdom
(Primordial beginning)

The Abyss — The Abyss

Strength
(Power of intention)

Mercy
(Power of vision)

Balance
(Creativity)

Splendour
(Power of intellect)

Endurance
(Power of now)

Foundation
(Knowledge)

Kingdom
(Presence)

The Tree of Life
In the Jewish Kabbalah, these are the ten stages through which the universe was created. They're also the ten qualities of God. As an adult grows, they ascend the tree and acquire these qualities for themselves.

CRITICS SAY: "Where's the evidence?"

Sufism

In the mystical form of Islam, the soul or self (nafs) has seven degrees of development, each with increasing purity.

The Pure Self
Self is entirely transcended. No ego or separate self left. Only the Divine exists. Any sense of individuality or separateness is an illusion.

The Self Pleasing to God
Inner marriage of self and soul. All power to act comes from God. You can do nothing by yourself. You no longer fear anything nor ask for anything. Genuine inner unity and wholeness.

The Pleased Self
You are content with your lot, and pleased with even the difficulties and trials of life, realizing that these difficulties come from God. Very different from the usual way of experiencing the world (i.e. focused on seeking pleasure and avoiding pain).

The Contented Self
The struggles of the earlier stages are basically over. The self is at peace. Old desires and attachments still exist but are no longer binding. Grateful, trusting, and adoring. One accepts difficulties in the same way one accepts benefits. The ego-self begins to let go, allowing the individual to come more closely in contact with the Divine.

The Inspired Self
Beginning to taste the joys of spiritual experience. Genuine pleasure from prayer, meditation and other spiritual activities, motivated by compassion, service and morals. Though not free from desires and selfishness, their power is significantly reduced. Emotional maturity is dawning.

The Regretful Self
Insight dawns. The negative effects of a habitually self-centred approach to the world become apparent. Wants and desires still dominate. But now you can see your faults. Regret and a desire for change grow. Attempts to follow higher impulses follow – not always successfully.

The Commanding Self
A false personality created by parents, school and culture. Selfish, controlling and lacking compassion. Must be recognized and bypassed (not destroyed) to grow.

The Arc of Ascent

> self

CRITICS SAY
"Says who?"

Source: Sufi (Laleh Bakhtiar), Sufi.org, Wikipedia, Idries Shah

The Seven Chakras

In this Eastern system, you develop by mastering life-force energy expressed through certain energy centres or "chakras" (roughly centred on various glands and organs). Imbalances in these energy wheels create feelings of blockage and dissatisfaction.

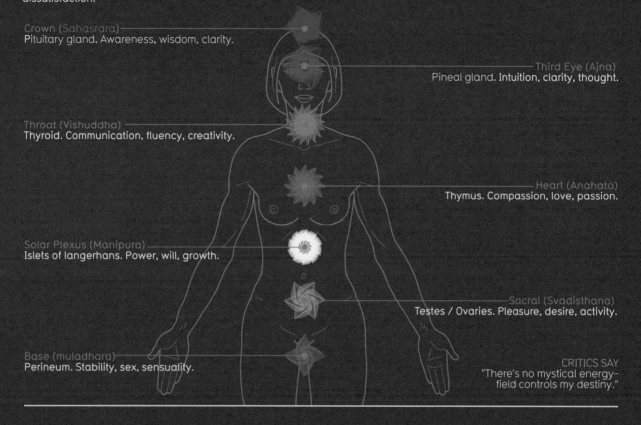

Crown (Sahasrara)
Pituitary gland. Awareness, wisdom, clarity.

Third Eye (Ajna)
Pineal gland. Intuition, clarity, thought.

Throat (Vishuddha)
Thyroid. Communication, fluency, creativity.

Heart (Anahata)
Thymus. Compassion, love, passion.

Solar Plexus (Manipura)
Islets of langerhans. Power, will, growth.

Sacral (Svadisthana)
Testes / Ovaries. Pleasure, desire, activity.

Base (muladhara)
Perineum. Stability, sex, sensuality.

CRITICS SAY
"There's no mystical energy-field controls my destiny."

Maslow's "Hierarchy of Needs"

Psychologist Abraham Maslow believed that adult growth occurs in seven stages. But only after certain needs are fulfilled in your life.

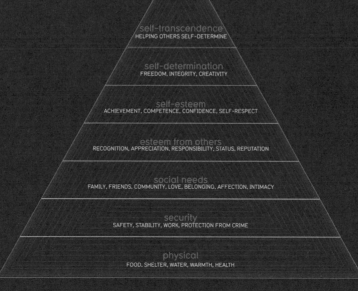

self-transcendence
HELPING OTHERS SELF-DETERMINE

self-determination
FREEDOM, INTEGRITY, CREATIVITY

self-esteem
ACHIEVEMENT, COMPETENCE, CONFIDENCE, SELF-RESPECT

esteem from others
RECOGNITION, APPRECIATION, RESPONSIBILITY, STATUS, REPUTATION

social needs
FAMILY, FRIENDS, COMMUNITY, LOVE, BELONGING, AFFECTION, INTIMACY

security
SAFETY, STABILITY, WORK, PROTECTION FROM CRIME

physical
FOOD, SHELTER, WATER, WARMTH, HEALTH

CRITICS SAY
"Little evidence. Fundamental human needs don't change over time and certainly can't be ranked in a hierarchy."

source: Wikipedia, Sufi.org, IdriesShah.com

Loevinger's Stages of Self-Development

Psychologist Jane Loevinger's system emphasizes the maturing of conscience. Social rules govern most people's personal decisions. But if differences appear between social rules and your behaviour, you must adapt to resolve the conflict, i.e. you have to grow.

	Opportunist	Diplomat	Expert
DEFINED BY	mistrust & manipulation	the group (tribe, family, nation)	knowledge
POSITIVES	energetic	dependable	ideas & solutions
SELF-DEFINITION	self-centred	self-in-group	self-autonomy
ACTION	whatever	obeying	doing
INTERESTS	domination, control	neatness, status, reputation	efficiency, improvement, perfection
THINKING	black & white	concrete	watertight
BEHAVIOUR	opportunistic	controlled	superior
WORLD VIEW	hostile, dangerous place	conformist, fundamentalist	rational, scientific
LOOKING FOR	rewards	acceptance	perfection
MORALITY	for self-interest only	given by the group	self-righteous
LANGUAGE HABITS	polarities: good/bad, fun/boring	superlatives, platitudes, clichés	"yes but…"
COMMON FLAWS	selfish	hostility to "outsiders"	selfish
FEAR OF	being overpowered	disapproval, rejection	loss of uniqueness
DEFENCES	blaming, distortion	suppression, projection, idealization	intellectualizing, hostile humour, blaming tools
SOCIALLY	two-faced, hostile	facilitator, socialite	seek to stand out from the crowd
RELATIONSHIPS	exploitative, volatile	useful for status	useful or not?
WHEN OPPOSED	tantrums, harsh retaliation	meekly accept	argumentative, belittling, opinionated

Achiever	Individualist	Strategist	Alchemist
independence	unconventionality	strength & autonomy	complexity, authenticity
conviction, fairness, enthusiasm	inspiring & spontaneous	insightful, principled, balanced	charismatic, authentic leaders
self-in-society	self as individual	self-determination	transparent self
perfecting	being & feeling	integrating	playing, reinventing
reasons, causes, goals, effectiveness	unique personal achievements	patterns, trends, processes, complexity	problems of language and meaning
rational, sceptical	holistic	visionary	intuitive
challenging, supportive	creative	highly collaborative, spontaneous	free
postmodern, scientific	paradoxical, no need to explain everything	multi-faceted, ambiguous	chaotic
root causes	uniqueness	authenticity	truths
self-chosen	non-judgemental, almost amoral	deeply principled, will sacrifice self for values	very high moral standards
ask lots of "why" questions	contrasting ideas, vivid language	complex, lyrical	fluid orators
exhaustion, over-extension, self-criticism	can appear aloof & unapproachable	impatient with theirs & others' development	feeling better than others
failure, loss of control	self-deception	not fulfilling their potential	fearless
rationalization, self-criticism	sublimation, spiritualization	suppression, humour, altruism	sublimation, humour
genuinely friendly	fun!	great communicators	can talk to anyone
diverse, intense & meaningful	intense & mutually rewarding	vital for intimacy & growth	deeply empathic
"we agree to differ"	respectful, differences are celebrated	tolerant, insightful, responsive	empathetic

CRITICS SAY: The "self" is a complex of developing parts, not governed by a single factor.

source: Susanne Cook-Greuter, Ego Development: Nine Levels of Increasing Embrace, Wikipedia

Spiral Dynamics

Measures how people think. The intensity with which you embrace or reject each coloured value system reveals how high you are up the development spiral. Can also be applied to societies and cultures.

Developed by Professor Clare Graves, Dr Don Beck and Chris Cowan

Yellow Autonomous

Behaviour Ecological thinking. **Embraces** Change and chaos. Self-directed. **Attitude** See the big picture. Life is learning. **Decision-making** Highly principled. Knowledge based. **Admires** The competent. **Seeks** integrity. **Loves** Natural systems, knowledge, multiplicity. **Wants** Self-knowledge. **Hides** Attachment. **Good side:** Free. Wise. Aware. **Bad side:** Overly intellectual, excessively sceptical, angst ridden.

Orange Achiever

Behaviour Strategic. Scientific thinking. Competes for success. Driven. Competitive. **Attitude** Goal orientated. Play to win. Survival of the fittest. **Decisions** Bottom line. Test options for best results. Consult experts. **Admires** The successful. **Seeks** Affluence. Prosperity. Rational truth. **Loves** Success, status. **Wants** Self-expression. **Hides** Lies **Good side:** Great communication and creativity. Risk taking. Optimistic. **Bad side:** Workaholic. Babbling. Fearful.

Red Egocentric

Behaviour Self-centred. **Attitude** Do what you want, regardless. Live for the moment. The world is a jungle. Might makes right. **Decisions based on** what gets respect, what feels good now. **Admires** The powerful. **Seeks** Power, glory and revenge. **Loves** Glitz, conquest, action. **Wants** Self-definition. **Hides** Shame. **Good side:** Spontaneous, purposeful. **Under pressure:** Dominating, blaming, aggressive. **Bad side:** Passive, sluggish, fearful.

Beige Instinctive

Behaviour Instinctive. Materialistic. Greedy. Fearful. **Attitude** Do what you can to stay alive. **Seeks** Food, water, warmth, security.

Turquoise Whole View
Behaviour Holistic intuitive thinking. **Attitude** Global. Harmonious. An ecology of perspectives. **Decision-making** Flow. Blending. Looking up and downstream. Long range. **Admires** Life! **Seeks** Interconnectedness. Peace in an incomprehensible world. **Loves** Information. Belonging. Doing.

Green Communitarian
Behaviour Consensus-seeking. Harmony within the group. Accepting. Dialogue. **Attitude** Everybody is equal. **Decision-making** Consensus. Collaborative. Accept everyone's input. **Admires** The charismatic. **Seeks** Inner peace with caring community. **Loves** Affection, good relationships, beneficial resolution. **Wants** Self-reflection. **Hides** Doubts. **Good side:** Listens well. Receptive. Perceptive, imaginative. **Bad side:** "Politically correct", inauthentic.

Blue Absolutist
Behaviour Authoritarian. Cautious. Careful. Fit in. Discipline. Faith. **Attitude** Only one right way. **Decision-making** based on obeying rules, following orders, doing "right". **Admires** The righteous. **Seeks** Peace of mind. **Loves** Everything in its right place. **Wants** Self-acceptance. **Hides** Grief. **Good side:** Balanced, compassionate. **Bad side:** Needy, possessive, jealous, bitter, critical.

Purple Tribal
Behaviour Impulsive. Honour the "old ways". **Attitude** Self-gratifying. **Decision-making** Based on custom and tradition. **Seeks** Safety, security. **Admires** The clan. **Hides** Guilt. **Good side:** Fluid with a healthy sexuality. **Bad side:** Overly emotional, obsessive, frigid, impotent, numb.

CRITICS SAY: "Says who? Exact characteristics for advance stages are unclear and speculative."

source: spiraldynamics.net, wikipedia

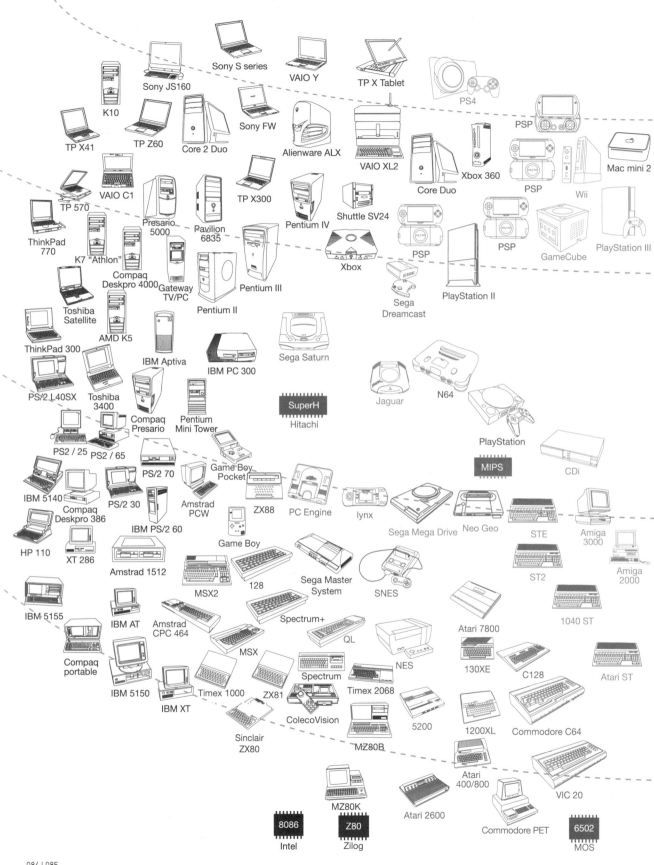

Sony S series

VAIO Y

TP X Tablet

PS4

Sony JS160

K10

PSP

Sony FW

TP X41

TP Z60

Core 2 Duo

Alienware ALX

VAIO XL2

Xbox 360

PSP

Mac mini 2

VAIO C1

TP X300

Core Duo

PSP

Wii

TP 570

Shuttle SV24

ThinkPad
770

Presario
5000

Pavilion
6835

Pentium IV

PSP

PSP

GameCube

PlayStation III

K7 "Athlon"

Compaq
Deskpro 4000

Gateway
TV/PC

Pentium III

Xbox

Sega
Dreamcast

PlayStation II

Toshiba
Satellite

Pentium II

ThinkPad 300

AMD K5

IBM Aptiva

Sega Saturn

Jaguar

N64

PS/2 L40SX

Toshiba
3400

IBM PC 300

PS2 / 25

PS2 / 65

Compaq
Presario

Pentium
Mini Tower

SuperH

Hitachi

PlayStation

IBM 5140

Compaq
Deskpro 386

PS/2 70

PS/2 30

Game Boy
Pocket

Game Boy

Amstrad
PCW

ZX88

PC Engine

lynx

MIPS

CDi

Sega Mega Drive

Neo Geo

STE

Amiga
3000

HP 110

XT 286

IBM PS/2 60

ST2

Amiga
2000

Amstrad 1512

MSX2

128

Sega Master
System

SNES

1040 ST

IBM 5155

IBM AT

Amstrad
CPC 464

Spectrum+

QL

Atari 7800

MSX

130XE

C128

Atari ST

Compaq
portable

Spectrum

NES

IBM 5150

Timex 1000

ZX81

Timex 2068

5200

1200XL

Commodore C64

IBM XT

ColecoVision

Sinclair
ZX80

MZ80B

Atari
400/800

VIC 20

MZ80K

Atari 2600

8086

Z80

Commodore PET

6502

Intel

Zilog

MOS

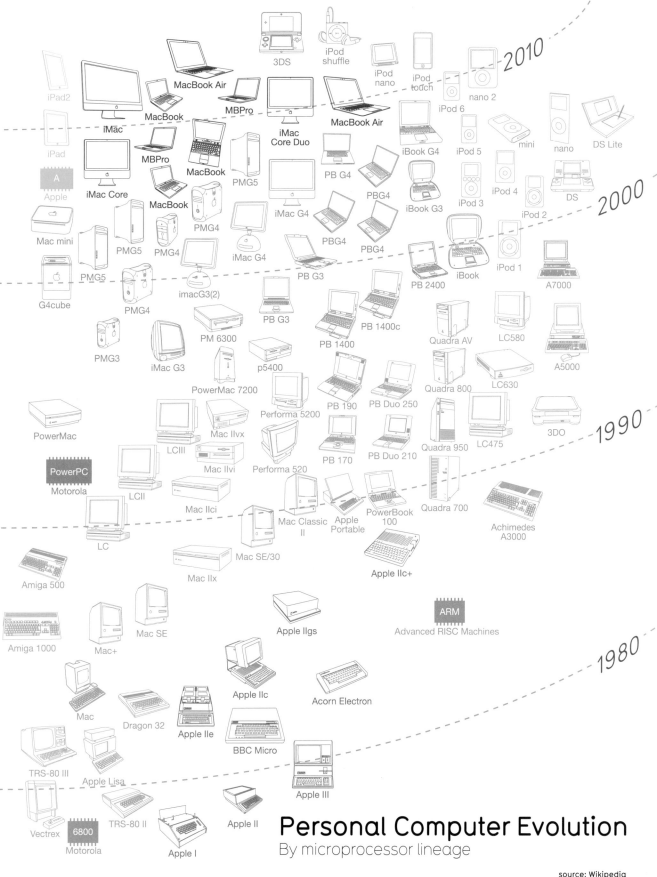

Personal Computer Evolution
By microprocessor lineage

source: Wikipedia

The One Machine
Map of the internet

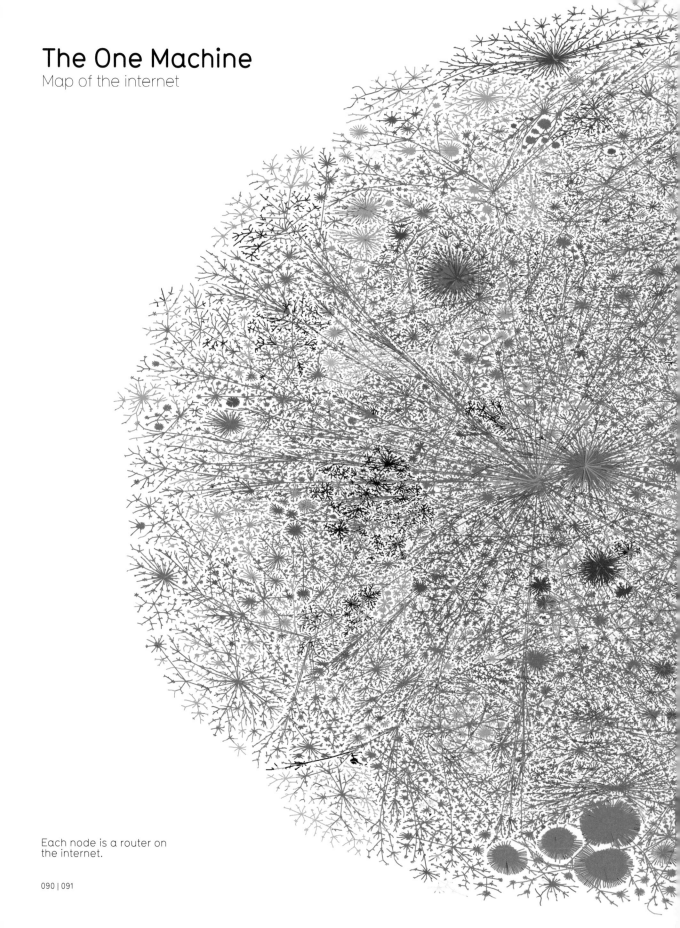

Each node is a router on
the internet.

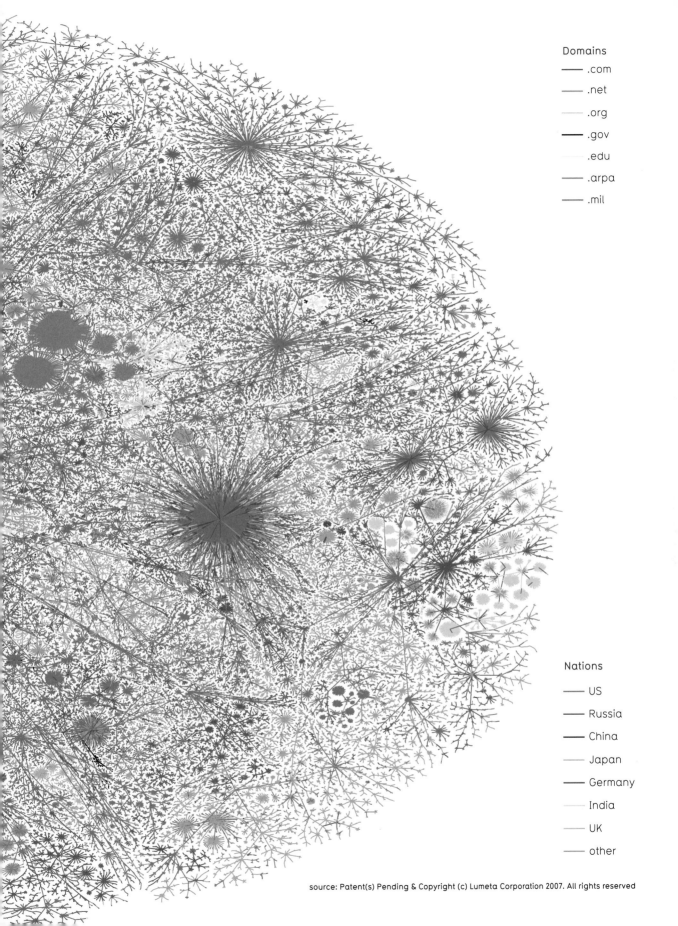

Domains
— .com
— .net
— .org
— .gov
— .edu
— .arpa
— .mil

Nations
— US
— Russia
— China
— Japan
— Germany
— India
— UK
— other

What Does China Censor Online?
Blocked keywords and websites

Falun Gong
A qigong-like spiritual practice violently supressed after followers protested against the government.

Gedhun Choekyi Nyima
2nd highest-ranking Tibetan spiritual leader after Dalai Lama. Arrested by the authorities in 1995. Not seen since.

Xinjiang
Northwest province, home to the Uyghur people and much ethnic tension.

June 4th
The usual name for the Tiananmen Square protests of 1989. (The word "Tiananmen" does not have the same association. It usually refers to the geographical place.)

01net.com 2ch.net 4chan.org 6park.com addicting
amnestyinternational.org antro.cl aol.com apple.
bbc.com bbspot.com bebo.com bild.de blogger.
bundestag.de cbc.ca china.ch china.cn china.com
cnn.com collegehumor.com crailtap.com cyberpre
de.wikipedia.org delfi.lt democracy.com
drudgereport.com e-gold.com ebaumsworld.
ehrenselmundo.es el "brain wash"elpais.com el
facebook.com fark "censorship jail" flickr.com fok.
friendster.com ga movement" gamefaqs.com g
globo.com goo "dalai" "democracy" ogle.ch go
googl "democratic progressive party" "despotism"
great "dissident" "eighty-nine" "buddha stretches
home Times" "eroticism" "evil" "exile" "falun" "Fa
indym Nyima" "genocide" "gerontocracy" "hongz
level.ro liberta"lun gong" "Ma Sanjia""Mein Kamp
marca.es mc browser" "oppression" "persecution
msn.com m Department""political dissident" "Play
nhl.com through labor" "Shanghai clique" "Shan
arcade.com "student federation" "student movem
purepwnage.co Chinese Students and Scholars" "
sapo.pt seznam.cz Mothers" "Tiananmen Square
stern.de studivz.de suchar.ne tagesscha indepe
tibet.com traffic4u.nl tw.yahoo.com tumblr.com"u
usa.gov userfriendly.org vatican.va vg.n ind
whatreallyhappened.com whitehouse.com whit Zha
wikipedia.org wordpress.com worldofwarcra Na
xanga.com yahoo.cn yahoo.co.jp yahoo.com ahc
yandex.ru yle.fi youtube.com ytmnd.com zh.wi
6park.com addictinggames.com aftonblade
amnestyinternational.org antro.cl aol.com apple.

ames.com amazon.com amnesty.com amnesty.org
m as.com asahi.com barrapunto.com bbc.co.uk
n (blogspot) boingboing.net bundesregierung.de
na.de china.org china "anti-communist" rin.com
e.ca dagbladet.no "Beijing Spring" motion.com ●——— Beijing Spring
viantart.com digg.com "anti-society" isney.com Brief period of political
m ebay.com ebay.de "blocking" com com liberalization in 1977. The public
is.es en.wikipedia.org "brutal torture" n espn.com were allowed to criticise the
xnews.com free.fr "Chinese democracy tibet.org regime. Lasted a year.
nespot.com gay "communist bandits" geenstijl.nl ●——— Communist Bandits
le.co.uk goog "democracy movement" google.de Derogatory term for communists
ogle.pl "dictatorship" cn greatfirewallofchina.org used by the Taiwan National Party.
thousand hands" "Epoch rg heise.de hi5.com ●——— buddha stretches a thousand hands
ngong" "Gedhun Choekyi .com imdb.com index.hu A Falun Gong pose.
" "Hui people riot" "human rights" org lemonde.fr
"news blackout" "no-limit m mail.ru marca.com ●——— Ma Sanjia
Chinese Central Propaganda lip.com mitbbs.com Forced labour camp where Falun
y" "Red Terror" "reeducation com news.bbc.co.uk Gong followers were detained.
i" "sky burial" "Sino-Russian border" no.be penny- ●——— Shanwei
t" "Independent Federation of prisonplanet.com Refers to Dongzhou, a village
nanmen incident" "Tiananmen a.it runescape.com where a series of protests against
ssacre" "Tibet Talk" "Tibetan sony.com spiegel.de government plans ended in a
ence" "Voice of the People" n.com thoonsen.com number of villagers being shot.
erground church" "Xinjiang g uol.com.br usa.com
pendence" "yilishen" "yellow peril" wenxuecity.com ●——— Yilishen
Ziyang "Freedom Forum of pedia.com wikipedia.de A company which scammed more
ing University" "June 4th" .pl wretch.cc wwe.com than one million Chinese investors
com.cn yahoo.com.hk yahoo.com.tw yahoo.fr by promising ants could be bought,
pedia.org 01net.com 163.com 2ch.net 4chan.org bred and sold back at a profit.
e amazon.com amnesty.com amnesty.org Revealed as a Ponzi scheme in
m as.com asahi.com barrapunto.com bbc.co.uk 2007.

Websites are either completely blocked or have offending pages removed.

source: ConceptDoppler.com, Wikipedia, GreatFirewallofChina.org (2008)

Water Towers

Daily total use
per person
4645 bottles

Direct use Indirect use

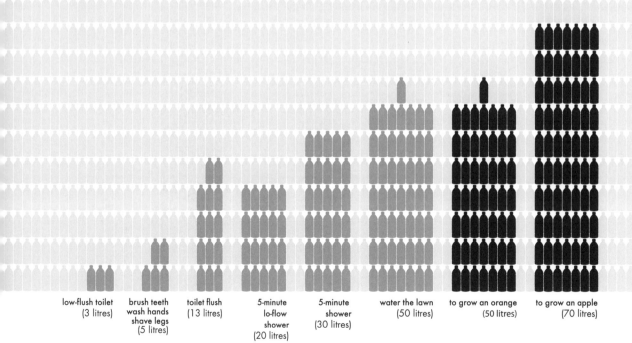

low-flush toilet
(3 litres)

brush teeth
wash hands
shave legs
(5 litres)

toilet flush
(13 litres)

5-minute
lo-flow
shower
(20 litres)

5-minute
shower
(30 litres)

water the lawn
(50 litres)

to grow an orange
(50 litres)

to grow an apple
(70 litres)

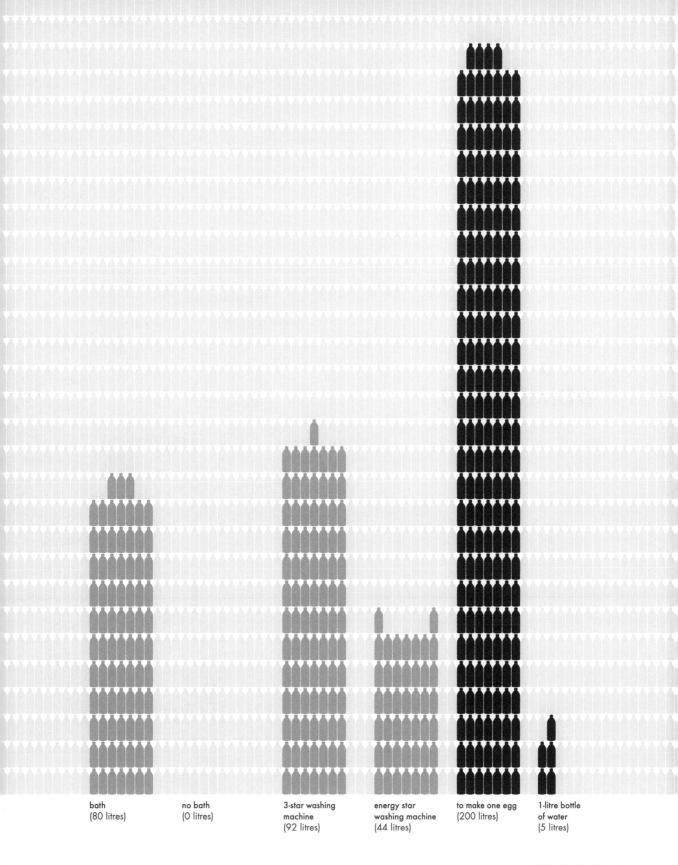

bath
(80 litres)

no bath
(0 litres)

3-star washing
machine
(92 litres)

energy star
washing machine
(44 litres)

to make one egg
(200 litres)

1-litre bottle
of water
(5 litres)

source: Wikipedia, Good Magazine

Drugs World

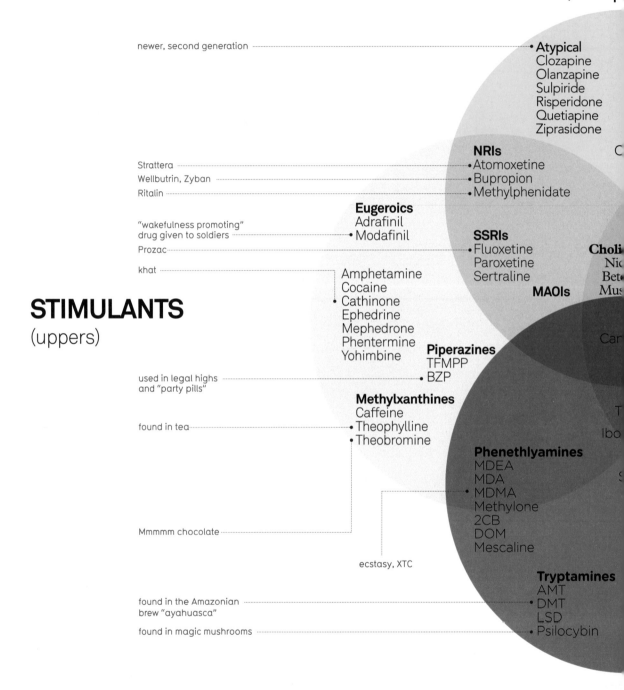

newer, second generation ············ **Atypical**
Clozapine
Olanzapine
Sulpiride
Risperidone
Quetiapine
Ziprasidone

NRIs
Strattera ······················· •Atomoxetine
Wellbutrin, Zyban ··············· •Bupropion
Ritalin ························· •Methylphenidate

Eugeroics
Adrafinil
"wakefulness promoting"
drug given to soldiers ·········· • Modafinil

SSRIs
Prozac ·························· •Fluoxetine
Paroxetine
khat ···················· Sertraline

Choli
Nic
Bet
Mus

STIMULANTS
(uppers)

Amphetamine
Cocaine
•Cathinone
Ephedrine
Mephedrone
Phentermine
Yohimbine

MAOIs

Car

Piperazines
TFMPP
used in legal highs
and "party pills" ············· •BZP

Methylxanthines
Caffeine
found in tea ············· •Theophylline
•Theobromine

T
Ibo

Phenethlyamines
MDEA
MDA
•MDMA
Methylone
2CB
DOM
Mescaline

S

Mmmmm chocolate ·············

ecstasy, XTC

Tryptamines
AMT
found in the Amazonian ·········· •DMT
brew "ayahuasca" LSD
found in magic mushrooms ·········· •Psilocybin

from Sal

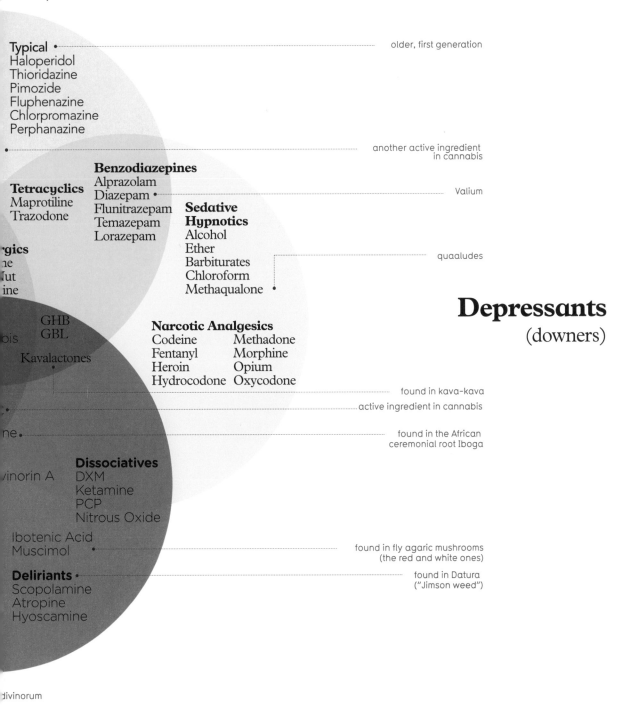

chotics
lizers)

Typical •⸱⸱⸱⸱⸱⸱⸱⸱⸱⸱⸱⸱⸱⸱⸱⸱⸱⸱⸱⸱⸱⸱⸱⸱⸱⸱⸱⸱⸱⸱⸱⸱⸱⸱⸱⸱⸱⸱ older, first generation
Haloperidol
Thioridazine
Pimozide
Fluphenazine
Chlorpromazine
Perphanazine

•⸱⸱⸱⸱⸱⸱⸱⸱⸱⸱⸱⸱⸱⸱⸱⸱⸱⸱⸱⸱⸱⸱⸱⸱⸱⸱⸱⸱⸱⸱⸱⸱⸱⸱ another active ingredient
in cannabis

Benzodiazepines
Alprazolam
Tetracyclics Diazepam •⸱⸱⸱⸱⸱⸱⸱⸱⸱⸱⸱⸱⸱⸱⸱⸱⸱⸱⸱⸱⸱⸱ Valium
Maprotiline Flunitrazepam **Sedative**
Trazodone Temazepam **Hypnotics**
Lorazepam Alcohol
rgics Ether
e Barbiturates
Jut Chloroform ⸱⸱⸱⸱⸱⸱⸱⸱⸱⸱⸱⸱⸱ quaaludes
ine Methaqualone •

GHB
GBL **Depressants**
bis (downers)
Kavalactones

Narcotic Analgesics
Codeine Methadone
Fentanyl Morphine
Heroin Opium
Hydrocodone Oxycodone

⸱⸱⸱⸱⸱⸱⸱⸱⸱⸱⸱⸱⸱⸱⸱⸱⸱⸱⸱⸱⸱⸱⸱⸱⸱⸱⸱⸱⸱⸱⸱⸱ found in kava-kava
⸱⸱⸱⸱⸱⸱⸱⸱⸱⸱⸱⸱⸱⸱⸱⸱⸱⸱⸱⸱⸱⸱⸱⸱⸱⸱⸱⸱⸱⸱⸱⸱ active ingredient in cannabis

ne •⸱⸱⸱⸱⸱⸱⸱⸱⸱⸱⸱⸱⸱⸱⸱⸱⸱⸱⸱⸱⸱⸱⸱⸱⸱⸱⸱⸱⸱ found in the African
ceremonial root Iboga

Dissociatives
inorin A DXM
Ketamine
PCP
Nitrous Oxide

Ibotenic Acid
Muscimol •⸱⸱⸱⸱⸱⸱⸱⸱⸱⸱⸱⸱⸱⸱⸱⸱⸱⸱⸱⸱⸱⸱⸱⸱⸱⸱⸱⸱ found in fly agaric mushrooms
(the red and white ones)
Deliriants •⸱⸱⸱⸱⸱⸱⸱⸱⸱⸱⸱⸱⸱⸱⸱⸱⸱⸱⸱⸱⸱ found in Datura
Scopolamine ("Jimson weed")
Atropine
Hyoscamine

divinorum

ogens
s)

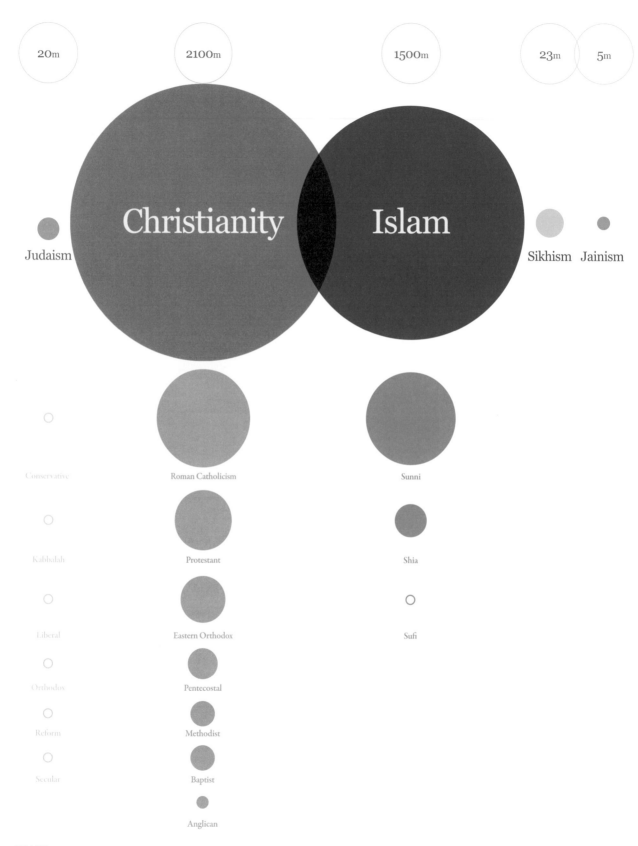

20m

2100m

1500m

23m

5m

Christianity

Islam

Judaism

Sikhism

Jainism

Conservative

Roman Catholicism

Sunni

Kabbalah

Protestant

Shia

Liberal

Eastern Orthodox

Sufi

Orthodox

Pentecostal

Reform

Methodist

Secular

Baptist

Anglican

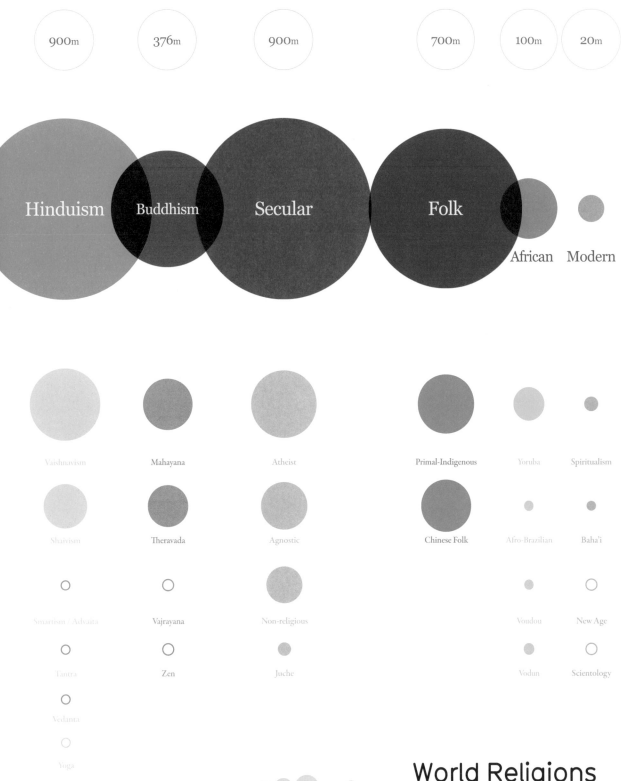

900m 376m 900m 700m 100m 20m

Hinduism Buddhism Secular Folk African Modern

Vaishnavism Mahayana Atheist Primal-Indigenous Yoruba Spiritualism

Shaivism Theravada Agnostic Chinese Folk Afro-Brazilian Baha'i

Smartism / Advaita Vajrayana Non-religious Voudou New Age

Tantra Zen Juche Vodun Scientology

Vedanta

Yoga

Number of adherents Adherents unknown

World Religions
By followers

source: Adherents.com

Moral Matrix

		masturbation	charging interest	inebriation	gambling	contraception	pre-marital sex	di
African	Brazilian							
	Vodou							
	Vodun							
	Yoruba							
Buddhism	Mahayana							
	Zen							
	Theravada							
	Vajrayana							
Christianity	Anglican							
	Baptist							
	E. Orthodox							
	Methodist							
	Mormon							
	Pentecostal							
	Protestant							
	Quaker							
	R. Catholic							
	Rastafari							
Hinduism	Smartism							
	Shaivite							
	Vashnavite							
	Vedanta							
	Yoga							
	Tantra							
Sikhism								
Jainism								
Islam	Shia							
	Sufi							
	Sunni							
Judaism	Reform							
	Orthodox							
	Liberal							
	Kabbalah							
	Secular							
	Conservative							
Modern	Bahai							
	New Age							
	Scientology							
	Tenrikyo							
Secular	Atheist / non							
	Juche							

		masturbation	charging interest	inebriation	gambling	contraception	pre-marital sex	di

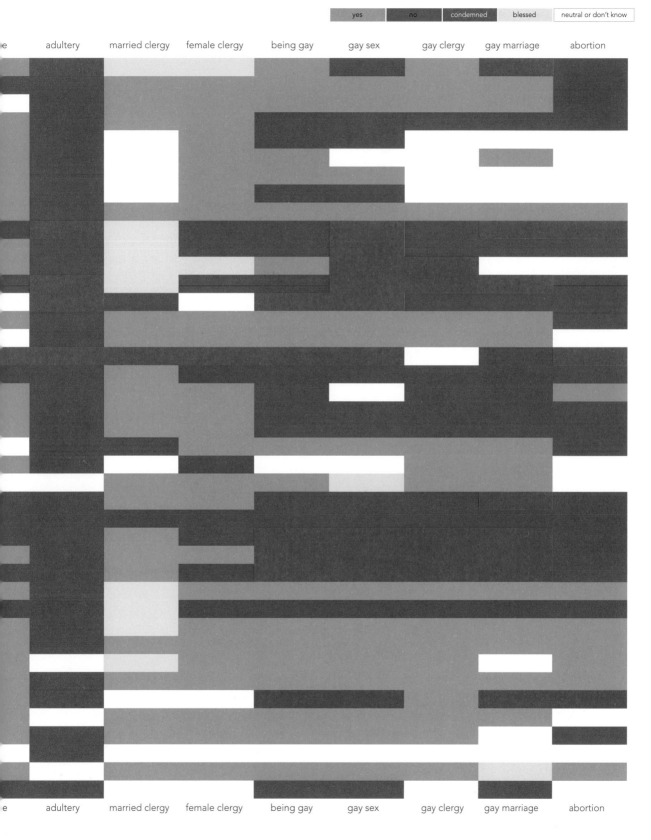

The Carbon Dioxide Cycle
Yearly man-made vs natural carbon emissions in gigatons (g)

emitted absorbed

9g
a year

+

550g
already in the
atmosphere

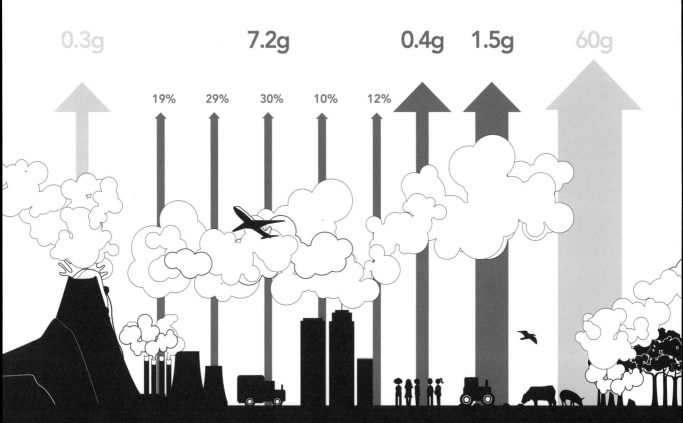

0.3g

7.2g

0.4g 1.5g

60g

19% 29% 30% 10% 12%

industry energy transport residential other deforestation

volcanoes fossil fuels people animals forest fires

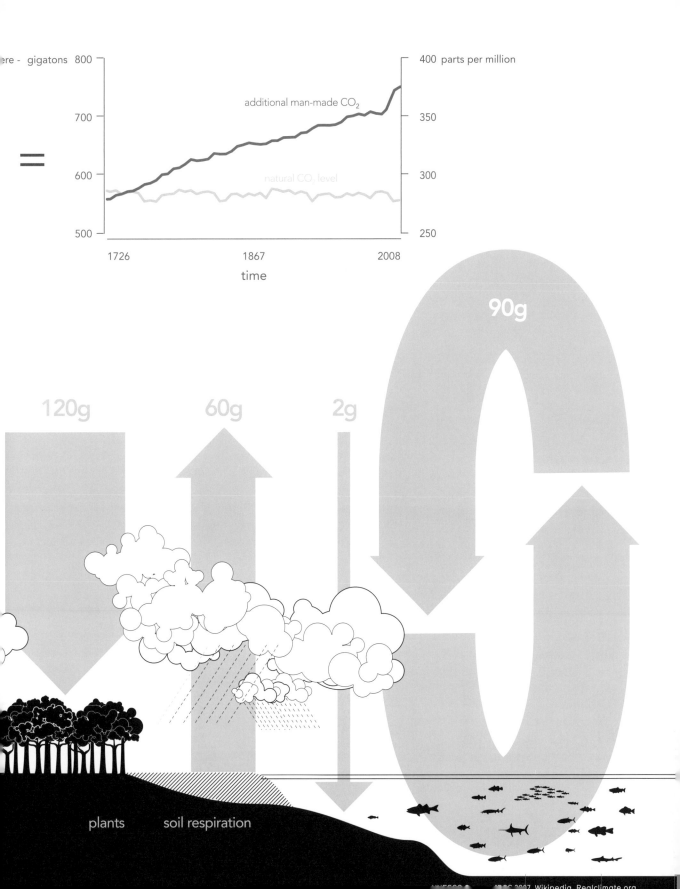

ere - gigatons 800

400 parts per million

additional man-made CO_2

700

350

natural CO_2 level

600

300

500

250

1726

1867

2008

time

90g

120g

60g

2g

plants soil respiration

1250 MB/s

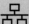

same bandwidth as a computer network

125 MB/s

USB key

Low Resolution
Amount of sensory information reaching the brain per second

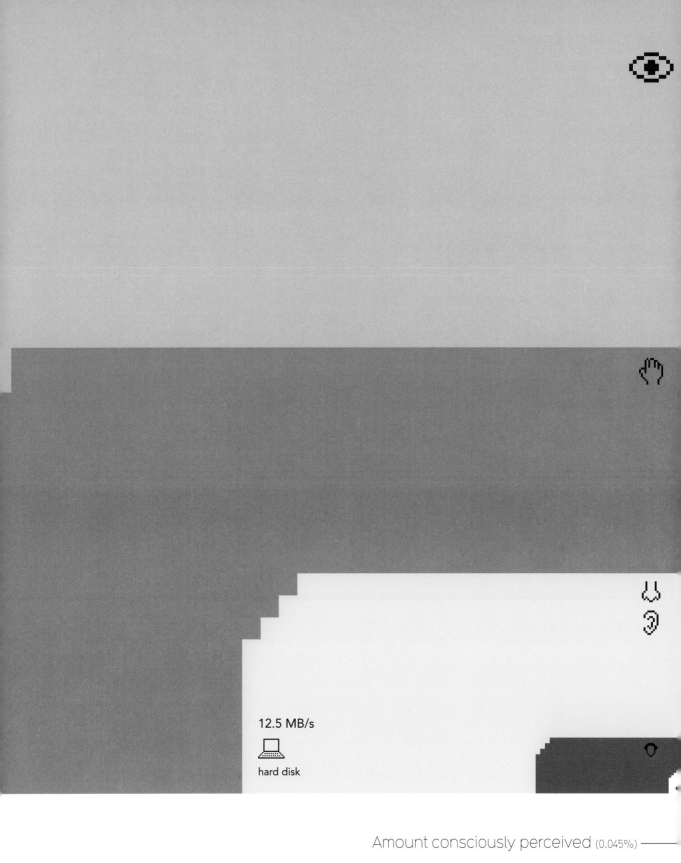

12.5 MB/s

hard disk

Amount consciously perceived (0.045%) —

source: Tor Nørretranders, The User Illusion: Cutting Consciousness Down to Size

Taste Buds
Complementary tastes

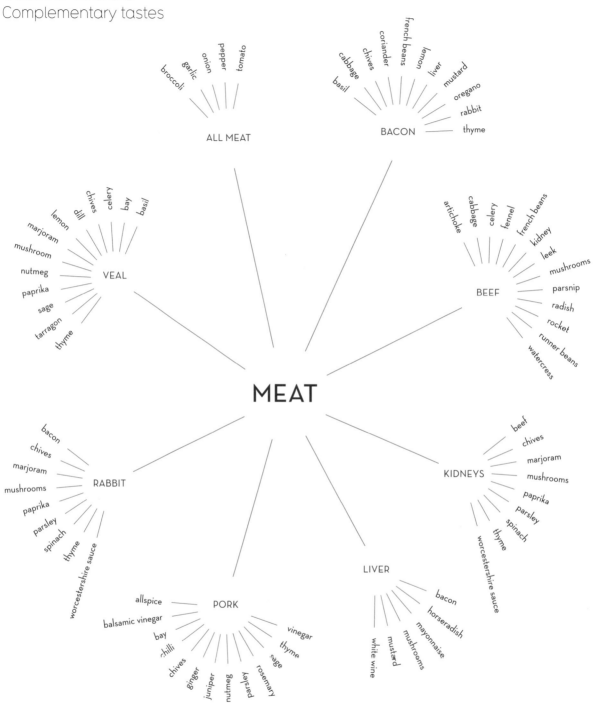

ALL MEAT
- broccoli
- garlic
- onion
- pepper
- tomato

BACON
- basil
- cabbage
- chives
- coriander
- french beans
- lemon
- liver
- mustard
- oregano
- rabbit
- thyme

VEAL
- dill
- chives
- celery
- bay
- basil
- lemon
- marjoram
- mushroom
- nutmeg
- paprika
- sage
- tarragon
- thyme

BEEF
- artichoke
- cabbage
- celery
- fennel
- french beans
- kidney
- leek
- mushrooms
- parsnip
- radish
- rocket
- runner beans
- watercress

MEAT

RABBIT
- bacon
- chives
- marjoram
- mushrooms
- paprika
- parsley
- spinach
- thyme
- worcestershire sauce

KIDNEYS
- beef
- chives
- marjoram
- mushrooms
- paprika
- parsley
- spinach
- thyme
- worcestershire sauce

LIVER
- bacon
- horseradish
- mayonnaise
- mushrooms
- mustard
- white wine

PORK
- allspice
- balsamic vinegar
- bay
- chilli
- chives
- ginger
- juniper
- nutmeg
- parsley
- sage
- rosemary
- thyme
- vinegar

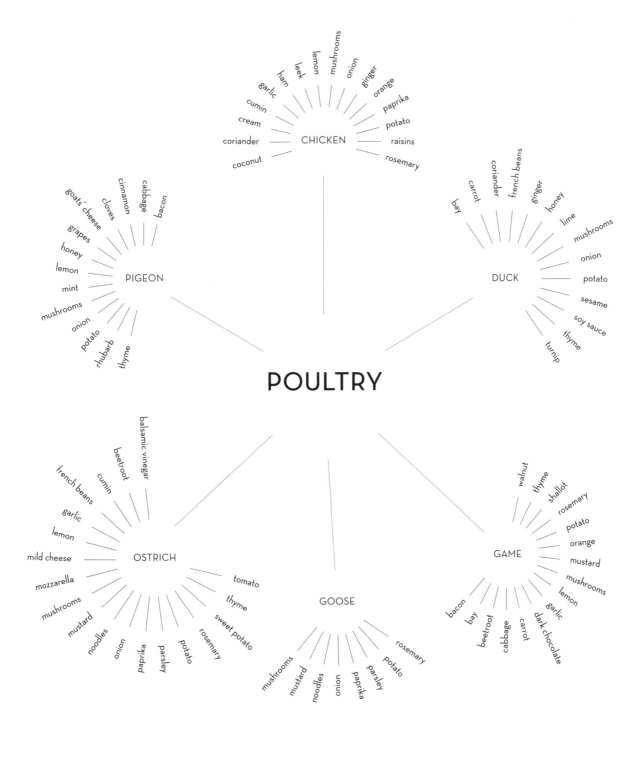

POULTRY

CHICKEN
garlic, ham, leek, lemon, mushrooms, onion, ginger, orange, paprika, potato, raisins, rosemary, coriander, cream, cumin, coconut

DUCK
bay, carrot, coriander, french beans, ginger, honey, lime, mushrooms, onion, potato, sesame, soy sauce, thyme, turnip

PIGEON
goats' cheese, cloves, cinnamon, cabbage, bacon, grapes, honey, lemon, mint, mushrooms, onion, potato, rhubarb, thyme

OSTRICH
french beans, garlic, cumin, beetroot, balsamic vinegar, lemon, mild cheese, mozzarella, mushrooms, mustard, noodles, onion, paprika, parsley, potato, rosemary, sweet potato, thyme, tomato

GOOSE
mushrooms, mustard, noodles, onion, paprika, parsley, potato, rosemary

GAME
walnut, thyme, shallot, rosemary, potato, orange, mustard, mushrooms, lemon, garlic, dark chocolate, carrot, cabbage, beetroot, bay, bacon

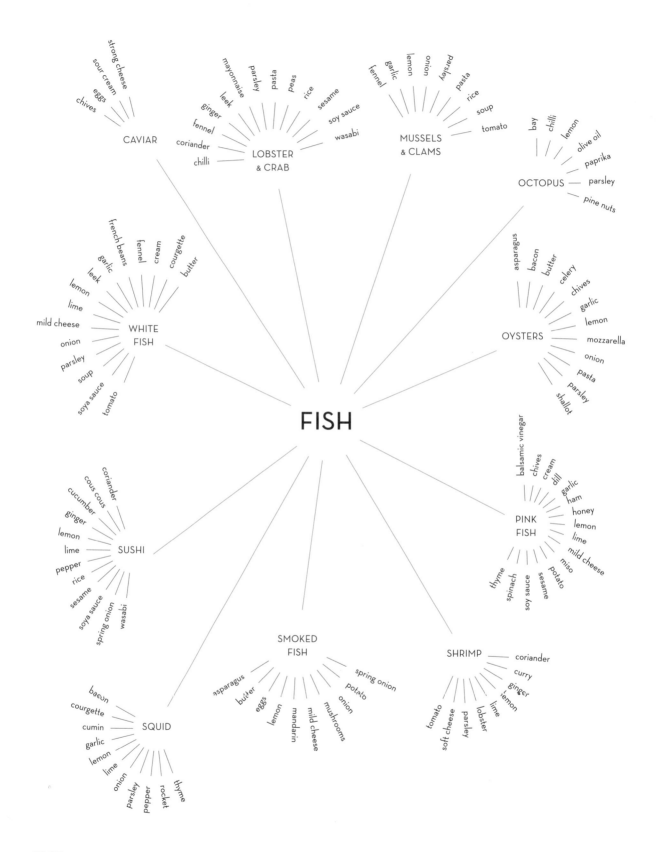

FISH

CAVIAR
- strong cheese
- sour cream
- eggs
- chives

LOBSTER & CRAB
- mayonnaise
- parsley
- pasta
- peas
- rice
- sesame
- leek
- ginger
- fennel
- coriander
- chilli
- soy sauce
- wasabi

MUSSELS & CLAMS
- fennel
- garlic
- lemon
- onion
- parsley
- pasta
- rice
- soup
- tomato

OCTOPUS
- bay
- chilli
- lemon
- olive oil
- paprika
- parsley
- pine nuts

WHITE FISH
- french beans
- garlic
- fennel
- cream
- courgette
- butter
- leek
- lemon
- lime
- mild cheese
- onion
- parsley
- soup
- soya sauce
- tomato

OYSTERS
- asparagus
- bacon
- butter
- celery
- chives
- garlic
- lemon
- mozzarella
- onion
- pasta
- parsley
- shallot

SUSHI
- coriander
- cous cous
- cucumber
- ginger
- lemon
- lime
- pepper
- rice
- sesame
- soya sauce
- spring onion
- wasabi

PINK FISH
- balsamic vinegar
- chives
- cream
- dill
- garlic
- ham
- honey
- lemon
- lime
- mild cheese
- miso
- potato
- sesame
- soy sauce
- spinach
- thyme

SMOKED FISH
- asparagus
- butter
- eggs
- lemon
- mandarin
- mild cheese
- mushrooms
- onion
- potato
- spring onion

SHRIMP
- coriander
- curry
- ginger
- lemon
- lime
- lobster
- parsley
- soft cheese
- tomato

SQUID
- bacon
- courgette
- cumin
- garlic
- lemon
- lime
- onion
- parsley
- pepper
- rocket
- thyme

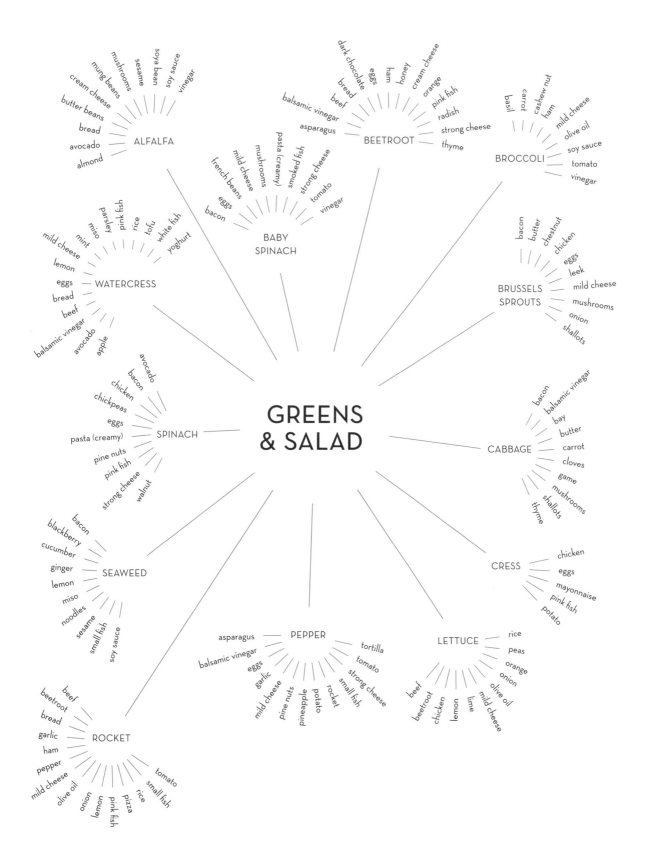

GREENS & SALAD

ALFALFA
soya bean, sesame, mushrooms, mung beans, cream cheese, butter beans, bread, avocado, almond, soy sauce, vinegar

BEETROOT
dark chocolate, eggs, ham, honey, cream cheese, bread, beef, orange, pink fish, balsamic vinegar, radish, asparagus, strong cheese, thyme

BROCCOLI
carrot, cashew nut, basil, ham, mild cheese, olive oil, soy sauce, tomato, vinegar

BABY SPINACH
pasta (creamy), mushrooms, smoked fish, mild cheese, strong cheese, french beans, tomato, eggs, bacon, vinegar

WATERCRESS
parsley, pink fish, mint, rice, miso, tofu, white fish, mild cheese, yoghurt, lemon, eggs, bread, beef, balsamic vinegar, avocado, apple

BRUSSELS SPROUTS
bacon, butter, chestnut, chicken, eggs, leek, mild cheese, mushrooms, onion, shallots

SPINACH
avocado, bacon, chicken, chickpeas, eggs, pasta (creamy), pine nuts, pink fish, strong cheese, walnut

CABBAGE
bacon, balsamic vinegar, bay, butter, carrot, cloves, game, mushrooms, shallots, thyme

SEAWEED
bacon, blackberry, cucumber, ginger, lemon, miso, noodles, sesame, small fish, soy sauce

CRESS
chicken, eggs, mayonnaise, pink fish, potato

PEPPER
asparagus, tortilla, balsamic vinegar, tomato, eggs, strong cheese, garlic, small fish, mild cheese, rocket, pine nuts, potato, pineapple

LETTUCE
rice, peas, orange, onion, olive oil, beef, mild cheese, beetroot, lime, chicken, lemon

ROCKET
beef, beetroot, bread, garlic, ham, pepper, mild cheese, olive oil, onion, lemon, pink fish, pizza, rice, small fish, tomato

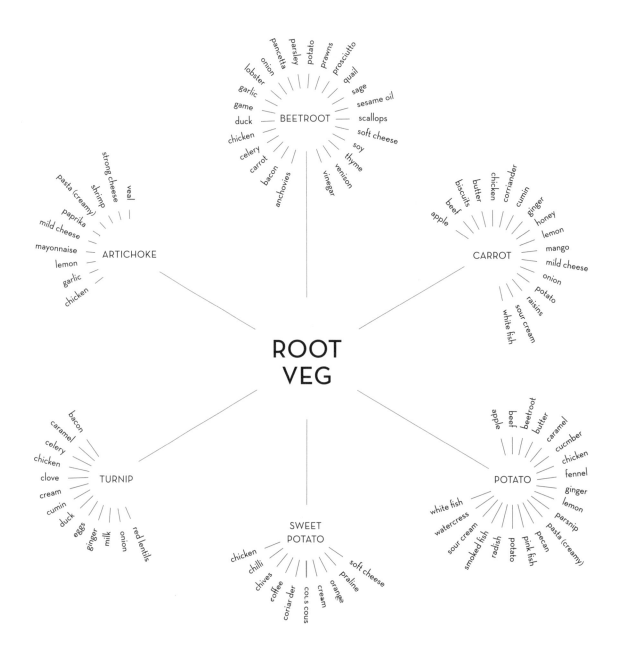

ROOT VEG

BEETROOT
pancetta
parsley
potato
prawns
prosciutto
onion
quail
lobster
sage
garlic
sesame oil
game
scallops
duck
soft cheese
chicken
soy
celery
thyme
carrot
venison
bacon
vinegar
anchovies

ARTICHOKE
strong cheese
pasta (creamy)
shrimp
veal
paprika
mild cheese
mayonnaise
lemon
garlic
chicken

CARROT
chicken
coriander
biscuits
butter
cumin
beef
ginger
apple
honey
lemon
mango
mild cheese
onion
potato
raisins
sour cream
white fish

TURNIP
bacon
caramel
celery
chicken
clove
cream
cumin
duck
eggs
ginger
milk
onion
red lentils

SWEET POTATO
chicken
chilli
chives
coffee
coriander
cous cous
cream
orange
praline
soft cheese

POTATO
beetroot
apple
beef
butter
caramel
cucmber
chicken
fennel
ginger
lemon
white fish
parsnip
watercress
pasta (creamy)
sour cream
pecan
smoked fish
pink fish
radish
potato

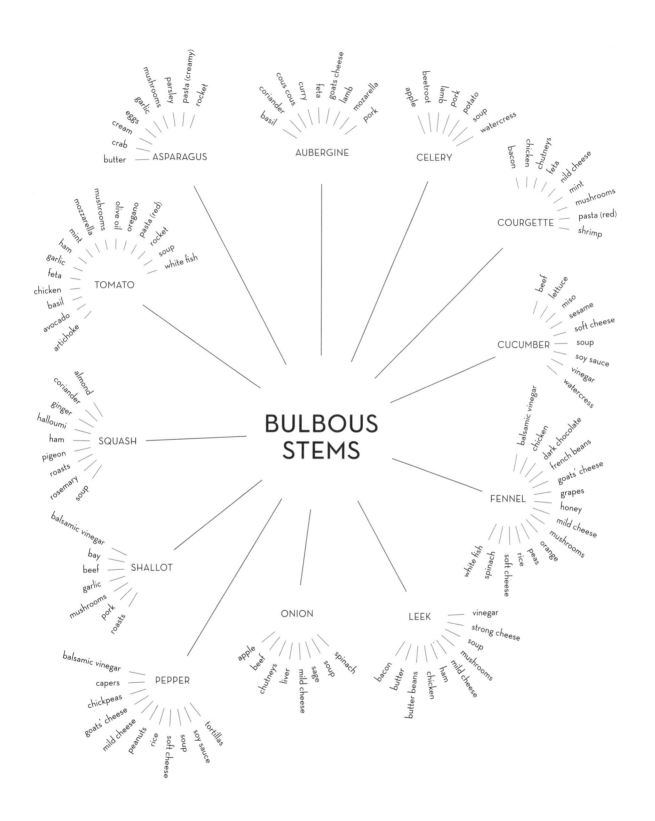

BULBOUS STEMS

ASPARAGUS — butter, crab, cream, eggs, garlic, mushrooms, parsley, pasta (creamy), rocket

AUBERGINE — basil, coriander, cous cous, curry, feta, goats cheese, lamb, mozzarella, pork

CELERY — apple, beetroot, lamb, pork, potato, soup, watercress

COURGETTE — bacon, chicken, chutneys, feta, mild cheese, mint, mushrooms, pasta (red), shrimp

TOMATO — ham, mint, mozzarella, mushrooms, olive oil, oregano, pasta (red), rocket, soup, white fish, garlic, feta, chicken, basil, avocado, artichoke

CUCUMBER — beef, lettuce, miso, sesame, soft cheese, soup, soy sauce, vinegar, watercress

SQUASH — almond, coriander, ginger, halloumi, ham, pigeon, roasts, rosemary, soup

FENNEL — balsamic vinegar, chicken, dark chocolate, french beans, goat's cheese, grapes, honey, mild cheese, mushrooms, orange, peas, rice, soft cheese, spinach, white fish

SHALLOT — balsamic vinegar, bay, beef, garlic, mushrooms, pork, roasts

LEEK — bacon, butter, butter beans, chicken, ham, mild cheese, mushrooms, soup, strong cheese, vinegar

ONION — apple, beef, chutneys, liver, mild cheese, sage, soup, spinach

PEPPER — balsamic vinegar, capers, chickpeas, goat's cheese, mild cheese, peanuts, rice, soft cheese, soup, soy sauce, tortillas

source: general internet and bbc.co.uk/food

Sunlight

TWO MAIN TYPES OF ULTRAVIOLET

| UVA | UVB | UVC |

Ages your skin Burns your skin UVC blocked by atmosphere

% REACHING GROUND

95% 5%

RELATED SKIN CANCER

Carcinoma (nasty) Melanoma (deadly)

SUNSCREEN PROTECTION

STAR SYSTEM SUN FACTOR (SPF)

UVA 12

How much sunscreen?

Divide your body into eleven zones

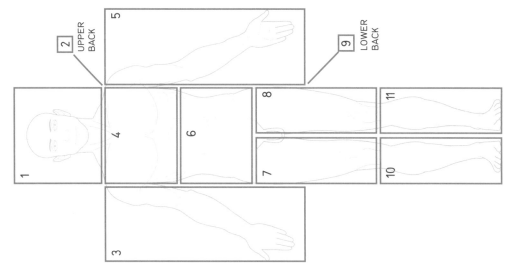
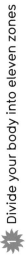

1
2 UPPER BACK
3
4
5
6
7
8
9 LOWER BACK
10
11

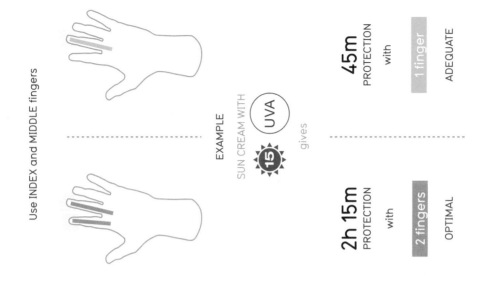

2 Apply 1 or 2 fingers of sunscreen per zone

Use INDEX and MIDDLE fingers

EXAMPLE

SUN CREAM WITH **15** UVA

gives

2h 15m PROTECTION with **2 fingers** — OPTIMAL

45m PROTECTION with **1 finger** — ADEQUATE

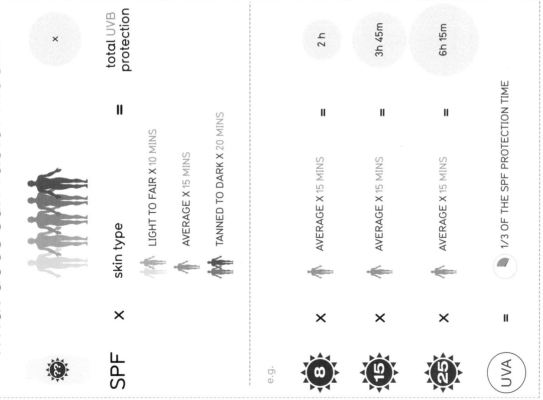

What does sun factor mean?

SPF × skin type = total UVB protection

LIGHT TO FAIR X 10 MINS
AVERAGE X 15 MINS
TANNED TO DARK X 20 MINS

e.g.

8 × AVERAGE X 15 MINS = 2 h

15 × AVERAGE X 15 MINS = 3h 45m

25 × AVERAGE X 15 MINS = 6h 15m

UVA = 1/3 OF THE SPF PROTECTION TIME

The Sunscreen Smokescreen

Sunlight & skin cancers

SKIN CANCER	Squamous Cell Carcinoma	Basal Cell Carcinoma	Melanoma
WHAT DOES IT AFFECT?	Lining of the skin (epithelium)	Deepest skin tissue layer (basal layer)	Cells that tan skin (melanocytes)
% OF SKIN CANCERS	20%	75%	5%
% OF CASES CAUSED BY SUNLIGHT	90% (UVA)	90% (UVB)	65% (UVB)
% OF SUFFERERS WHO DIE	0.4% (nasty)	0.07% (normally curable)	13% (deadly)

IN COMPARISON
brain 68%
breast 10%
colon 35%

How often?

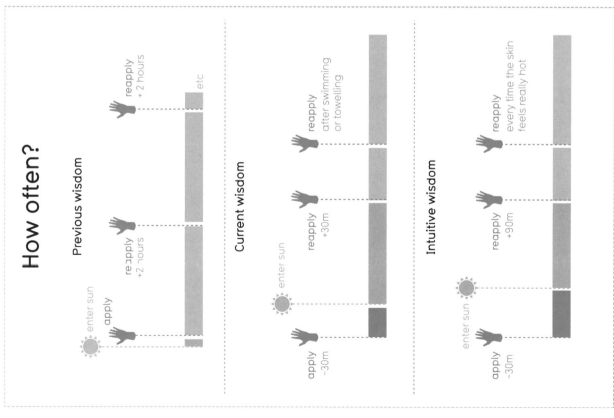

Previous wisdom

enter sun
apply
reapply +2 hours
reapply +2 hours
etc

Current wisdom

enter sun
apply -30m
reapply +30m
reapply after swimming or towelling

Intuitive wisdom

enter sun
apply -30m
reapply +90m
reapply every time the skin feels really hot

Melanoma incidence rates
Cases of the cancer per 100,000 people

AUS

60	
55	
50	
45	
40	
35	
30	
25	
20	
15	
10	
5	

1975 — 2007

USA

25 20 15 10 5

1975 — 2007

UK

25 20 15 10 5

1975 — 2007

What if it's cloudy?

CLOUD COVER

Thick clouds

reduce UV radiation by 80–99%

REFLECTIONS

UV reflections

fresh snow	80%
dry sand	20
grass	10
water	10

ALTITUDE

Snow burn

At 2,000 m above sea level UV radiation can be 30% more intense

2000M 30%
1500M 20%
1000M 10%

Don't forget – the sun is good!

20 mins of daily sunlight (without sunscreen) gives you a healthy dose of Vitamin D essential for health

Substantially more heart attack victims survive if struck during summer

Significantly more elderly people die in winter January, February and March

source: per capita data from Newscientist.com, Unstats.un.org, NationMaster.com

The Poison

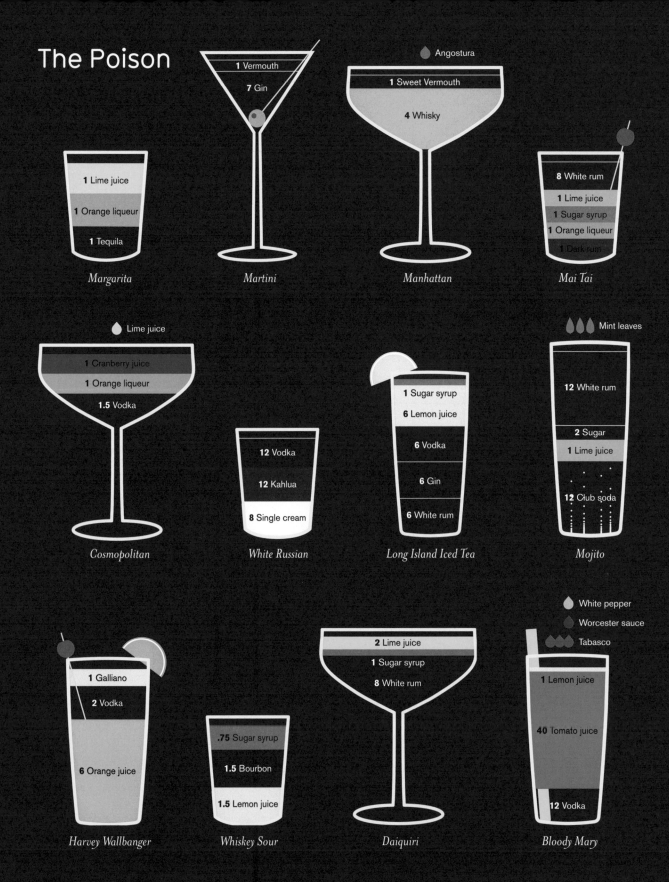

Margarita
- 1 Lime juice
- 1 Orange liqueur
- 1 Tequila

Martini
- 1 Vermouth
- 7 Gin

Manhattan
- Angostura
- 1 Sweet Vermouth
- 4 Whisky

Mai Tai
- 8 White rum
- 1 Lime juice
- 1 Sugar syrup
- 1 Orange liqueur
- 1 Dark rum

Cosmopolitan
- Lime juice
- 1 Cranberry juice
- 1 Orange liqueur
- 1.5 Vodka

White Russian
- 12 Vodka
- 12 Kahlua
- 8 Single cream

Long Island Iced Tea
- 1 Sugar syrup
- 6 Lemon juice
- 6 Vodka
- 6 Gin
- 6 White rum

Mojito
- Mint leaves
- 12 White rum
- 2 Sugar
- 1 Lime juice
- 12 Club soda

Harvey Wallbanger
- 1 Galliano
- 2 Vodka
- 6 Orange juice

Whiskey Sour
- .75 Sugar syrup
- 1.5 Bourbon
- 1.5 Lemon juice

Daiquiri
- 2 Lime juice
- 1 Sugar syrup
- 8 White rum

Bloody Mary
- White pepper
- Worcester sauce
- Tabasco
- 1 Lemon juice
- 40 Tomato juice
- 12 Vodka

The Remedy
Hangover cures from around the world

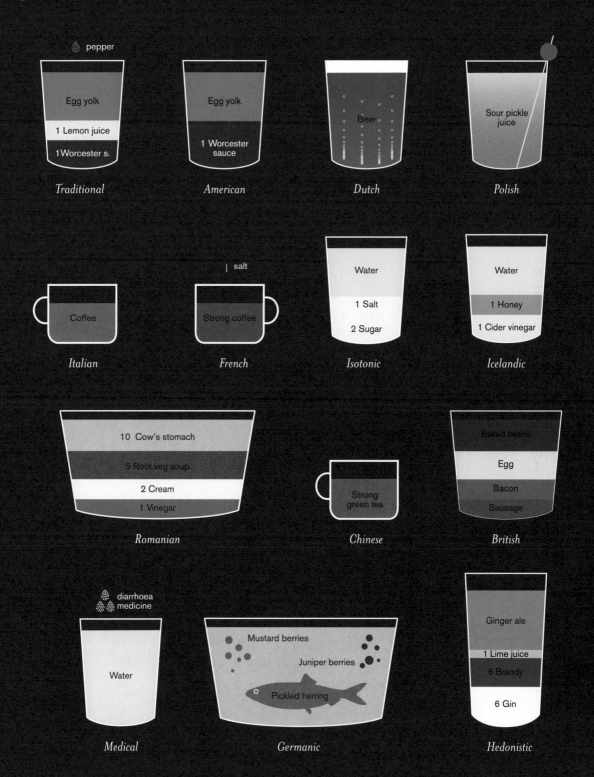

pepper

Egg yolk
1 Lemon juice
1 Worcester s.

Traditional

Egg yolk
1 Worcester sauce

American

Beer

Dutch

Sour pickle juice

Polish

Coffee

Italian

salt

Strong coffee

French

Water
1 Salt
2 Sugar

Isotonic

Water
1 Honey
1 Cider vinegar

Icelandic

10 Cow's stomach
5 Root veg soup
2 Cream
1 Vinegar

Romanian

Strong green tea

Chinese

Baked beans
Egg
Bacon
Sausage

British

diarrhoea medicine

Water

Medical

Mustard berries
Juniper berries
Pickled herring

Germanic

Ginger ale
1 Lime juice
6 Brandy
6 Gin

Hedonistic

source: Google

Salad Dressings
All in proportion

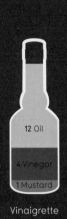

12 Oil
4 Vinegar
1 Mustard

Vinaigrette

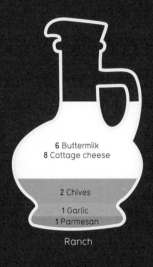

6 Buttermilk
8 Cottage cheese

2 Chives
1 Garlic
1 Parmesan

Ranch

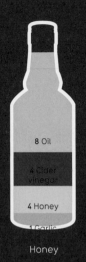

8 Oil
4 Cider vinegar
4 Honey
1 Garlic

Honey

Worcester sauce

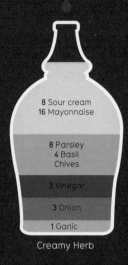

8 Sour cream
16 Mayonnaise
8 Parsley
4 Basil Chives
3 Vinegar
3 Onion
1 Garlic

Creamy Herb

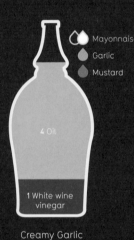

Mayonnaise
Garlic
Mustard

4 Oil

1 White wine vinegar

Creamy Garlic

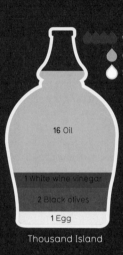

Lemon juice

6 Oil

1 Vinegar
1 Garlic

Oil, Lemon & Garlic

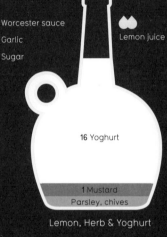

Worcester sauce
Garlic
Sugar

16 Oil

1 White wine vinegar
2 Black olives
1 Egg

Thousand Island

Lemon juice

16 Yoghurt

1 Mustard
Parsley, chives

Lemon, Herb & Yoghurt

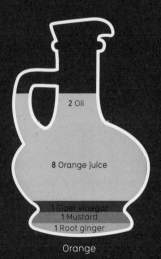

2 Oil

8 Orange juice

1 Cider vinegar
1 Mustard
1 Root ginger

Orange

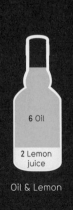

6 Oil

2 Lemon juice

Oil & Lemon

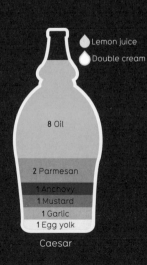

Lemon juice
Double cream

8 Oil

2 Parmesan
1 Anchovy
1 Mustard
1 Garlic
1 Egg yolk

Caesar

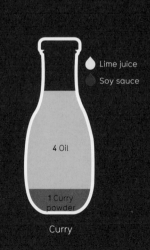

Lime juice
Soy sauce

4 Oil

1 Curry powder

Curry

source: Google

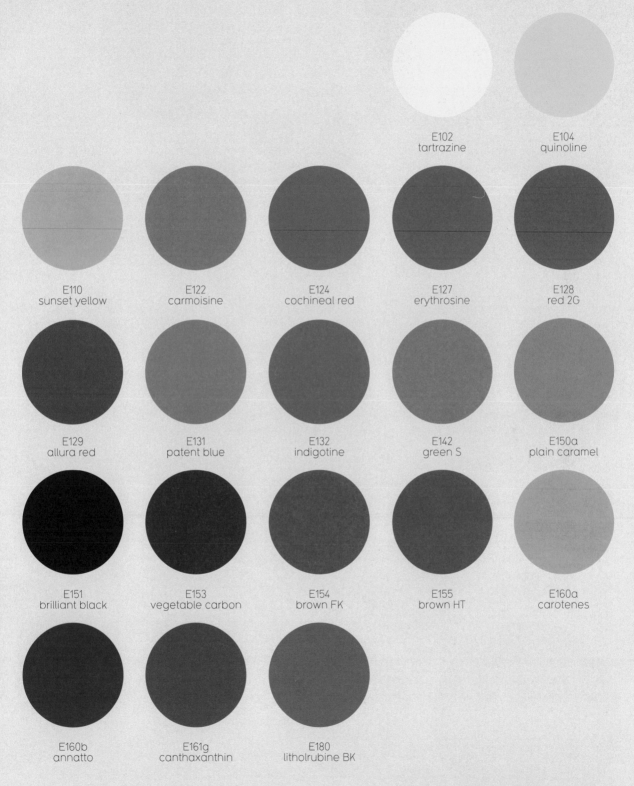

Not Nice
Food colourings linked to unpleasant health effects

E102
tartrazine

E104
quinoline

E110
sunset yellow

E122
carmoisine

E124
cochineal red

E127
erythrosine

E128
red 2G

E129
allura red

E131
patent blue

E132
indigotine

E142
green S

E150a
plain caramel

E151
brilliant black

E153
vegetable carbon

E154
brown FK

E155
brown HT

E160a
carotenes

E160b
annatto

E161g
canthaxanthin

E180
litholrubine BK

source: Centre for Science in the Public Interest, Cspinet.org

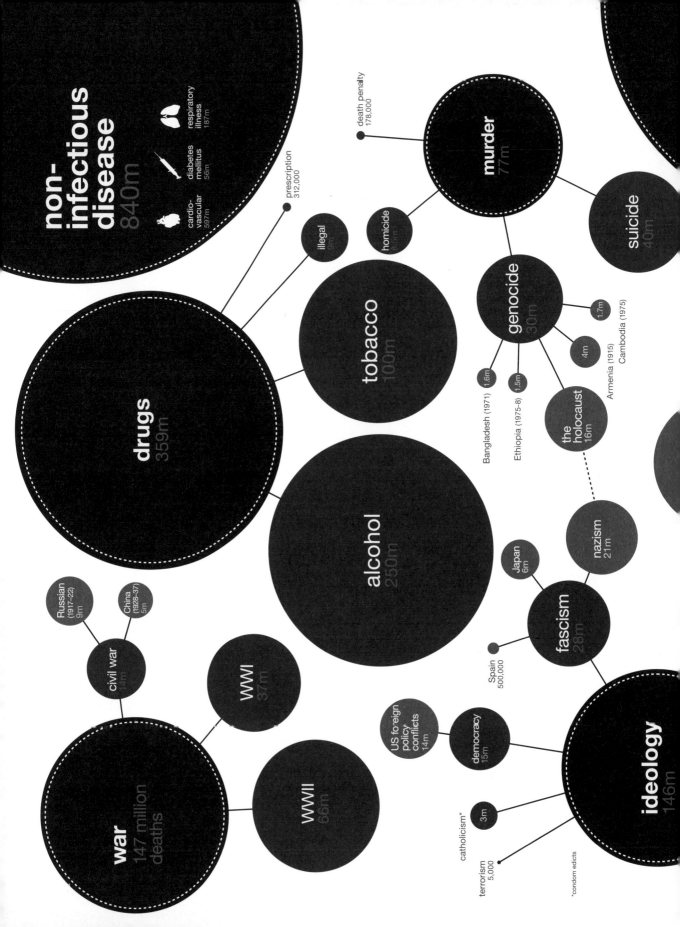

non-infectious disease
840m

cardio-vascular 597m
diabetes mellitus 56m
respiratory illness 187m

prescription 312,000

drugs 359m

illegal 9m

tobacco 100m

homicide 8.5m

murder 77m

death penalty 178,000

suicide 40m

genocide 30m

Bangladesh (1971) 1.6m
Ethiopia (1975-8) 1.5m
the holocaust 16m
Armenia (1915) 4m
Cambodia (1975) 1.7m

alcohol 250m

nazism 21m

Japan 6m

fascism 28m

Spain 500,000

Russian (1917-22) 9m
China (1928-37) 5m
civil war 14m

WWI 37m

WWII 66m

war 147 million deaths

US foreign policy conflicts 14m

democracy 15m

ideology 146m

catholicism* 3m

terrorism 5,000

*condom edicts

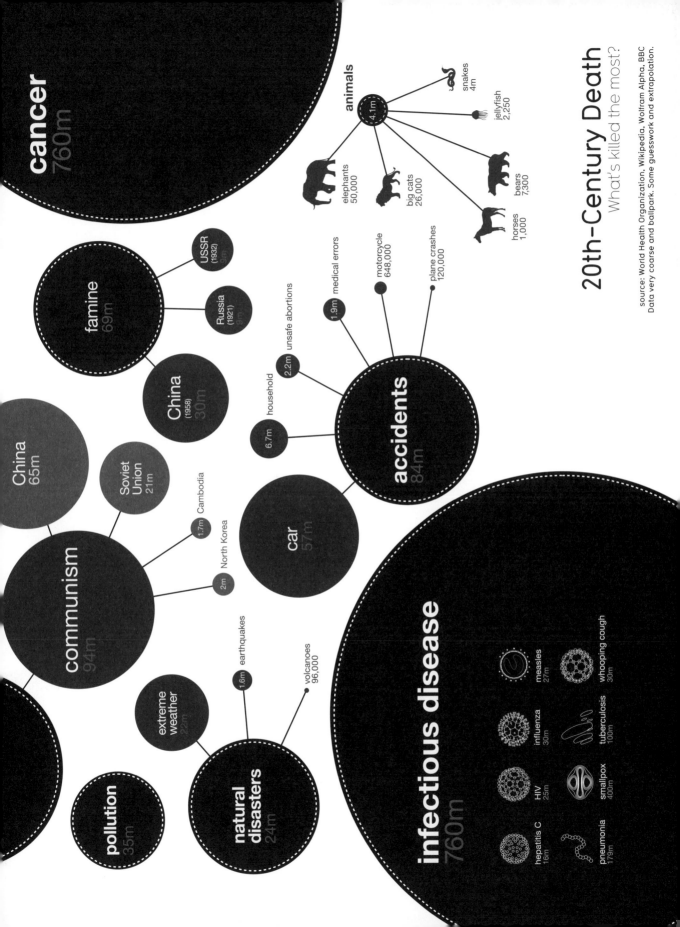

cancer
760m

animals 4.1m

snakes
4m

jellyfish
2,250

elephants
50,000

big cats
26,000

bears
7,300

horses
1,000

famine
69m

USSR (1932) 9m

Russia (1921) 5m

China (1958) 30m

China 65m

Soviet Union 21m

communism
94m

Cambodia 1.7m

North Korea 2m

medical errors 1.9m

motorcycle 648,000

plane crashes 120,000

unsafe abortions 2.2m

household 6.7m

accidents
84m

car 57m

earthquakes 1.6m

volcanoes 96,000

extreme weather 22m

pollution
35m

natural disasters
24m

infectious disease
760m

measles 27m

whooping cough 30m

influenza 30m

tuberculosis 100m

HIV 25m

smallpox 400m

hepatitis C 16m

pneumonia 179m

20th-Century Death

What's killed the most?

source: World Health Organization, Wikipedia, Wolfram Alpha, BBC
Data very coarse and ballpark. Some guesswork and extrapolation.

THE GLOBAL WARMING SCEPTICS

We don't believe there is any credible evidence that mankind's activities are the cause of global warming if that's even happening at all. There's only circumstantial evidence of a link between carbon dioxide levels and rising global temperatures.

Rising CO_2 levels are not always linked with rising temperatures

Because of extreme weather, Arctic temperature is often a dramatic barometer of global climate. But the temperatures there match poorly with human CO_2 emissions.

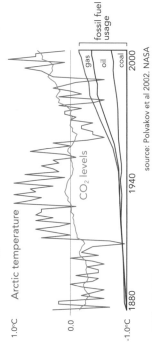

In the past, CO_2 rises have occured after temperature rises

Recognize this from *An Inconvenient Truth?* Al Gore famously showed that temperature and CO_2 are clearly linked back over 400,000 years. But if you zoom in....

...you see that CO_2 levels rise 800 years after the temperature does. This massive lag proves that CO_2 can't cause global warming!

THE SCIENTIFIC CONSENSUS

The earth's climate is rapidly warming. The cause is a thickening layer of carbon dioxide pollution, caused by humanity's activities. It traps heat in the atmosphere, creating a "greenhouse effect" that heats the earth. A rise in global temperatures of 3 to 9 degrees will cause devastation.

A single graph for a single small area is not enough evidence

You can't draw conclusions about the warming of the whole planet just by looking at a small area. It's like comparing apples and pears. It's impossible to tell what caused the warming of the Arctic in the 1930. Or whether it's the same mechanism that's causing global warming today.

We don't claim CO_2 caused temperature rises in the past

We say, because of its greenhouse effect, CO_2 makes natural temperature rises worse. Much worse in fact.

Historically, global warming cycles last 5000 years. The 800-year lag only shows that CO_2 did not cause the first 16% of warming. The other 4200 years were likely to have been caused by a CO_2 greenhouse effect.

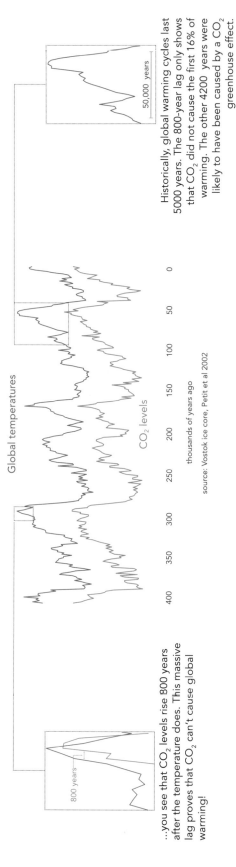

source: Vostok ice core, Petit et al 2002

We don't even have accurate temperature records

90% of temperature recording stations are on land. 70% of the world's surface is ocean. Cities and towns heat the atmosphere around land-based weather stations enough to distort the record of historical temperatures. It's called the urban heat island effect. And it's why we can't trust temperature records.

We do have accurate temperature records

Distortion of temperature records is a very real phenomenon. But it's one climate scientists are well aware of. Detailed filters are used to remove the effect from the records.

Global weather recording stations

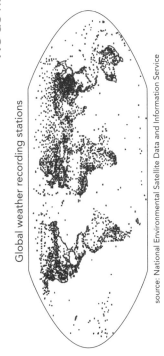

source: National Environmental Satellite Data and Information Service

It was actually hotter in medieval times than today

Between AD 800 and 1300 was a Medieval Warm Period where temperatures were very high. Grapes were grown in England. The Vikings colonized Greenland. This occurred centuries before we began pumping CO_2 into the atmosphere. More proof that CO_2 and temperature are not linked. Because of this – and to make 20th-century warming look unique – UN scientists constantly play down this medieval period in their data.

It was hotter in some areas of the world and not in others

This was likely a local warming, rather than a global warming, equivalent to warming today. Ice cores show us that there were periods of both cold and warmth at the time. And there's no evidence it affected the southern hemisphere at all. The records also show that the earth may have been slightly cooler (by 0.03 degrees Celsius) during the 'medieval warm period' than today.

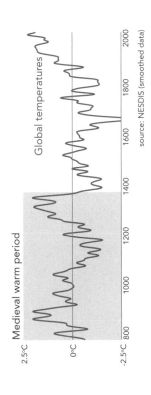

source: NESDIS (smoothed data)

The famous "hockey stick" temperature graph has been discredited

Made famous by Al Gore, the "hockey stick" graph shows that 20th-century temperatures are showing an alarming rise. But the hockey stick appears or disappears depending on the statistical methods employed. So unreliable has it become that the UN's International Panel On Climate Change dropped it from their 2007 report.

Reworked, enhanced versions still show the "hockey stick" shape

The hockey stick is 8 years old. There are dozens of other newer, more detailed temperature reconstructions. Each one is different due to different methods and data. But they all show similar striking patterns: the 20th century is the warmest of the entire record. And that warming is most dramatic after 1920 (when industrial activity started releasing CO_2 into the atmosphere).

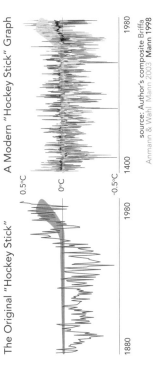

The Original "Hockey Stick"

A Modern "Hockey Stick" Graph

source: Author's composite Briffa Anmann & Wahl 2003 Mann 1998

THE GLOBAL WARMING SCEPTICS

THE SCIENTIFIC CONSENSUS

Ice core data is unreliable

A lot of our temperature records come from measuring the gases trapped in ice cores. These are segments of deep ice unmelted for hundreds of thousands of years. The trapped air inside acts as "photographs" of the contents of the atmosphere going back millennia. But ice-cores are not "closed systems" that preserve ancient air perfectly. Air can get in and out. Water can also absorb the gases, changing the result. And deep ice is under huge amounts of pressure. Enough to squeeze gas out. All in all this adds up to make ice cores unreliable.

Ice records are reliable

Ice core data is taken from many different samples to reduce errors. Also, other evidence (temperature records, tree rings, etc) back these readings up. All these results combined make the records very reliable.

The predictions of future global warming don't depend on ice cores. But ice cores do show that the climate is sensitive to changes in cycles and that CO_2 has a strong influence.

Overall, CO_2 levels from different ice cores are remarkably similar.

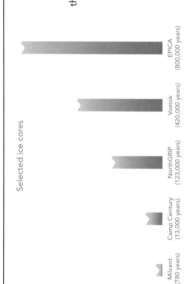

Selected ice cores

Milcent
(780 years)

Camp Century
(13,000 years)

NorthGRIP
(123,000 years)

Vostok
(420,000 years)

EPICA
(800,000 years)

When the evidence doesn't fit, the scientists edit the evidence

Ice core data from Siple in the Arctic shows the concentrations of CO_2 in the atmosphere in 1890 to be 328 parts per million. However, according to the consensus, that level was not reached until 1973. So the rise in CO_2 levels happens 83 years too early.

To fix it, scientists moved the graph 83 years to the right to make the data exactly fit.

Scientists correct their results when new evidence comes to light

No other ice core data in the world shows CO_2 levels rising above 290 parts per million in the last 650,000 years. It's possible it might have happened for a year or a day. But consistently, no.

Some areas of ice are more porous than others. At Siple, the more recent shallow ice was quite porous. So new air was able to circulate quite far down. That affected the record.

We detected and compensated for this. That's why the data has been shifted.

CO_2 levels ice at Siple (Arctic)

the original data

the adjusted data

328 ppm

350

300

250

1744 1878 1891 1953 2000

Source: Neftel 1985, Friedli 1986

CO$_2$ stays in the atmosphere for only 5 to 10 years, not the 50–200 years stated by UN scientists

The ocean absorbs the CO$_2$ so it can't accumulate to dangerous levels in the atmosphere. In fact, the oceans are so vast they can absorb 50 times as much CO$_2$ as there is in the atmosphere – more than all the fossil fuels on the planet!

Conclusion: humans can't have been emitting CO$_2$ fast enough to account for all the extra CO$_2$ in the atmosphere.

When you take the entire complex ocean-climate system into account 50–200 years is more accurate

CO$_2$ is absorbed in 5 to 10 years by the *shallow* ocean. Not the deep ocean. It takes 50–200 years for CO$_2$ to be mixed into the deep ocean where it stays. CO$_2$ in the shallow ocean, however, is prone to escaping back into the atmosphere. So CO$_2$ absorbed by the ocean often comes straight back out again.

Also the more carbon the ocean absorbs, the less it's able to absorb. It becomes saturated. It's a very complex process. But if you take the entire ocean-climate system, full absorption of atmospheric CO$_2$ takes around 50,000 years.

CO$_2$ absorption by the oceans

CO$_2$ atmos

shallow ocean — "fertilizer" for plankton — dissolved as carbonic acid — 5-10 years

deep ocean — dead plankton — shells, bones — 50-200 years

CONSENSUS CONCLUSION
Man-made CO$_2$ is driving climate change this time

We don't claim that greenhouse gases are the major cause of the ice ages and warming cycles. What drives climate change has long been believed to be the variation in the earth's orbit around the sun over thousands of years.

In a normal warming cycle, the sun heats the earth, the earth gets hotter. The oceans warm up, releasing huge amounts of CO$_2$. This creates a greenhouse effect that makes warming much, much more intense.

That's why humanity's release of CO$_2$ is so perilous. We're out of step with the natural cycle. And we haven't even got to the stage where the oceans warm up.

SCEPTICAL CONCLUSION
Man-made CO$_2$ cannot be driving climate change

Whatever affects global temperatures and causes global warming is not CO$_2$. Whatever the cause, it works like this: the cause affects the climate balance, then the temperature changes accordingly. The oceans then adjust over a period of decades and centuries. Then the balance of CO$_2$ in the atmosphere increases.

So the global panic about CO$_2$ causing global warming is baseless and fear-mongering. The UN's reports on the matter are biased, unscientific and alarmist.

source: Solomon, Lawrence, The Deniers (Richard Vigilante Books, 2008), RealClimate.org

Behind Every Great Man...
Dictators' wives

	Nadezhda Alliluyeva	Eva Braun	Yang Kaihui	Imelda Marcos	Mirjana (Mira) Markovic
Wife					
Husband	Stalin	Hitler	Mao	Marcos	Milosevic
Pre-marital occupation	clerk	assistant and model	communist!	beauty queen	professor of sociology
How they met	her father sheltered Stalin in 1911 after he escaped from Siberian exile	she was assistant to his personal photographer	her father was Mao's teacher	whirlwind courtship during "holy week"	at school, she borrowed his card to rent *Antigone* from the library. Oh yeah?
Years of marriage	13	about 40 minutes	8	35	32
Children	2		3	4	2
Rumoured quality of marriage	strained and violent	changeable	troubled	good	very good
Political power rating	none	(1 fist)	none	(5 fists)	(4 fists)
Key governmental roles	none	none	prominent female member of party	Governor of Manila, Ambassador plenipotentiary	puppet-master, leader of "Yugoslav United Left"
Style rating	none	(4 shoes)	(4 shoes)	(5 shoes)	(5 shoes)
Nickname	none	The Rolleiflex Girl	none	The Steel Butterfly	The Red Witch
Notable talents	none – super dull	photography, athletics	very intelligent	none	politics
Trademark/idiosyncrasy	left-handed	nude sunbathing	feminist	very ostentatious and flamboyant	would berate her husband in front of state officials, wore only black Versace
Obsessions and pathologies	suicide	lots of make-up	good communists don't covet material things	shoes, clothes, paintings	media products, plastic surgeons, rich friends
Most salacious rumour	she was Stalin's daughter	she was pregnant when she died OR she didn't sleep in the same room as Hitler	said she would have killed herself when she and Mao divorced if she didn't have kids	sent a plane to pick up white sand from Australia for her beach resort	ordered the murder of Ivan Stambolic, a rival to her husband. Had at least four officials killed after they disagreed with her. Disappeared a journalist who criticized her.
Reason for death	officially "appendicitis" – really, shot	suicide – bit into a cyanide capsule	publicly executed by the Nationalists	still alive	still alive

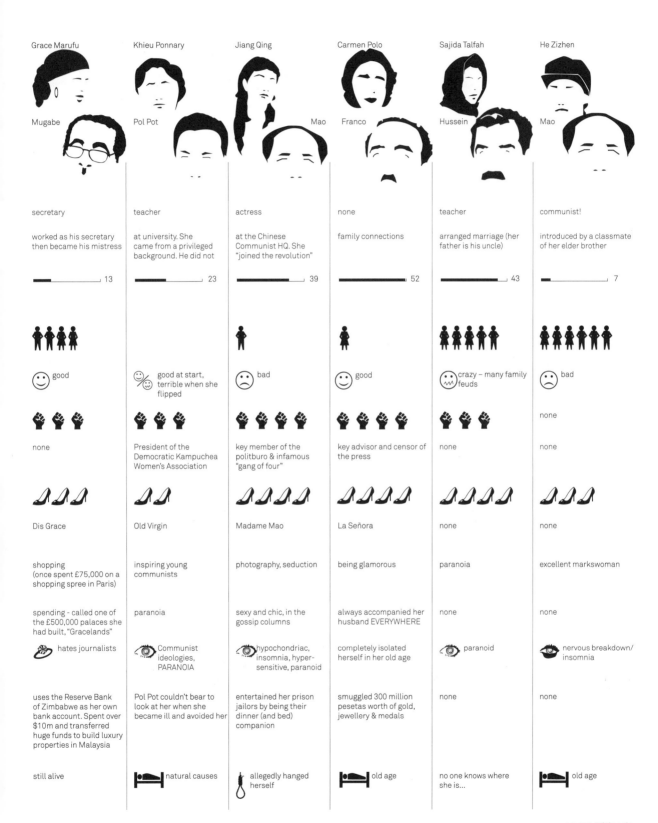

Grace Marufu	Khieu Ponnary	Jiang Qing	Carmen Polo	Sajida Talfah	He Zizhen
Mugabe	Pol Pot	Mao	Franco	Hussein	Mao
secretary	teacher	actress	none	teacher	communist!
worked as his secretary then became his mistress	at university. She came from a privileged background. He did not	at the Chinese Communist HQ. She "joined the revolution"	family connections	arranged marriage (her father is his uncle)	introduced by a classmate of her elder brother
13	23	39	52	43	7
good	good at start, terrible when she flipped	bad	good	crazy – many family feuds	bad
none	President of the Democratic Kampuchea Women's Association	key member of the politburo & infamous "gang of four"	key advisor and censor of the press	none	none
Dis Grace	Old Virgin	Madame Mao	La Señora	none	none
shopping (once spent £75,000 on a shopping spree in Paris)	inspiring young communists	photography, seduction	being glamorous	paranoia	excellent markswoman
spending - called one of the £500,000 palaces she had built, "Gracelands"	paranoia	sexy and chic, in the gossip columns	always accompanied her husband EVERYWHERE	none	none
hates journalists	Communist ideologies, PARANOIA	hypochondriac, insomnia, hyper-sensitive, paranoid	completely isolated herself in her old age	paranoid	nervous breakdown/ insomnia
uses the Reserve Bank of Zimbabwe as her own bank account. Spent over $10m and transferred huge funds to build luxury properties in Malaysia	Pol Pot couldn't bear to look at her when she became ill and avoided her	entertained her prison jailors by being their dinner (and bed) companion	smuggled 300 million pesetas worth of gold, jewellery & medals	none	none
still alive	natural causes	allegedly hanged herself	old age	no one knows where she is...	old age

source: Wikipedia

Bubble chart	Bubble comparison	Bubble race	Bubble race with strings	Bubble clusters	Bubble network	Bubble treemap	Bubble star ring
Infographic	Charticle	Word cloud	Matrix	Family tree	Mind map (tidy)	Mind map (organic)	Concept map
Bubbles (nested)	Polar grid (segmented)	Sun burst	Coxcomb	Polar grid	Icicle pie	Mandala (complex)	Mandala
Radar	Spiral	Concept fan	Fan	Synergy map	Bubble mind map	Venn bubbles	Semantic polar grid
Decision tree	Dunno what to call it	Conetree	Icicle tree 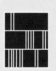	Treemapa 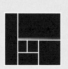	Flowchart 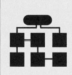	Sankey 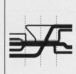	Periodic table

Types of Information Visualization

source: Edward Tufte, visual-literacy.org

Pass the...

A table of condiments that periodically go bad

No.	Symbol	Name	Shelf life
1	Tz	Tzatziki	2 days
2	Sa	Salsa	2 days
3	Gu	Guacamole	2 days
4	Ps	Peanut / Satay sauce	2 days
5	Be	Beef extract	3 days
6	L	Lemon Juice	3 days
7	Sc	Sour cream	3 days
8	Ss	Sweet and sour sauce	3 days
9	Ra	Raita	5 days
10	Mg	Meat gravy	5 days
11	Hu	Hummus	5 days
12	Ma¹	home-made mayonnaise	1 week
13	Wc	Whipped cream	1 week
14	Og	Onion gravy	1 week
15	O	Oyster sauce	2 weeks
16	Cu	Custard	3 weeks
17	Lc	Lime chutney	3 weeks
18	Pa	Parmesan cheese	3 weeks
19	B	Butter	3 weeks
20	M	Margarine	3 weeks
21	Gs	Granulated sweetener	3 weeks
22	J	Jam	1 month
23	Tr	Treacle	1 month
24	Mg	Mango chutney	1 month
25	T	Tomato chutney	1 month
26	Vg	Vegetable gravy	1 month
27	Bq	BBQ sauce	1 month
28	Ch	Chilli sauce	1 month
29	Pl	Plum sauce	1 month
30	Hs	Hoisin sauce	1 month
31	Fd	French dressing	1 month
32	Dm	Dijon mustard	1 month
33	Lc	Lemon curd	6 weeks
34	Bs	Brown sauce	6 weeks
35	H	Horseradish	6 weeks
36	K	Ketchup	6 weeks
37	Mi	Mint sauce	6 weeks
38	Ta	Tartar sauce	6 weeks
39	Pk	Pickle	6 weeks
40	Pi	Piccalilli	6 weeks
41	Sp	Sweet pickle	6 weeks
42	Id	Italian dressing	6 weeks
43	Td	Thousand island dressing	6 weeks
44	Ma	Mayonnaise	2 months
45	Sc	Salad cream	2 months
46	Fs	Flaxseed oil	2 months
47	Ca	Cayenne pepper	3 months
48	Ch	Chilli powder	3 months
49	Bm	Brown mustard	3 months
50	Wa	Wasabi	3 months
51	Ma	Marmalade	6 months
52	Pb	Peanut butter	6 months
53	Y	Yeast extract	6 months
54	Ta	Tahini	6 months
55	Ms	Maple syrup	1 year
56	Pa	Palm oil	1 year
57	P	Peanut oil	1 year
58	So	Soybean oil	1 year
59	Sf	Sunflower oil	1 year
60	C	Cocoa	1 year
61	Bb	Black pepper	1 year
62	Ym	Yellow mustard	18 months
63	Wv	White wine vinegar	2 years
64	Cv	Cider vinegar	2 years
65	W	Worcester sauce	2 years
66	Sy	Soy sauce	3 years
67	Ol	Olive oil	4 years
68	Bv	Balsamic vinegar	5 years
69	Mv	Malt vinegar	indefinite
70	H	Honey	indefinite
71	Sa	Salt	indefinite
72	Su	Sugar	indefinite

idea: Internet Apocryphal / source: Google

NATURE

vs

NURTURE

Your genes control everything. Hair colour. Behaviour. Intelligence. Personality. Sure, environment has a role, but it's your genes that rule you.

You learn pretty much everything you do. From standing and walking to talking and socializing. Your environment and your choices make you who you are…

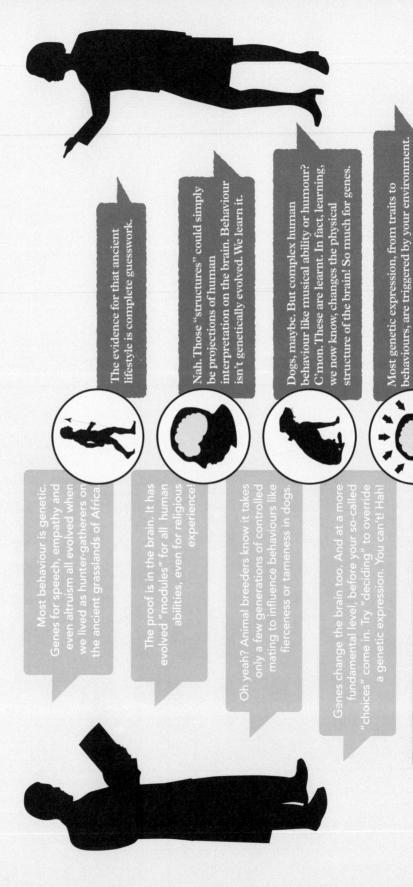

Most behaviour is genetic. Genes for speech, empathy and even altruism all evolved when we lived as hunter-gatherers on the ancient grasslands of Africa.

The evidence for that ancient lifestyle is complete guesswork.

The proof is in the brain. It has evolved "modules" for all human abilities, even for religious experience!

Nah. Those "structures" could simply be projections of human interpretation on the brain. Behaviour isn't genetically evolved. We learn it.

Oh yeah? Animal breeders know it takes only a few generations of controlled mating to influence behaviours like fierceness or tameness in dogs.

Dogs, maybe. But complex human behaviour like musical ability or humour? C'mon. These are learnt. In fact, learning, we now know, changes the physical structure of the brain! So much for genes.

Genes change the brain too. And at a more fundamental level, before your so-called "choices" come in. Try "deciding" to override a genetic expression. You can't! Hah!

Most genetic expression, from traits to behaviours, are triggered by your environment. Nurture comes first!

Okay then, what about behavioural problems such as depression, mental illness and autism? They're all highly inheritable.

Yeah, it's fashionable to say that, yes. But, even after years of study, researchers have failed to turn up a single gene for mental illness or depression.

Ahhhhh but behavioural disorders like autism are highly inheritable. In identical twins, if one twin is autistic, the other has a 60% chance of being autistic. In non-identical twins the chance is only 5%. That goes for intelligence too.

In autism, maybe. But you can't then stretch it to all behaviour and certainly not intelligence. Intelligent parents *teach* their kids to be intelligent.

But don't intelligent parents also provide the genes for high IQ? Twins separated at birth are often remarkably similar in IQ and personality, even when they haven't met. This proves there are genetic influences for everything. Even taste in music!

Yeah, but if it was all genes, you'd expect identical twins to be 100% the same. Figures for IQ may be high. But it's way less, to non-existent, for other traits like personality.

But identical twins reared apart become more alike, even when they haven't met. That means that genes must shape our personalities.

Hmmmmmm. Many studies of twins are flawed and biased. Often they just compare identical twins reared apart after birth. They don't use "controls" of unrelated people with the same background as the twins to check that age, gender, ethnicity and cultural environment are not also influencing personality. The whole field is biased.

Pffff.

Grrrrr!

CONCLUSION
50-50

Both nature and nurture each contribute
(in arguable proportions) to who we are.
They also "speak the same language".
That is, they both change the structure of the brain.
In summary, humans are dynamic creative organisms.
Learning and experience amplify the effect of genes on behaviour.

source: Skeptic.com

Postmodernism

Postmodernism is pretty much a buzz word now. Anything – and everything – can be described as postmodern now. The design of a building. The samples used in a record. The layout of a page. The collective mood of a generation. Cultural or political fragmentation. The rise of blogging and crowd-wisdom. Anything that starts with the word "meta". But what does it mean?

In art, where it all began, it's a style of sorts. Ironic and parodying. Very playful and very knowing. Knowing of history, culture, and often knowing of itself. Postmodern art and entertainment is often self-conscious. It calls attention to itself as a piece of art, or a production, or something constructed. A character who knows they are a character in a novel, for example. Or even the appearance of an author in their own book. (Like me, David, writing this. Hello.)

Overall, postmodern art says there's no difference between refined and popular culture, "high" or "low" brow. It rejects genres and hierarchies. Instead, it embraces complexity, contradiction, ambiguity, diversity, interconnectedness, and criss-crossing referentiality.

The idea is: let's not pretend that art can make meaning or is even meaningful. Let's just play with nonsense.

All of this springs from the discovery of a new relationship to truth. In a postmodern perspective, truth is a not single thing "out there" to be discovered. Instead truth must be assembled or constructed. Sometimes, it's constructed visibly, from many different components (i.e. scientists gathering results of multiple studies). Other times, it happens invisibly by society, or by cultural mechanisms and other processes that can't be easily seen by the individual.

So when someone "speaks the truth", what they are saying is actually an assemblage of their schooling, their cultural background, and the thoughts and opinions they've absorbed from their environment. In a way, you could say that their culture is speaking through them.

For that reason, it becomes more accurate and safer, in postmodern times, to assemble truth with the help of other people, rather than just decide it independently.

A clear example of this is the scientific method. Any scientist can do an experiment and declare a discovery about the world. But teams of other scientists must verify or "peer-review" that truth before it's safe to accept it. The truth here has been assembled by many people.

All the time, though, there is an understanding that even this final "truth" may well just be temporary or convenient, a place-holder to be changed or binned later on. (Well, that *should* be the case. Even scientific discoveries have a tendency to harden into dogma.)

If you accept this key postmodern insight, then immediately it becomes impossible for any individual to have a superior belief. There's no such thing as "absolute truth". No one "knows" the truth. Or can have a better truth than someone else. If an individual – or a group, organization or government – does claims to have truth and declares that truth to you, they are likely to be attempting to overpower and control you.

Confusingly, these kinds of entities are known as "Modernist". Modernity is all about order and rationality. The more ordered a society is, Modernists believe, the better it functions. If "order" is superior, then anything that promotes "disorder" has to be wrong. Taken to an extreme, that means anything different from the norm – ideas, beliefs, people – must be excluded. Or even destroyed. In the history of Western culture this

has usually meant anyone non-white, non-male, non-heterosexual and non-rational.

This is one reason why tension still erupts between holders of "absolute truth" (say the Church) and postmodern secular societies. Or between an entity like an undemocratic government which seeks to control its populace and the internet, a truly postmodern piece of technology. This is because postmodernity has a powerful weapon that can very easily and very quickly corrode Modernist structures built on "old-fashioned" absolute truth: *deconstruction.*

If all truth is constructed, then deconstruction becomes useful. Really useful. If you deconstruct something, its meanings, intentions and agendas separate and rise to the surface very quickly – and everything quickly unravels.

Take a novel, for example. You can deconstruct the structure of the text, and the personality of the characters. Then you can deconstruct the author's life story, their psychological background, and their culture and see how that influenced the text. If you keep going, you can start on the structure of human language and thought. Beyond that, a vast layer of human symbols. Beyond that ... well, you can just keep going...

Belief systems and modernist structures protect themselves from threats like deconstruction with "grand narratives". These are compelling stories to explain and justify why a certain belief system exists. They work to gloss over and mask the contradictions, instabilities and general "scariness" inherent in nature and human life.

Liberate the entire working class. Peace on Earth. There is one true God. Hollywood is one big happy family. History is progress. One day we will know everything. These are all grand narratives.

All modern societies – even those based on science – depend on these myths. Postmodernism rejects them on principle. Instead it goes for "mini-narratives", stories that explain small local events – all with an awareness that any situation, no matter how small, reflects in some way the global pattern of things. Think global, act local, basically.

So a postmodern society, unglossed-over by a grand narrative, must embrace the values of postmodernity as its key values. That means that complexity, diversity, contradiction, ambiguity, and interconnectedness all become central. In social terms that means a lack of obvious hierarchies (equal rights for all), embracing diversity (multi-culturalism), and that all voices should be heard (consensus). Interconnectedness is reflected in our technology and communications. In the 21st century anything that cannot be stored by a computer ceases to be knowledge.

That's the goal, anyway. There are pitfalls. Runaway postmodernism creates a grey goo of no-meaning. Infinite consensus creates paralysis. Over-connection leads to saturation. Too much diversity leads to disconnection. Complexity to confusion.

So in the midst of all this confusion and noise and diversity, without a grand narrative, who are you? Postmodern personal values are not moral but instead values of participation, self-expression, creativity. The focus of spirituality shifts from security in absolute given truth to a search for significance in a chaotic world. The idea that there is anything stable or permanent disappears. The floor drops away. And you are left there, playing with nonsense.

source: constructed from Wikipedia, an essay by Mary Klages, University of Colorado, Wisegeek.com

Death Spiral
You're going to go one way. Which way?

Cancer
1 in 7

Heart disease
1 in 3

Dying from any cause
1 in 1

personal threats – planetary threats

source: Guardian.co.uk, Time, Google

Stroke
1 in 23

Bus /train accident
1 in 77

Ageing sun engulfs Earth

Medical error (hospital)
1 in 300

Assault by firearm
1 in 325

House fire
1 in 1431

Diabetes
1 in 4096

Freak lawnmower accident
1 in 5300

Passive smoking
1 in 7895

Electrocution (home)
1 in 9308

Suicide
1 in 9380

Assault
1 in 16,421

Hernia
1 in 16,742

Murder
1 in 18,000

Drug overdose
1 in 18,125

Car accident
1 in 18,585

Flu
1 in 19,415

Falling down
1 in 20,666

Skin cancer
1 in 29,500

Power-line accident
1 in 40,103

Super volcano
Destroys climate

Tsunami (coastal dweller)
1 in 50,000

Walking down the street
1 in 52,000

Food poisoning
1 in 55,600

Avalanche
1 in 78,535

Accidental drowning
1 in 79,065

Fire
1 in 81,524

Choking
1 in 97,000

Explosion
1 in 107,787

Dog attack
1 in 147,717

Act of nature
1 in 225,107

Magnetic Field Reversal
Earth fried by cosmic radiation

Runaway climate change
Earth cooked

Falling off a boat
1 in 400,900

Freezing
1 in 469,000

Asteroid impact
1 in 500,000

Bicycle accident
1 in 578,000

Terrorist attack (overseas)
1 in 565,000

Drowning in the bath
1 in 685,000

Choking on your own vomit
1 in 850,000

Heat stroke
1 in 950,000

Fireworks accident
1 in 1,000,000

Asteroid collision
Seismic shock wave destroys us all

Falling out of bed
1 in 72,000,000

Falling off a ladder
1 in 2,300,000

Lightning
1 in 2,320,000

Flood
We all drown

Legal execution
1 in 3,441,325

Ozone layer destruction
UV radiation kills all life

Nuclear accident
1 in 10,000,000

Global nuclear war
That was our planet, you maniacs!

Plane crash
1 in 11,000,000

Bee sting
1 in 15,000,000

Bubonic plague
1 in 30,000,000

Super virus
Super ill

Ignition of nitrwear
1 in 36,589,556

Galactic magnetic cloud collapses
Crushing the planet

Tears planet apart
Wormhole

Freak solar flare
Fries us all

Mountain lion attack
1 in 32,000,000

Grey goo
Runaway nanotech eats us

Blogging
1 in 35,000,000

Mad Cow Disease
1 in 40,000,000

Amusement park accident
1 in 72,300,000

SARS
1 in 100,000,000

Gamma ray burst
Nearby dying star irradiates us

Cybernetic revolution
All hail our new robotic overlords

Hadron Collider accident
Oops! Scientists create a black hole

Alien invasion
All hail our new extraterrestrial overlords

Falling coconut
1 in 250,000,000

Omega Point
Storage capacity of universe hit

New Ice Age
Planet freezes

Shark attack
1 in 578,000,000

Meteor landing on your house
1 in 182, 139,00,000

Biblical apocalypse
Jesus returns for Judgement Day

Google Insights

The intensity of certain search terms compared

Beer vs Wine

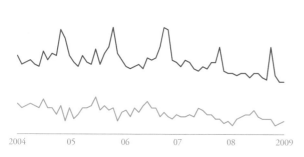

2004 05 06 07 08 2009

Tea vs Coffee

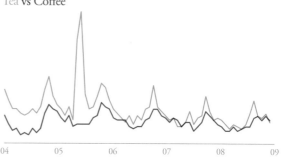

04 05 06 07 08 09

Lipstick vs Recession

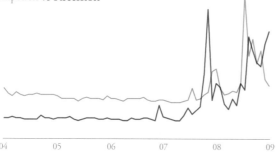

04 05 06 07 08 09

Marriage vs Divorce

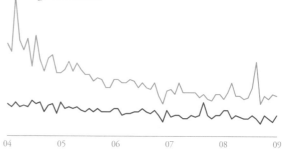

04 05 06 07 08 09

Microsoft vs Apple

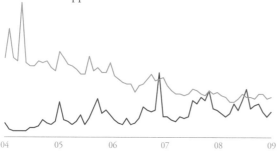

04 05 06 07 08 09

MySpace vs Facebook

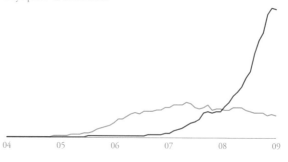

04 05 06 07 08 09

Cornflakes vs Muesli vs Porridge

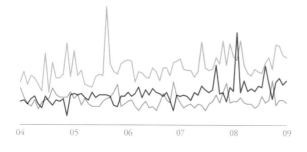

04 05 06 07 08 09

Cornflakes vs Muesli vs Porridge vs Toast

04 05 06 07 08 09

What's Better than Sex?

PTO for the answer

Britney Spears **vs** Paris Hilton

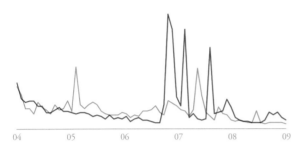

| 04 | 05 | 06 | 07 | 08 | 09 |

Lap Band **vs** Gastric Bypass

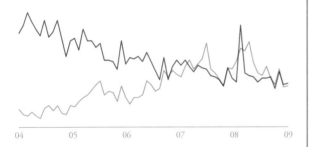

| 04 | 05 | 06 | 07 | 08 | 09 |

Facebook **vs** Twitter

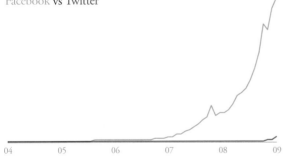

| 04 | 05 | 06 | 07 | 08 | 09 |

Chocolate Ice Cream **vs** Vanilla Ice Cream

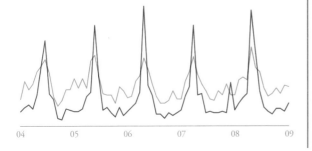

| 04 | 05 | 06 | 07 | 08 | 09 |

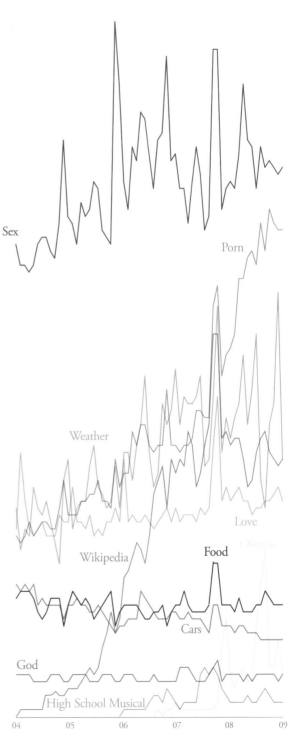

Sex

Porn

Weather

Love

Obama

Wikipedia

Food

Cars

God

High School Musical

| 04 | 05 | 06 | 07 | 08 | 09 |

source: Google Insights

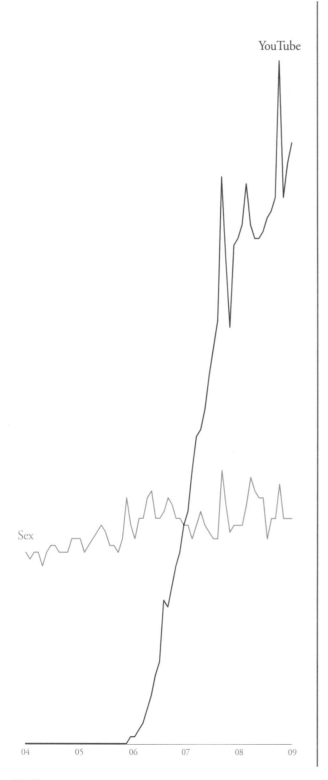

YouTube

Sex

04 05 06 07 08 09

Kyoto Targets

Bullseye!

Greece Germany Sweden England

On target

these countries look like they're doing very well due of a lack of pre-1997 records to compare against

Bulgaria Czech Republic Hungary Poland Romania Slovak Republic

Dependent on "extras"

Belgium Croatia Portugal Slovenia France Netherlands

Off target

Austria Finland Ireland Luxembourg Japan Norway

Fail

Canada Denmark Italy Scotland Spain Switzerland

Despite Kyoto, the EU's carbon emmissions has increased by 1% by 2012

source: European Environment Agency

The Varieties of Romantic Relationship

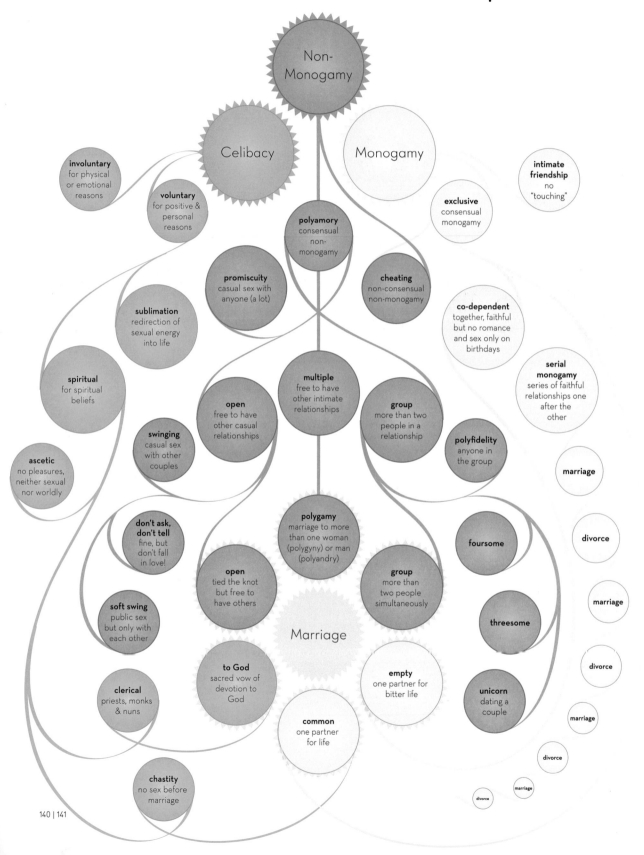

Non-Monogamy

Celibacy

Monogamy

involuntary
for physical or emotional reasons

voluntary
for positive & personal reasons

intimate friendship
no "touching"

exclusive
consensual monogamy

polyamory
consensual non-monogamy

cheating
non-consensual non-monogamy

promiscuity
casual sex with anyone (a lot)

sublimation
redirection of sexual energy into life

co-dependent
together, faithful but no romance and sex only on birthdays

spiritual
for spiritual beliefs

multiple
free to have other intimate relationships

group
more than two people in a relationship

serial monogamy
series of faithful relationships one after the other

open
free to have other casual relationships

swinging
casual sex with other couples

polyfidelity
anyone in the group

ascetic
no pleasures, neither sexual nor worldly

marriage

don't ask, don't tell
fine, but don't fall in love!

polygamy
marriage to more than one woman (polygyny) or man (polyandry)

foursome

divorce

open
tied the knot but free to have others

group
more than two people simultaneously

soft swing
public sex but only with each other

marriage

threesome

Marriage

clerical
priests, monks & nuns

to God
sacred vow of devotion to God

empty
one partner for bitter life

divorce

unicorn
dating a couple

common
one partner for life

marriage

chastity
no sex before marriage

divorce

marriage

divorce

The Evolution of Marriage in the West

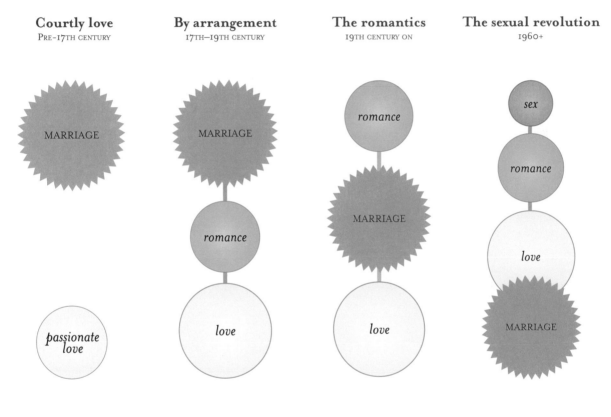

Courtly love
PRE-17TH CENTURY

By arrangement
17TH–19TH CENTURY

The romantics
19TH CENTURY ON

The sexual revolution
1960+

MARRIAGE

passionate love

MARRIAGE

romance

love

romance

MARRIAGE

love

sex

romance

love

MARRIAGE

Marriage an economic and political contract negotiated by families. Love, a divine madness, always found outside of marriage.

Marriages arranged but expected to lead to romance and, ultimately, love.

Romance, the essential spark that leads first to marriage and then to enduring love.

Sexual gratification and pleasure necessary for romance.
That may, in turn, lead to love and *only* then to marriage.

source: Wikipedia

30 Years Makes a Difference

LAKE CHAD

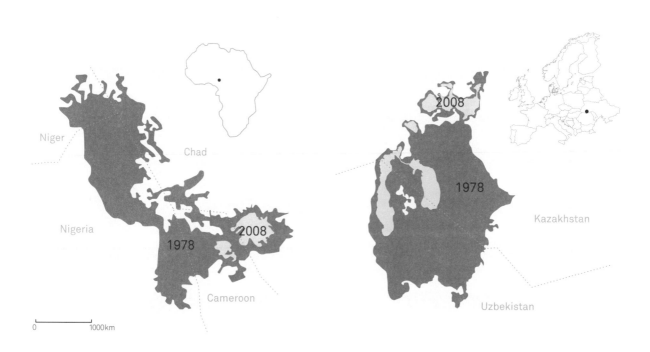

Niger

Chad

Nigeria

1978

2008

Cameroon

0 1000km

THE ARAL SEA

2008

1978

Kazakhstan

Uzbekistan

OZONE HOLE

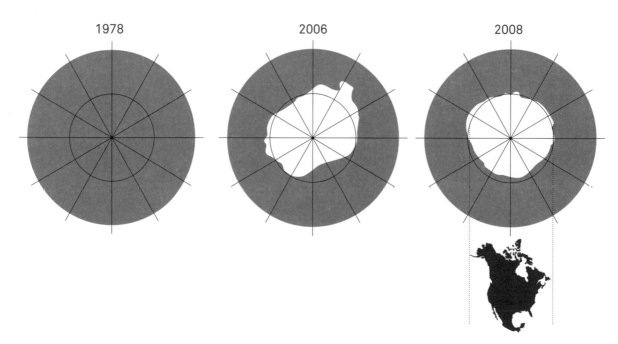

1978

2006

2008

NORTH POLAR ICE CAP

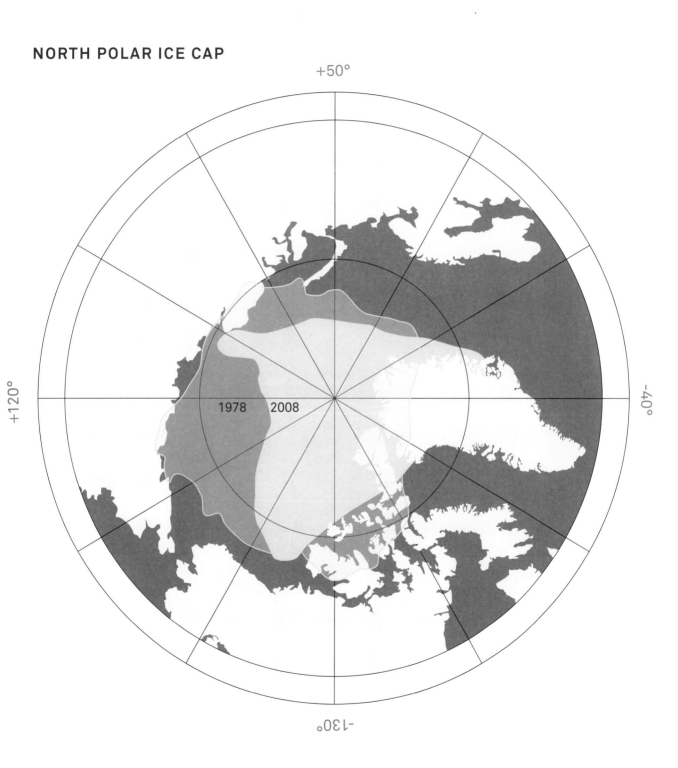

+50°

+120°

−40°

−130°

1978 2008

source: NASA

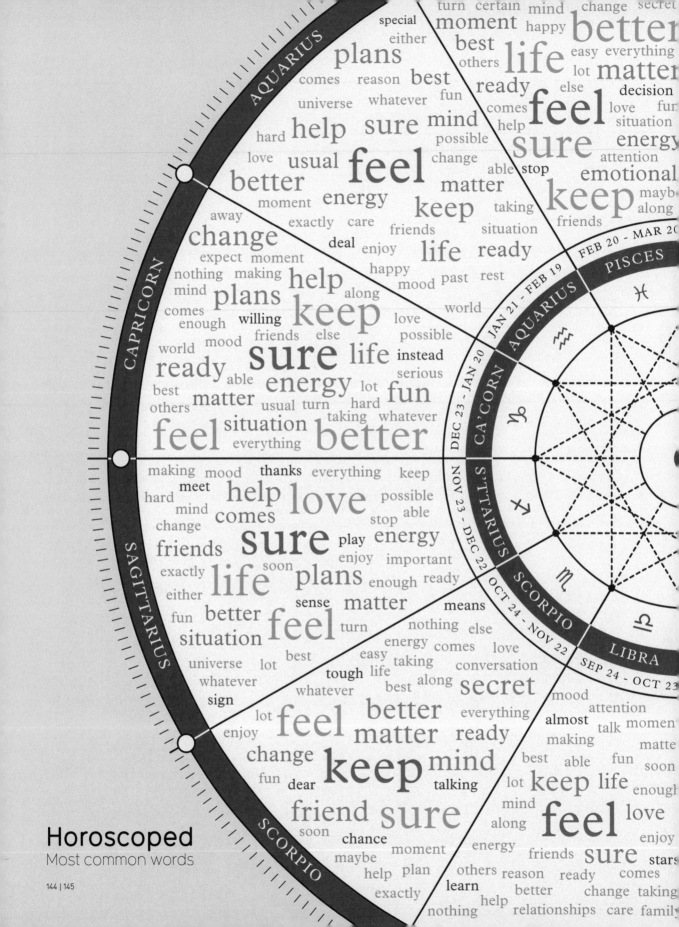

Horoscoped
Most common words

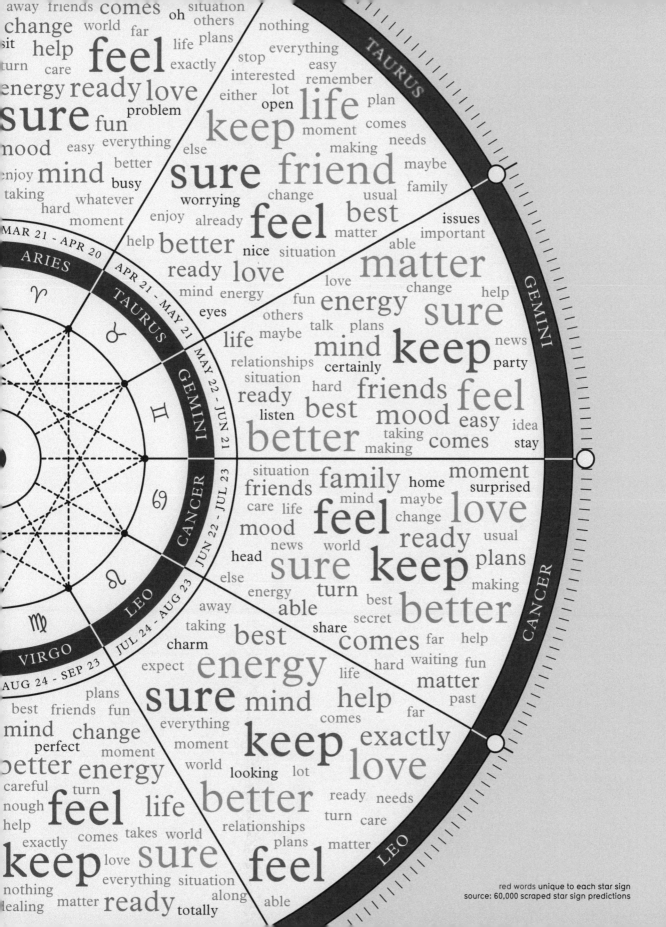

red words unique to each star sign
source: 60,000 scraped star sign predictions

Better than Bacon
The real centre of the Hollywood universe

A study of over 1 million films and actors at the website oracleofbacon.org has revealed a series of actors who are way better connectors for the game Six Degrees of Kevin Bacon than Mr Bacon himself.

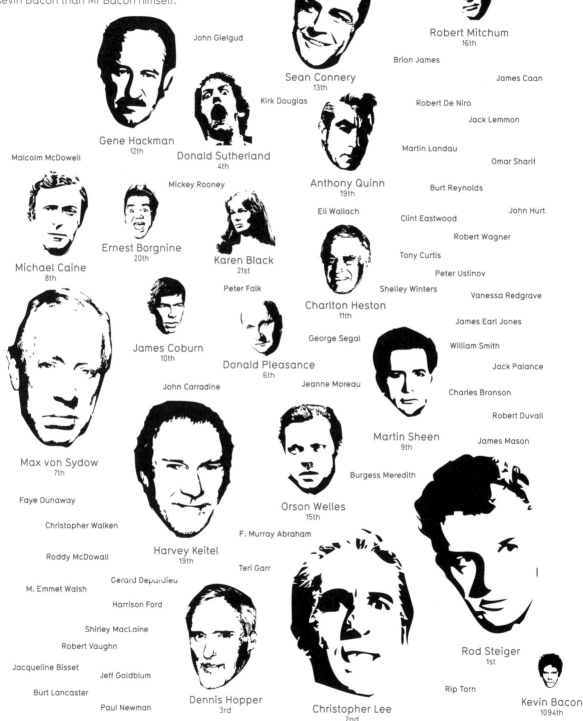

John Gielgud

Robert Mitchum
16th

Brion James

James Caan

Sean Connery
13th

Kirk Douglas

Robert De Niro

Jack Lemmon

Martin Landau

Omar Sharif

Gene Hackman
12th

Donald Sutherland
4th

Anthony Quinn
19th

Burt Reynolds

John Hurt

Malcolm McDowell

Mickey Rooney

Eli Wallach

Clint Eastwood

Robert Wagner

Tony Curtis

Peter Ustinov

Ernest Borgnine
20th

Karen Black
21st

Shelley Winters

Vanessa Redgrave

Michael Caine
8th

Peter Falk

Charlton Heston
11th

James Earl Jones

William Smith

George Segal

Jack Palance

James Coburn
10th

Donald Pleasance
6th

Jeanne Moreau

Charles Bronson

John Carradine

Robert Duvall

James Mason

Martin Sheen
9th

Burgess Meredith

Max von Sydow
7th

Faye Dunaway

Orson Welles
15th

Christopher Walken

F. Murray Abraham

Roddy McDowall

Harvey Keitel
19th

Teri Garr

Gerard Depardieu

M. Emmet Walsh

Harrison Ford

Shirley MacLaine

Robert Vaughn

Jacqueline Bisset

Jeff Goldblum

Burt Lancaster

Dennis Hopper
3rd

Christopher Lee
2nd

Rod Steiger
1st

Rip Torn

Kevin Bacon
1094th

Paul Newman

source: OracleofBacon.org

Calculating the Chances

Five-year cancer survival rates

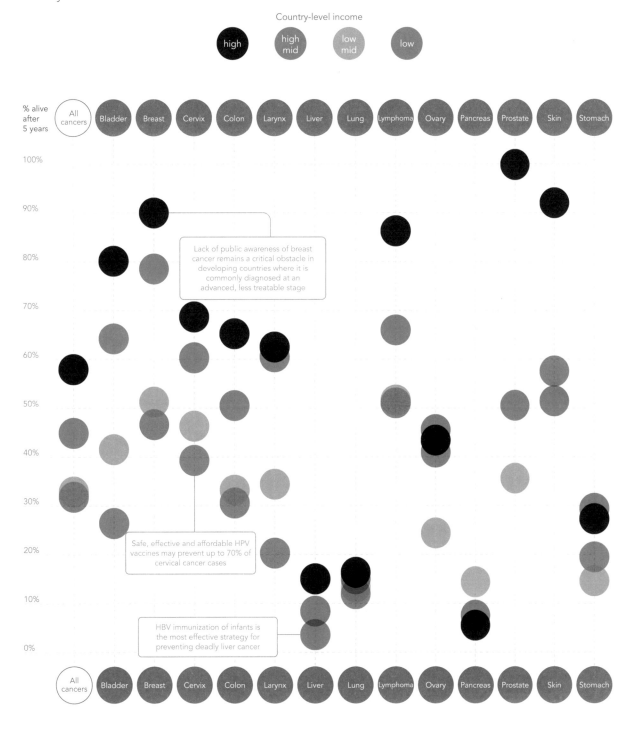

Country-level income

high · high mid · low mid · low

% alive after 5 years

All cancers · Bladder · Breast · Cervix · Colon · Larynx · Liver · Lung · Lymphoma · Ovary · Pancreas · Prostate · Skin · Stomach

100% · 90% · 80% · 70% · 60% · 50% · 40% · 30% · 20% · 10% · 0%

Lack of public awareness of breast cancer remains a critical obstacle in developing countries where it is commonly diagnosed at an advanced, less treatable stage

Safe, effective and affordable HPV vaccines may prevent up to 70% of cervical cancer cases

HBV immunization of infants is the most effective strategy for preventing deadly liver cancer

note: lack of colour spot means missing data // data: bit.ly/cancerburden
source: International Agency for Research on Cancer, UK Office for National Statistics, National Cancer Institute

Some Things You Can't Avoid

Characteristics and behaviours that increase the likelihood of certain ailments

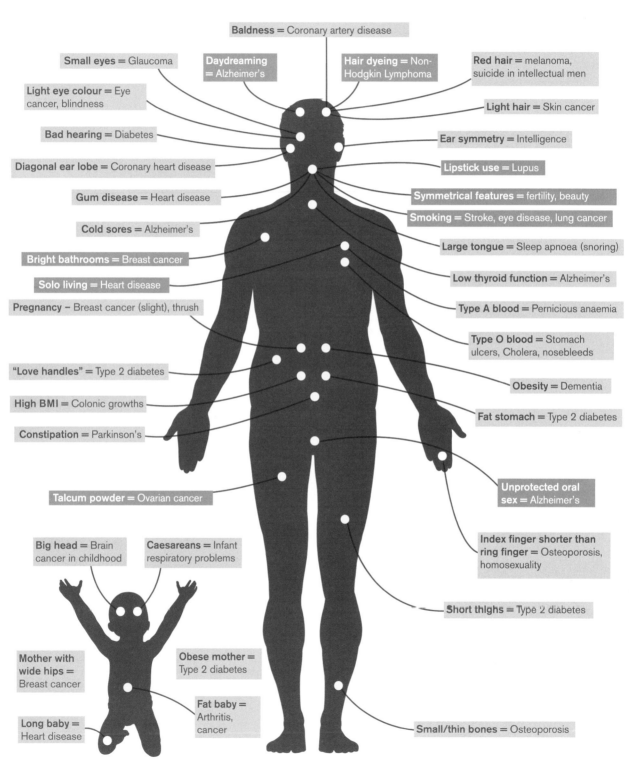

Baldness = Coronary artery disease

Small eyes = Glaucoma

Daydreaming = Alzheimer's

Hair dyeing = Non-Hodgkin Lymphoma

Red hair = melanoma, suicide in intellectual men

Light eye colour = Eye cancer, blindness

Light hair = Skin cancer

Bad hearing = Diabetes

Ear symmetry = Intelligence

Diagonal ear lobe = Coronary heart disease

Lipstick use = Lupus

Gum disease = Heart disease

Symmetrical features = fertility, beauty

Cold sores = Alzheimer's

Smoking = Stroke, eye disease, lung cancer

Bright bathrooms = Breast cancer

Large tongue = Sleep apnoea (snoring)

Solo living = Heart disease

Low thyroid function = Alzheimer's

Pregnancy – Breast cancer (slight), thrush

Type A blood = Pernicious anaemia

Type O blood = Stomach ulcers, Cholera, nosebleeds

"Love handles" = Type 2 diabetes

Obesity = Dementia

High BMI = Colonic growths

Fat stomach = Type 2 diabetes

Constipation = Parkinson's

Unprotected oral sex = Alzheimer's

Talcum powder = Ovarian cancer

Index finger shorter than ring finger = Osteoporosis, homosexuality

Big head = Brain cancer in childhood

Caesareans = Infant respiratory problems

Short thighs = Type 2 diabetes

Mother with wide hips = Breast cancer

Obese mother = Type 2 diabetes

Long baby = Heart disease

Fat baby = Arthritis, cancer

Small/thin bones = Osteoporosis

Or decrease the likelihood

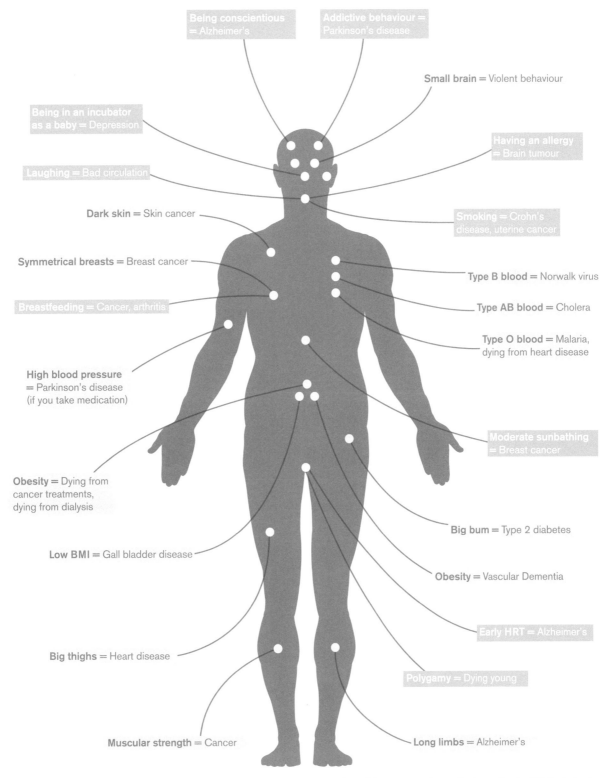

Being conscientious = Alzheimer's

Addictive behaviour = Parkinson's disease

Small brain = Violent behaviour

Being in an incubator as a baby = Depression

Having an allergy = Brain tumour

Laughing = Bad circulation

Dark skin = Skin cancer

Smoking = Crohn's disease, uterine cancer

Symmetrical breasts = Breast cancer

Type B blood = Norwalk virus

Breastfeeding = Cancer, arthritis

Type AB blood = Cholera

Type O blood = Malaria, dying from heart disease

High blood pressure = Parkinson's disease (if you take medication)

Moderate sunbathing = Breast cancer

Obesity = Dying from cancer treatments, dying from dialysis

Big bum = Type 2 diabetes

Low BMI = Gall bladder disease

Obesity = Vascular Dementia

Early HRT = Alzheimer's

Big thighs = Heart disease

Polygamy = Dying young

Muscular strength = Cancer

Long limbs = Alzheimer's

source: PubMed, Medscape.com, HealthDay, biomedicine.org, eupedia.com, Reuters, yale.edu, NHSdirect.nhs.uk

By Descent
Decreased risk – increased risk

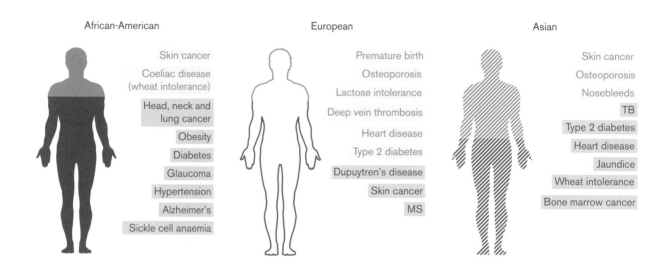

African-American

Skin cancer
Coeliac disease
(wheat intolerance)
Head, neck and
lung cancer
Obesity
Diabetes
Glaucoma
Hypertension
Alzheimer's
Sickle cell anaemia

European

Premature birth
Osteoporosis
Lactose intolerance
Deep vein thrombosis
Heart disease
Type 2 diabetes
Dupuytren's disease
Skin cancer
MS

Asian

Skin cancer
Osteoporosis
Nosebleeds
TB
Type 2 diabetes
Heart disease
Jaundice
Wheat intolerance
Bone marrow cancer

By Gender
Decreased risk – increased risk

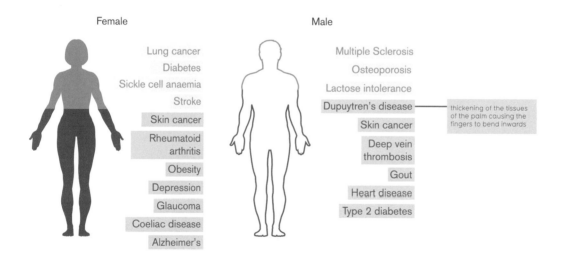

Female

Lung cancer
Diabetes
Sickle cell anaemia
Stroke
Skin cancer
Rheumatoid
arthritis
Obesity
Depression
Glaucoma
Coeliac disease
Alzheimer's

Male

Multiple Sclerosis
Osteoporosis
Lactose intolerance
Dupuytren's disease — thickening of the tissues
of the palm causing the
fingers to bend inwards
Skin cancer
Deep vein
thrombosis
Gout
Heart disease
Type 2 diabetes

source: PubMed, Medscape.com, HealthDay, biomedicine.org, eupedia.com, Reuters, yale.edu, NHSdirect.nhs.uk

Body By

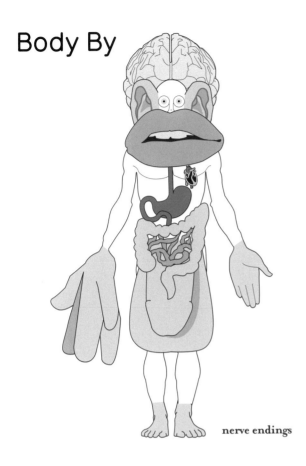

nerve endings

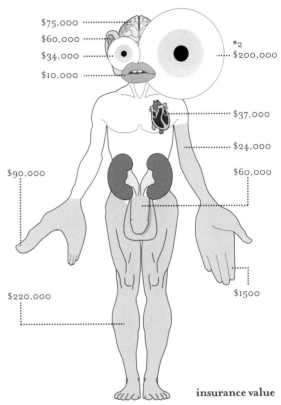

$75,000
$60,000
$34,000
$10,000

*2
$200,000

$37,000

$24,000

$90,000

$60,000

$220,000

$1500

insurance value

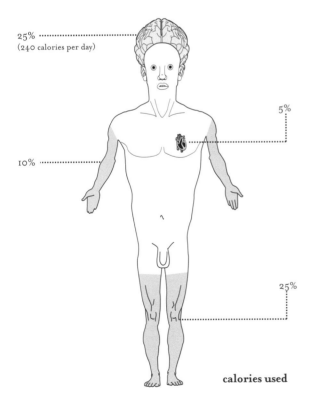

25%
(240 calories per day)

5%

10%

25%

calories used

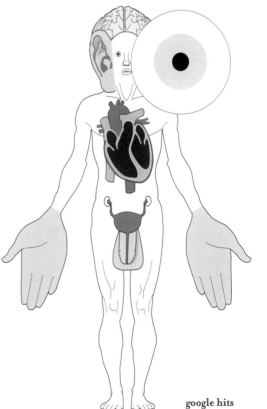

google hits

source: Google, Wikipedia

Microbes Most Dangerous

By survival time outside the body

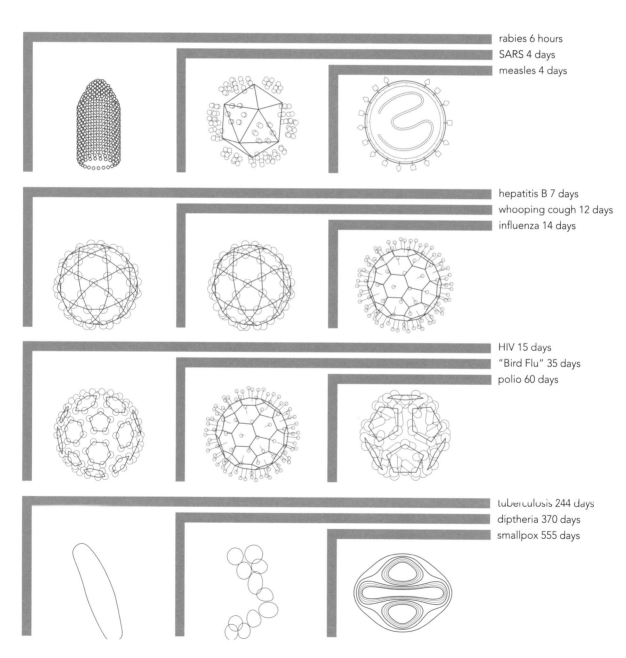

rabies 6 hours
SARS 4 days
measles 4 days

hepatitis B 7 days
whooping cough 12 days
influenza 14 days

HIV 15 days
"Bird Flu" 35 days
polio 60 days

tuberculosis 244 days
diptheria 370 days
smallpox 555 days

source: Centre For Disease Control & Prevention, NewScientist.com. Design inspired by Geigy

Cosmetic Ingredients
Shampoo. Suntan lotion. Soap. Cleanser. Lipstick.

CHLORHEXIDINE DIGLUCONATE, 1,4-DIOXANE, ACETATE, ACETONE, ACETYLATED LANOLIN ALCOHOL, ACRYLATES COPOLYMER, ACRYLATES / OCTYLPROPENAMIDE COPOLYMOR, ALCOHOL DENAT, ALCOHOL SD-40, ALGAE/SEAWEED EXTRACT, ALLANTOIN, ALPHA HYDROXY ACID, ALPHA LIPOIC ACID, ALPHA-ISOMETHYL IONONE, AMMONIUM LAURETH SULFATE, AMMONIUM LAURYL SULPHATE, ANIGOZANTHOS FLAVIDUS (BLOODWORT), ARACHIDYL PROPIONATE, ASCORBIC ACID, ASCORBYL PALMITATE, BEESWAX, BENZALKONIUM CHLORIDE, BENZOIC ACID, BENZOYL PEROXIDE, BENZYL SALICYLATE, BETA HYDROXY ACID (SALICYLIC ACID), BORIC ACID, BUTYL METHOXYDIBENZOYLMETHANE, BUTYLATED HYDROXYANISOLE, BUTYLENE GLYCOL DICAPRYLATE/DICRAPATE, BUTYLPARABEN, BUTYLPHENYL METHYLPROPIONAL, C12-15 ALKYL BENZOATE, CAFFEINE, CAMPHOR, CARBOMERS (934, 940, 941, 980, 981), CARICA PAPAYA (PAPAYA), CARMINE, CARNAUBA WAX, CAVIAR (ROE EXTRACT), CELLULOSE, CERAMIDES, CETALKONIUM CHLORIDE, CETEARETH, CETEARYL ALCOHOL, CHAMOMILLA RECUTITA (CHAMOMILE), CL 14700 (E125), CL 191140 (YELLOW 5 ALUMINIUM LAKE), CITRONELLOL, COCAMIDE MEA, COCAMIDOPROPYL BETAINE, COLLAGEN, COUMARIN, CYCLIC (HYDROXY) ACID, CYCLOMETHICONE, D&C RED NO. 6 BARIUM LAKE, DIETHANOLAMINE (DEA), DIETHYLHEXYL BUTAMIDO TRIAZONE, DIEMETHICONE, DIOCTYL SODIUM SULFOSUCCINATE, DISODIUM COCOAMPHODIACETATE, DISODIUM LAURYL PHENYL ETHER DISULFONATE, DMDM HYDANTOIN, EDTA, ELASTIN, ELLAGIC ACID, ETHYL ALCOHOL (ETHANOL), ETHYLPARABEN, EUGENOL, FD&C YELLOW NO. 5 ALUMINUM LAKE, GLYCERIN, GLYCERYL STEARATE, GLYCINE, GLYCOGEN, GLYCOL STEARATE, GLYCOLIC ACID, GRAPE SEED EXTRACT, GREEN TEA EXTRACT (CAMELLIA SINENSIS), HEXYL CINNAMAL, HYALURONIC ACID, HYDROGEN PEROXIDE, HYDROLYZED COLLAGEN, HYDROQUINONE, HYDROXYLSOHEXYL 3-CYCLOHEXENE CARBOXALDEHYDE, ISOPROPYL ALCOHOL, ISOPROPYL ISOSTEARATE, ISOPROPYL IANOLATE, ISOPROPYL MYRISTATE, ISOPROPYL PALMITATE, ISOSTEARAMIDOPROPYL ETHYLDIMONIUM ETHOSULFATE, ISOSTEARIC ACID KAOLINE (CHINA CLAY), KOJIC ACID, L-ERGOTHIONEINE, LACTIC ACID, LAMINARIA DIGITATA (HORSEHAIR KELP), LANOLIN, LECITHIN, LICORICE EXTRACT (BHT), LIGHT MINERAL OIL, LIMONENE, LINALOOL, LINOLEAMIDOPROPYL, LINOLEIC ACID, LYSINE, METHYLISOTHIAZOLINONE, METHYLPARABEN, MINERAL OIL, MYRISTYL MYRISTATE, MYRTRIMONIUM BROMIDE, OCTOCRYLENE, OCTYL METHOXYCINNAMATE, OCTYL PALMITATE, OCTYLDODECANOL, OLEYL ALCOHOL, OXYBENZONE (BENZOPHENONE-3), PABA (PARA-AMINOBENZOIC ACID), PADIMATE O, PANTHENOL, PARABEN, PARAFFIN, PARFUM, PC-DIMONIUM CHLORIDE PHOSPHATE, PEG-40 CASTOR OIL, PETROLATUM, PHENOXYETHANOL, PHENYL TRIMETHICONE, PHENYLBENZIMIDAZOLE SULFONIC ACID, PHTHALATES, POLY HYDROXY ACID, POLYBUTENE, PROLINE, PROPYLENE GLYCOL, PROPYLPARABEN, QUATERNIUM-15, RESVERATROL, RETINOL (ALSO VITAMIN A), RETINYL PALMITATE, RETINAL PALMITATE POLYPEPTIDE, ROSE HIPS, SALYCYLIC ACID, SILICONE (DIMETHYL SILICONE), SILICA, SILK POWDER, SILK PROTEINS, SODIUM ACRYLATES/C10-30 ALKYL ACRYLATE CROSSPOLYMER, SODIUM BICARBONATE, SODIUM BORATE, SODIUM CETEARYL SULFATE, SODIUM CHLORIDE, SODIUM FLUORIDE, SODIUM HYALURONATE, SODIUM LAUREL SULFATE, SODIUM LAURETH SULFATE, SODIUM LAURYL SULFATE, SODIUM METHACRYLATE, SORBIC ACID, SORBITOL (MINERAL OIL), STEARIC ACID, SULFUR, TALC, TAPIOCA STARCH, TARTARIC ACID, TITANIUM DIOXIDE, TOCOPHERYL ACETATE, TRICLOSAN, TRIDECETH-12, TRIMETHOXYCAPRYLYLSILANE, TRISODIUM EDTA, TYROSINE, VITAMIN A (RETINOL), VITAMIN B, VITAMIN C (CITRIC ACID), VITAMIN D, VITAMIN E (TOCOPHEROL), WATER, WHITE PETROLATUM, WHITE WAX, XANTHAN GUM

| GOOD | FINE | OKAY | NASTY | TOXIC | DEADLY |

source: CosmeticDatabase.com, Environmental Working Group

Things That'll Give You Cancer
Source: the media

abortion

acrylamide

agent **orange**

Nut mould. Nasty. — alcohol **aldrin** alfatoxin

asphalt fumes **atrazine**

meat **benzene** **benzadine**

High doses in smokers linked to lung cancer — betacarotene **betel nuts** birth

bread breasts bus stations **cadmium**

Fungicide — captan **carbon tetrachloride** careers

Vinyl acetate in gum — **foods** chewing gum Chinese food Chinese herbal

chlordane **chlorinated** **camphene**

chloroform cholesterol **chromium coaltar**

curry **cyclamates** dairy products **DDT** deodorants depleted

diesel exhaust diet soda dimethylsulphate

Safe — **epichlorhydrin** ethilenedibromide ethnic beliefs

Lack of real contact alters our biology apparently — facebook **fat** fibre fluoridation flying **formaldehyde**

gingerbread global warming gluteraldehyde **granite** grilled

supplements **heliobacter pylori** **hepatitis B**

bone mass **HRT** hydrazine hydrogen peroxide **incense**

In poorly ventilated spaces —

Higher risk of breast cancer — laxatives **lead** left-handedness **Lindane** Listerine low

Minimal risk — mammograms manganese menopause methylbromide

No link. Now proven. — mixed spices mobile phones moisturizers **mould** MTBE

breast feeding not having a twin **nuclear power**

juice **oxygenated gasoline** oyster sauce ozone

Contains carcinogens — **PCBs** peanuts **pesticides** pet birds plastic

When mouldy —

It's the creosote. Don't lick. — PVC radio masts **radon** railway sleepers

sausage dye selenium semi conductor plants

soy sauce statins **stress** strontium styrene

sunscreen **talc** testosterone tetrachloroethylene

tooth fillings toothpaste tooth whitening

Probably okay — underarm-shaving **unvented** **stoves**

vegetables **vinyl** **bromide**

vitamins vitreous fibres wallpaper

well water wifi wine

x-rays

154 | 155

a c r y l o n i t r i l

air pollution alar Pesticide & fruit spray

arsenic **asbestos**

AZT babyfood **barbecued**

benzopyrene **beryllium**

control pills bottled water bracken Only if contaminated

calcium channel blockers cannabis Linked to testicular cancer but also has anti-tumour effects

for women car fumes casual sex celery **charred**

supplements chinese medicine chips chloramphenicol Antibiotic

chlorinated water **chlorodiphenyl**

coffee **coke ovens** cooked foods crackers creosote May help combat cancer

uranium depression **dichloryacetylene dieldrin**

dinitrotouluene **dioxane** **dioxin** dogs unproven links to breast cancer

ethyleacrilate ethylene **ethylenedichloride** Ex-Lax

free radicals french fries fruit frying **gasoline** genes

meat **Gulf war** hair dye hamburgers health Linked to many cancers

virus hexachlorbutadiene hexachlorethane high

infertility jewellery **Kepone** kissing lack of exercise Kissing disease (infectious mononucleosis)

cholesterol low fibre diet magnetic fields **malonaldehyde**

methylenechloride microwave ovens milk hormones

nickel night lighting nightshifts **nitrates not** Probable cause of cancer

plants Nutrasweet **oestrogen** olestra olive oil orange

ozone depletion papaya **passive smoking**

IV bags polio vaccine power lines proteins Prozac

redmeat Roundup saccharin salmon salt sausage Most red meat linked to bowel cancer

shaving shellfish sick buildings smoked fish Air quality

sulphuric acid **sunbeds** **sunlight**

tight bras toast toasters **tobacco**

train stations **trichloroethylene** tritium

uranium **UV radiation**

vinyl chloride vinyl toys

weight gain welding fumes

winter **wood dust** work

source: UK and US media reports [via numberwatch.co.uk], Wikipedia

Types of Coffee

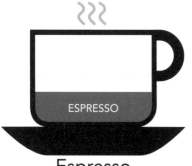

Espresso
[ess-press-oh]

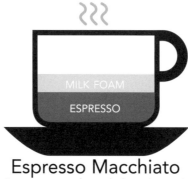

Espresso Macchiato
[ess-press-oh mah-ke-ah-toe]

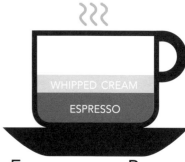

Espresso con Panna
[ess-press-oh kon pawn-nah]

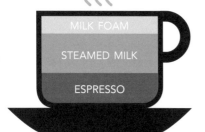

Caffé Latte
[caf-ay lah-tey]

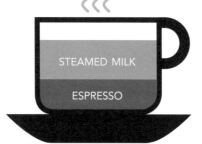

Flat White
[Fla-te-why-te]

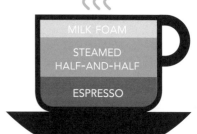

Caffé Breve
[caf-ay brev-ay]

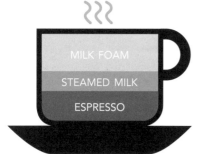

Cappuccino
[kap-oo-chee-noh]

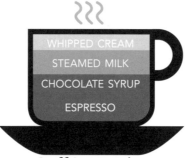

Caffé Mocha
[caf-ay moh-kuh]

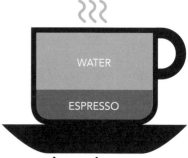

Americano
[uh-mer-i-kan-oh]

Caffeine content

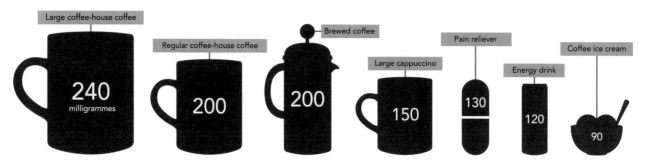

Large coffee-house coffee — 240 milligrammes

Regular coffee-house coffee — 200

Brewed coffee — 200

Large cappuccino — 150

Pain reliever — 130

Energy drink — 120

Coffee ice cream — 90

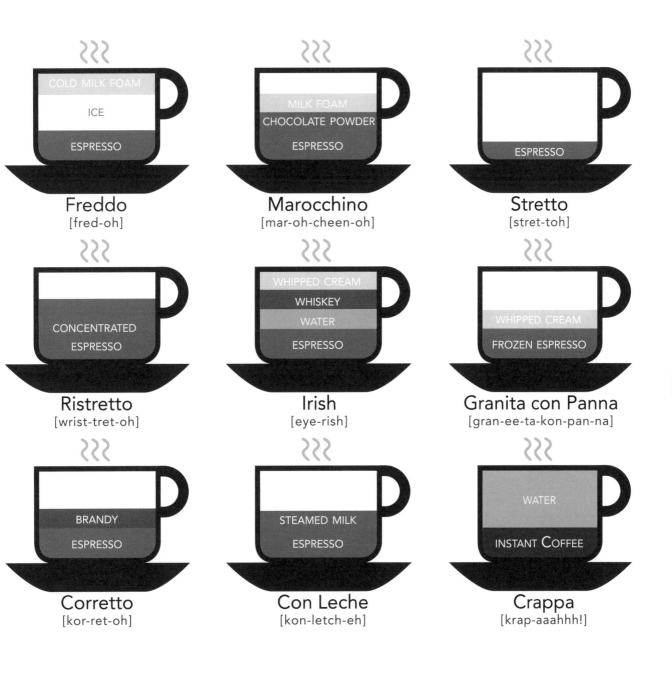

Freddo
[fred-oh]

COLD MILK FOAM
ICE
ESPRESSO

Marocchino
[mar-oh-cheen-oh]

MILK FOAM
CHOCOLATE POWDER
ESPRESSO

Stretto
[stret-toh]

ESPRESSO

Ristretto
[wrist-tret-oh]

CONCENTRATED ESPRESSO

Irish
[eye-rish]

WHIPPED CREAM
WHISKEY
WATER
ESPRESSO

Granita con Panna
[gran-ee-ta-kon-pan-na]

WHIPPED CREAM
FROZEN ESPRESSO

Corretto
[kor-ret-oh]

BRANDY
ESPRESSO

Con Leche
[kon-letch-eh]

STEAMED MILK
ESPRESSO

Crappa
[krap-aaahhh!]

WATER
INSTANT COFFEE

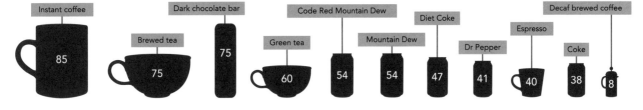

Instant coffee	Brewed tea	Dark chocolate bar	Green tea	Code Red Mountain Dew	Mountain Dew	Diet Coke	Dr Pepper	Espresso	Coke	Decaf brewed coffee
85	75	75	60	54	54	47	41	40	38	8

idea: Lokesh Dhakar @ lokeshdhakar.com

Tons of Carbon
Emissions per year

250 tons absorbed by 100 square metres of forest in its lifetime

150,000
Eyjafjallajökull volcano
(per day)

72,000
a large university

4,600
Space Shuttle mission

84,000
all UK music festivals

560,000
European aviation industry
per day

5,336,000
global wine industry

3,400,000
2012 London Olympics
(projected)

292,500
opening fizzy drinks
in America

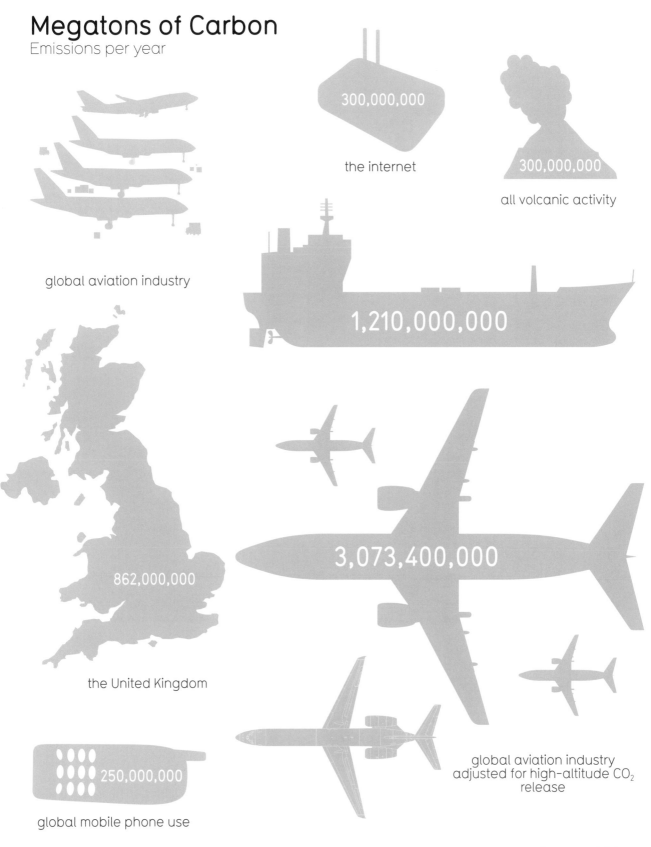

Megatons of Carbon
Emissions per year

300,000,000

the internet

300,000,000

all volcanic activity

global aviation industry

1,210,000,000

862,000,000

the United Kingdom

3,073,400,000

global aviation industry
adjusted for high-altitude CO$_2$
release

250,000,000

global mobile phone use

all measurements in tons

Articles of War

Most edited Wikipedia pages

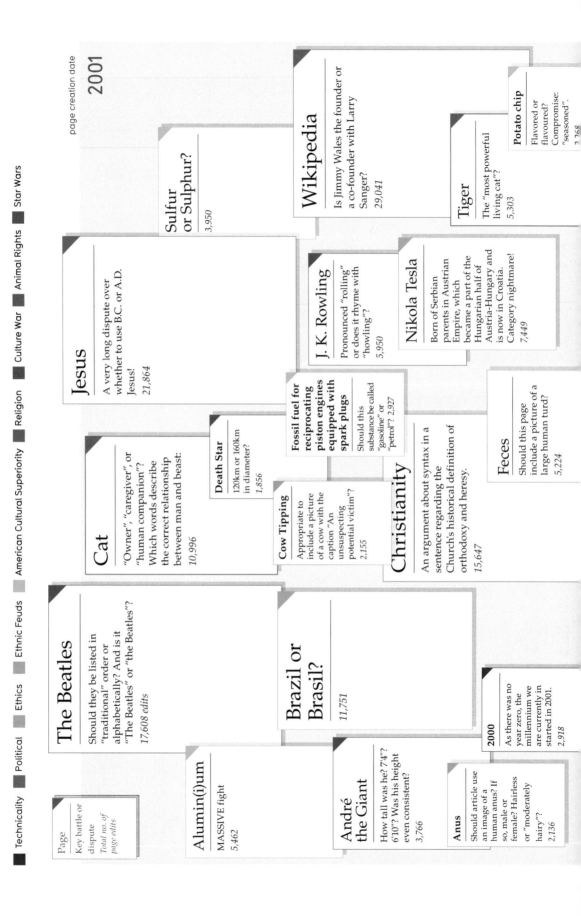

Legend: Technicality · Political · Ethics · Ethnic Feuds · American Cultural Superiority · Religion · Culture War · Animal Rights · Star Wars

Page
Key battle or dispute
Total no. of page edits

page creation date

2001

Sulfur or Sulphur?
3,950

Wikipedia
Is Jimmy Wales the founder or a co-founder with Larry Sanger?
29,041

Tiger
The "most powerful living cat"?
5,303

Potato chip
Flavored or flavoured? Compromise: "seasoned".
3,768

Jesus
A very long dispute over whether to use B.C. or A.D. Jesus!
21,864

J. K. Rowling
Pronounced "rolling" or does it rhyme with "howling"?
5,950

Nikola Tesla
Born of Serbian parents in Austrian Empire, which became a part of the Hungarian half of Austria-Hungary and is now in Croatia. Category nightmare!
7,449

Cat
"Owner", "caregiver", or "human companion"? Which words describe the correct relationship between man and beast:
10,996

Death Star
120km or 160km in diameter?
1,856

Fossil fuel for reciprocating piston engines equipped with spark plugs
Should this substance be called "gasoline" or "petrol"? 2,927

Cow Tipping
Appropriate to include a picture of a cow with the caption "An unsuspecting potential victim"?
2,155

Christianity
An argument about syntax in a sentence regarding the Church's historical definition of orthodoxy and heresy.
15,647

Feces
Should this page include a picture of a large human turd?
5,224

The Beatles
Should they be listed in "traditional" order or alphabetically? And is it "The Beatles" or "the Beatles"?
17,608 edits

Alumin(i)um
MASSIVE fight
5,462

Brazil or Brasil?
11,751

André the Giant
How tall was he? 7'4"? 6'10"? Was his height even consistent?
3,766

Anus
Should article use an image of a human anus? If so, male or female? Hairless or "moderately hairy"?
2,136

2000
As there was no year zero, the millennium we are currently in started in 2001.
2,918

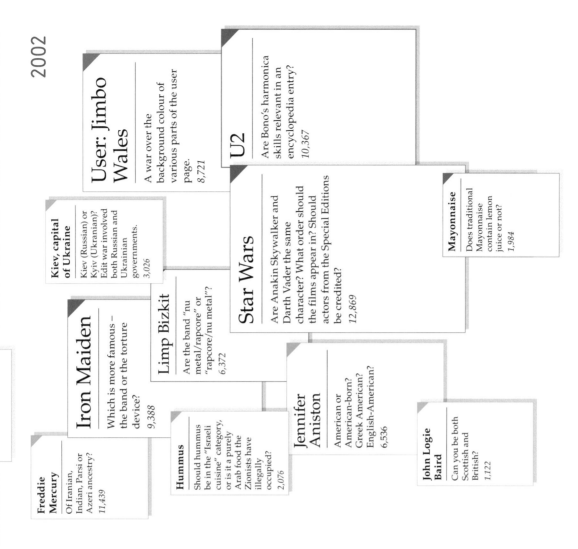

User: Jimbo Wales

A war over the background colour of various parts of the user page.
8,721

U2

Are Bono's harmonica skills relevant in an encyclopedia entry?
10,367

Kiev, capital of Ukraine

Kiev (Russian) or Kyiv (Ukranian)? Edit war involved both Russian and Ukrainian governments.
3,026

Mayonnaise

Does traditional Mayonnaise contain lemon juice or not?
1,984

Iron Maiden

Which is more famous – the band or the torture device?
9,388

Limp Bizkit

Are the band "nu metal/rapcore" or "rapcore/nu metal"?
6,372

Star Wars

Are Anakin Skywalker and Darth Vader the same character? What order should the films appear in? Should actors from the Special Editions be credited?
12,869

Freddie Mercury

Of Iranian, Indian, Parsi or Azeri ancestry?
11,439

Hummus

Should hummus be in the "Israeli cuisine" category, or is it a purely Arab food the Zionists have illegally occupied?
2,076

Jennifer Aniston

American or American-born? Greek American? English-American?
6,536

John Logie Baird

Can you be both Scottish and British?
1,122

Arachnophobia

Appropriate to include a huge picture of a tarantula on a page about fear of spiders?
640

Articles of War
Most edited Wikipedia pages

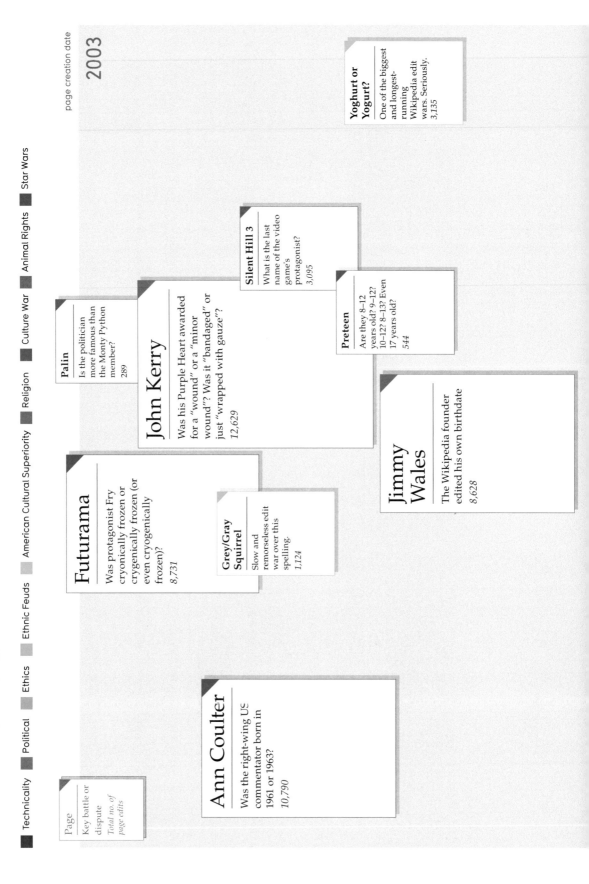

Technicality ■ Political ■ Ethics ■ Ethnic Feuds ■ American Cultural Superiority ■ Religion ■ Culture War ■ Animal Rights ■ Star Wars

page creation date

2003

Page
Key battle or
dispute
*Total no. of
page edits*

Palin
Is the politician
more famous than
the Monty Python
member?
289

John Kerry
Was his Purple Heart awarded
for a "wound" or a "minor
wound"? Was it "bandaged" or
just "wrapped with gauze"?
12,629

Silent Hill 3
What is the last
name of the video
game's
protagonist?
3,095

Preteen
Are they 8–12
years old? 9–12?
10–12? 8–13? Even
17 years old?
544

Futurama
Was protagonist Fry
cryonically frozen or
crygenically frozen (or
even cryogenically
frozen)?
8,731

**Grey/Gray
Squirrel**
Slow and
remorseless edit
war over this
spelling.
1,124

Jimmy
Wales
The Wikipedia founder
edited his own birthdate
8,628

**Yoghurt or
Yogurt?**
One of the biggest
and longest-
running
Wikipedia edit
wars. Seriously.
3,135

Ann Coulter
Was the right-wing US
commentator born in
1961 or 1963?
10,790

Street Fighter character articles

Drawn-out edit wars over the correct heights and weights of fictional characters

2,147

Money (Pink Floyd song)

What exactly is this song's time signature? 7/8, 7/4 or even 21/8?

573

Wii

"Wii", "Nintendo Wii" or "the Wii"? Should "wee" link here or to the article on urine?

20,077

Pwned

What does this piece of geek slang actually mean? Who invented it? How do you pronounce it?

26

US Election 2008

Is Stephen Colbert considered a serious candidate? If so, was it Stephen Colbert (comedian) or Stephen Colbert (character)?

14,957

Pregnancy

The picture of a nude pregnant women in this article provoked an enormous debate – and even the intervention of Wikipedia founder, Jimmy Wales.

5,671

Grace Kelly and Cher

Gay icons?

2,282

House MD

Should we mention the show's lack of Asian diversity?

8,423

Sega Genesis & Sega Mega Drive

What's the proper name for the article when both names are used? Surely something can't be two things at the same time? An eight-month debate.

3,670

Cute

Is it NPOV (Neutral Point of View) to say an animal is "cute"?

21

Clover (Creature)

Cloverfield, Clover, The Cloverfield creature, or Clover (creature)?

1,654

Compact Disc

Is a tradename and so should be capitalized. HOWEVER the logo says "Compact disc.".

3,888

2006 Atlantic Hurricane Season

Tropical Storm Zeta formed on 30 December, 2005 and lasted until 6 January, 2006. Which hurricane season does this count as?

3,254

Angels & Airwaves is/are a band

British English requires "are" as the band comprises multiple people. American English requires "is", as the band is a singular entity. FIGHT!

8,055

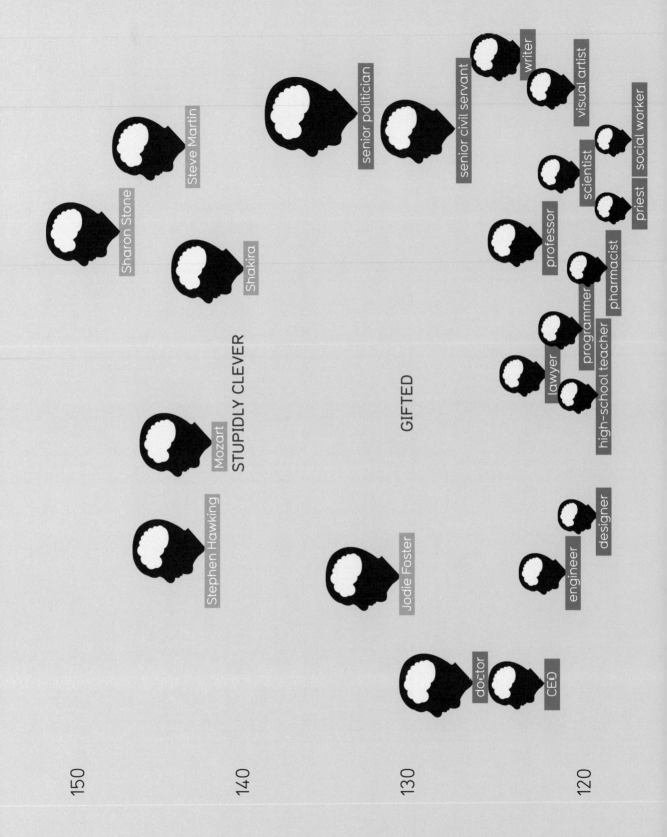

150

140

STUPIDLY CLEVER

Sharon Stone

Steve Martin

Stephen Hawking

Mozart

Shakira

senior politician

GIFTED

130

Jodie Foster

senior civil servant

writer

visual artist

scientist

professor

priest | social worker

pharmacist

lawyer

programmer

high-school teacher

120

doctor

CED

engineer

designer

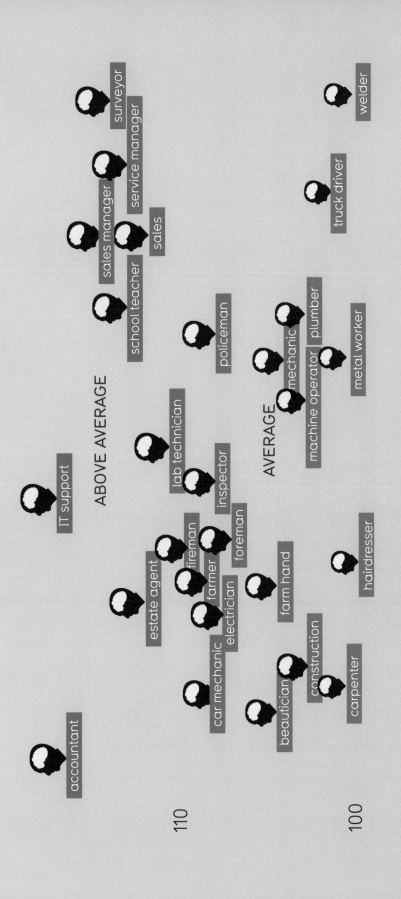

Who Clever are You?
Average IQs of different callings

source: University of Wisconsin Henmon–Nelson IQ Distributions 1992–94 via Hauser, Robert M (2002)

The Buzz vs The Bulge
Caffeine vs Calories

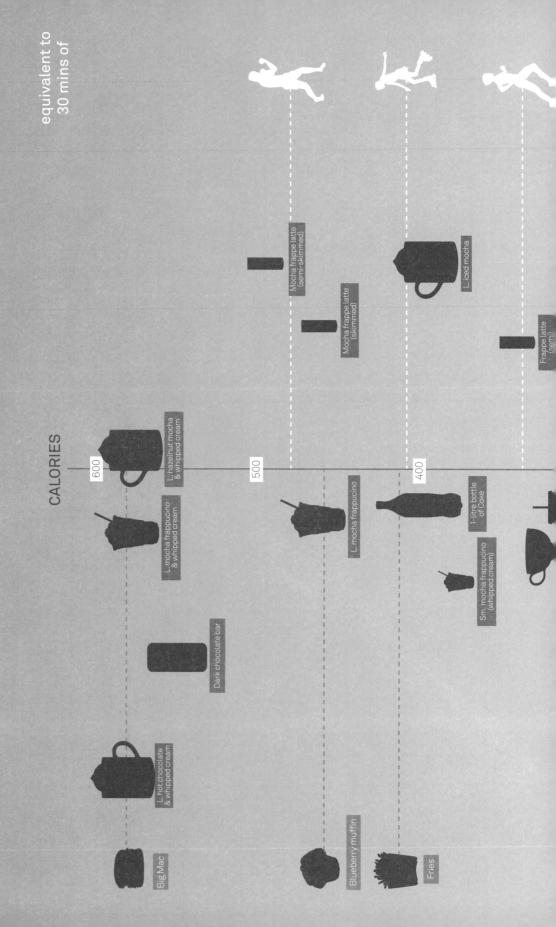

equivalent to
30 mins of

CALORIES

600

500

400

L. hazelnut mocha
& whipped cream

L. mocha frappucino
& whipped cream

Dark chocolate bar

L. hot chocolate
& whipped cream

Big Mac

L. mocha frappucino

1-litre bottle
of Coke

Sm. mocha frappucino
(whipped cream)

Blueberry muffin

Fries

Mocha frappe latte
(semi-skimmed)

Mocha frappe latte
(skimmed)

L. iced mocha

Frappe latte
(semi)

CAFFEINE

300

250

200

L. black Americano

Iced coffee

L. brewed coffee

Frappe latte (skimmed)

Sm. iced mocha

Iced latte

Brewed coffee (black)

Sm. iced coffee

L. latte

L. cappucino

300

L. cappucino (skimmed milk)

2x pain killers

150

100

L. McCoke

Energy drink

200

Sm. mocha frappucino

Coffee ice cream

Double espresso

Instant coffee

CALORIES

0

Sm. latte

Sm. chai tea latte

Dr. Pepper

Sm. black Americano

Tea & milk

Black tea

100

Coke

Green tea

Espresso

Sm. hot chocolate (whipped cream)

Strip of dark chocolate

Decaf coffee

50

CAFFEINE (in miligrams)

0

Butter croissant

Glass of wine

Source: Guardian Data Store, Starbucks.co.uk, Calorie-Counter.com

	MORNING				AFTERNOON			
ATKINS	omelette			tomato	salmon			salad
LOW G.I.	porridge		skim milk	oj	carrot & barley soup			
WEIGHT WATCHERS	porridge & raisins			brown sugar	small burger		salad	apple
ZONE	grapes	rye toast	fruit	peanut butter				
CABBAGE SOUP	fruit				cabbage soup			
DETOX	oats		yoghurt	fruit	tzatziki		veg crudités	
JUICE DIET	carrot & apple				carrot & veg juice			
CALORIE COUNTING	4 tbsp branflakes		skim milk	apple	mozzarella, tomato & avocado salad			french bread
MEDITERRANEAN	toast	yoghurt	blueberries	almonds	chickpea salad			
WEIGHT GAIN	6 x cream cheese bagels		yoghurt	oj	pitta bread	tuna	lentil soup	apple juice
SUNLIGHT	sunlight				sunlight			
SCARSDALE	grapefruit		toast	black coffee	assorted cold cuts		stewed tomatoes	

EVENING				SNACKAGE		WATER
grilled chicken		veg		chocolate shake	granola bar	x 8
wholewheat pasta bake				yoghurt	raspberries	x 8
tuna steak	olive sauce	assorted veg	french bread	fat-free yoghurt		x 8
grapes	rye bread	olive oil	peanut butter			x 8
cabbage soup				fruit		x 8
potato & bean casserole				yoghurt	fruit	x 8
veg juice						x 8
roast pork				hummus	crudités	x 8
spinach frittata				hummus	crisp bread	x 8
spaghetti	salami	bread	milk	bread & jam	ice cream	x 8
vitamin D				oxygen		x 8
shellfish	salad	veg		hummus		x 8

Calories In
Average load

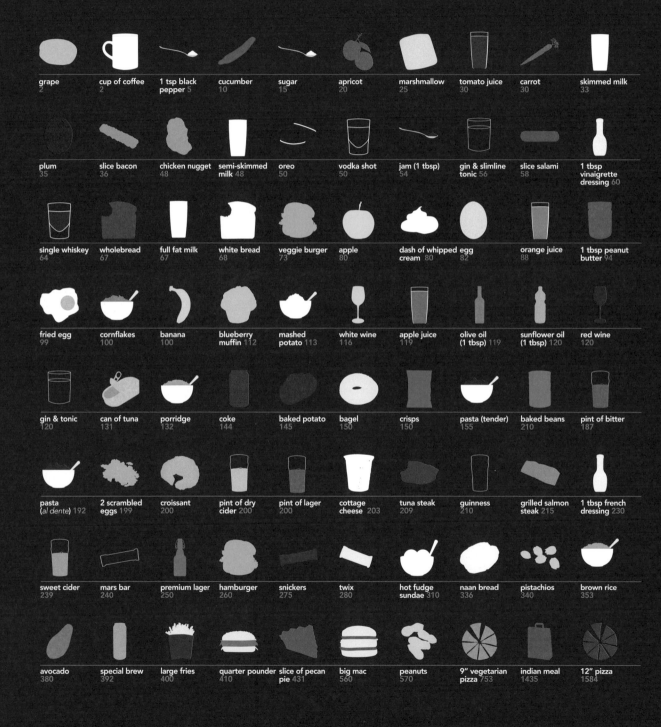

grape 2	cup of coffee 2	1 tsp black pepper 5	cucumber 10	sugar 15	apricot 20	marshmallow 25	tomato juice 30	carrot 30	skimmed milk 33
plum 35	slice bacon 36	chicken nugget 48	semi-skimmed milk 48	oreo 50	vodka shot 50	jam (1 tbsp) 54	gin & slimline tonic 56	slice salami 58	1 tbsp vinaigrette dressing 60
single whiskey 64	wholebread 67	full fat milk 67	white bread 68	veggie burger 73	apple 80	dash of whipped cream 80	egg 82	orange juice 88	1 tbsp peanut butter 94
fried egg 99	cornflakes 100	banana 100	blueberry muffin 112	mashed potato 113	white wine 116	apple juice 119	olive oil (1 tbsp) 119	sunflower oil (1 tbsp) 120	red wine 120
gin & tonic 120	can of tuna 131	porridge 132	coke 144	baked potato 145	bagel 150	crisps 150	pasta (tender) 155	baked beans 210	pint of bitter 187
pasta (al dente) 192	2 scrambled eggs 199	croissant 200	pint of dry cider 200	pint of lager 200	cottage cheese 203	tuna steak 209	guinness 210	grilled salmon steak 215	1 tbsp french dressing 230
sweet cider 239	mars bar 240	premium lager 250	hamburger 260	snickers 275	twix 280	hot fudge sundae 310	naan bread 336	pistachios 340	brown rice 353
avocado 380	special brew 392	large fries 400	quarter pounder 410	slice of pecan pie 431	big mac 560	peanuts 570	9" vegetarian pizza 753	indian meal 1435	12" pizza 1584

Calories Out
Average burn for 30 minutes of...

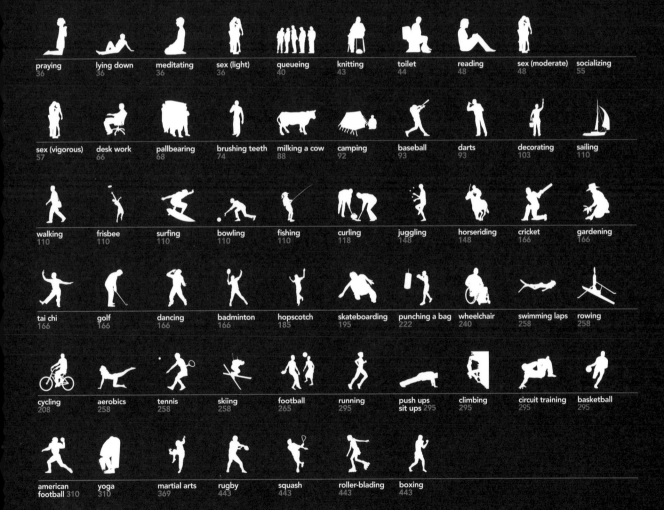

praying 36	lying down 36	meditating 36	sex (light) 36
queueing 40	knitting 43	toilet 44	reading 48
sex (moderate) 48	socializing 55		

sex (vigorous) 57 · desk work 66 · pallbearing 68 · brushing teeth 74 · milking a cow 88 · camping 92 · baseball 93 · darts 93 · decorating 103 · sailing 110

walking 110 · frisbee 110 · surfing 110 · bowling 110 · fishing 110 · curling 118 · juggling 148 · horseriding 148 · cricket 166 · gardening 166

tai chi 166 · golf 166 · dancing 166 · badminton 166 · hopscotch 185 · skateboarding 195 · punching a bag 222 · wheelchair 240 · swimming laps 258 · rowing 258

cycling 208 · aerobics 258 · tennis 258 · skiing 258 · football 265 · running 295 · push ups sit ups 295 · climbing 295 · circuit training 295 · basketball 295

american football 310 · yoga 310 · martial arts 369 · rugby 443 · squash 443 · roller-blading 443 · boxing 443

source: cross-referenced from various dieting websites

Types of Facial Hair
A little hair says a lot about a man

Major
Al-Assad, Hafez
Syria (ruled 1971-2000)
Killed: 25,000

Traditional
Al-Bashir, Omar
Sudan (1989-)
Killed: 400,000

Painter's Brush
Kai-Shek, Chiang
China (1928-31)
Killed: 30,000

Pyramid
Franco, Francisco
Spain (1939-75)
Killed: 30,000

Freestyle
King Abdullah
Saudi Arabia (2005-)
Killed: -

Chevron
Lenin, Vladimir Ilyich
Russia (1917-24)
Killed: 30,000

Handlebar
Stalin, Joseph
Soviet Union (1924-53)
Killed: 23,000,000

Natural Full
Castro, Fidel
Cuba (1976-2008)
Killed: 30,000

Horseshoe
Habre, Hissene
Chad (1982-90)
Killed: 40,000

Toothbrush
Hitler, Adolf
Germany (1933-45)
Killed: 58,000,000

Walrus
Hussein, Saddam
Iraq (1979-2003)
Killed: 6,000,000

Zappa
Mengitsu, Haile Maiam
Ethiopa (1987-91)
Killed: 150,000

Fu Manchu
Temujin, Genghis Khan
Mongolia (1205-27)
Killed: millions

Nu Geek
McCandless
UK (1971)
Killed: 0

source: Wikipedia and general web

Exxon Valdez
oil spill

28,000 km²

Deepwater Horizon
oil spill

5,750 km²

Amazon rainforest
depletion yearly

6,400 km²

Forest loss
Indonesia yearly

5,900 km²

Arable land destroy
2010 Russian heat w

114,500 km²

Haiti earthquake
2010

13,000 km²

Chile earthquake
2010

300,000 km²

New Zealand earthquake
2011

5,800 km²

Japan ear
2011

140,000 km²

earthquake areas experiencing at least "strong" shaking

Scale of Devastation
Square kilometres

Thailand floods 2011

60,000 km²

by
e

Wildfires during 2010
Russian heat wave
8,800 km^2

United Kingdom surface area
242,000 km^2

Chernobyl
exclusion zone
1,300 km^2

uake

Pakistan floods 2010
114,500 km^2

Australia floods 2010
850,000 km^2

Sources: USGS, ScienceDirect, Wikipedia

Amphibian Extinction Rates
Canaries in a coal mine?

Normal rate
1x

200x

Chrytid fungus

Habitat Loss

UV-Radiation

Insecticides

In the 1930s, the
African clawed frog
was popular as a
pregnancy test.
Doctors would inject
a female frog with a
woman's urine. If
the frog laid any
eggs, the woman
was pregnant. Alas
the frog was also an
immune carrier of
the deadly chytrid
fungus. Escaped
frogs gradually
spread the fungus
around the world.

Even a tiny amount
of malathion, the
most common
insecticide in the
US, can lead to a
devastating chain
reaction that
destroys bottom-
dwelling algae, the
primary food of
tadpoles. Malathion,
together with the
pesticide Atrazine,
are considered key
factors in the loss of
entire populations
of amphibians.

Today
25,400x

SPECIES TODAY

◯	Gone	122
◯	Going	427
◖	At risk	2503
◖	Still here	3497

source: National Academy of Sciences, Discovery.com

Motive

Searches for the phrase "we broke up because..."

he couldn't keep his hands to himself • "we're at different stages in our lives" • she was cheating with women • he wanted to experience the whole college thing • he said he needed space • he's a complete idiot with I don't clip my toenails enough I was cheating on him so he made-out with the guy I was cheating on him with • of Drugs • of Def Jam • of her partying ways • his parents don't like me • his girlfriend got suspicious • her husband needs oral sex • I didn't love her • i too much control him • of all of the time he spent on his attempts to break into film-making • we had different life goals • of religious reasons – he refused to worship me • of my drinking – I binge drink • he has a small pee-pee and wouldn't buy me any jewellery • I smothered her • we didn't have anything in common and everything was completely physical • of parental disapproval • he pressured me into having sex she just realized I'm a better friend • I have a high-pitched voice! I wasn't comfortable telling her who I really am • we fell out of love • he couldn't keep his hands to himself • he is traumatized by his former relationship and can't reach his feelings for anything or anyone. • We, well, my family has money • i moved. i want him back more than i can say • I basically caught him in bed with one of his co-workers • he liked another guy. Yes, a guy • he was short and kind of looked like a giant mole that stood upright • of one of those arguments • she was way too hurt by my lack of effort to call her • I "bug" him • I was overprotective? • he lied too much & went crazy & punched a hole in the wall • he made out with my friend • i realized me being insecure due to the hurtful past experiences, was not going to enable us to take our he doesn't have "love" for me relationship to the next level • he said i wasnt treating him right. and i wasnt • of time and dist. • I was a complete arsehole to her • of this election • i asked "are we ok?" caused she seemed a little weird lately and she said next time you ask that again we are thru • we fought a lot and several red flags kept showing up • I felt that he deserved better than me. • I needed help. I have abandonment, insecurity, and anxiety issues • she wants to find herself as an individual • she likes to deal with her problems alone and not to really share them • he thinks his career won't match up to mine • I realized that I had been gradually developing strong feelings for one of her close friends • He belonged to a different religion and wanted me to convert • not because I got somebody pregnant • she hurt me on Valentines night • we love each other? • we had never been with anyone else and we felt it was too serious for our age of artistic differences We Were On A Break And I Started To Treat Him Bad i lied about my age • I can't make him stay with me • He's in love with his mother • I'm "immature" & like to party too much...... ummm hello I'm twenty-one!!!! • I couldn't have a tree • she didn't want to change her FB status • of the stock market • I'm passive • I wouldn't submit to his views on what a wife should be • we couldn't agree on a sex position together • he only saw me as a weekend fling • he has a fatal flaw, as caring, romantic, and intuitive as he is, he has a horrid temper... • I felt that he wasn't present in the relationship. I felt alone while seeing him • he was gay • I feel that I hurt her too much and I feel she deserves better • i told simple lies (small lies that i didnt have to tell) • im too "clingy" • he cheated on me twice and he told people I was crazy It was a year ago • I was jealous that he swiped her ass with her credit card, and not mine • she was too flirty • she just realized I'm a better friend. • he always ignored me and got mad over any little thing. He was extremely jealous • he messed around with my worse enemy • the sex was bad • his fear of commitment?!? • he is not financially stable • I am dangerous • no reason

source: searches for "we broke up because..." on Facebook, Twitter & Google. Apologies for heterosexual bias

Timing

Most common break-up times, according to Facebook status updates

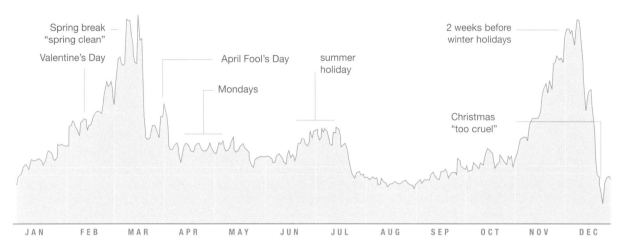

Spring break "spring clean"

Valentine's Day

April Fool's Day

Mondays

summer holiday

2 weeks before winter holidays

Christmas "too cruel"

JAN FEB MAR APR MAY JUN JUL AUG SEP OCT NOV DEC

source: Facebook lexicon

Delivery

Most common methods of break-up

Those born before 1975

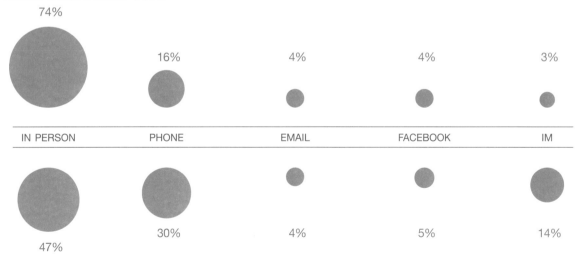

74%

16%

4%

4%

3%

| IN PERSON | PHONE | EMAIL | FACEBOOK | IM |

47%

30%

4%

5%

14%

Those born after 1984

source: survey of 10,000 Twitter users

Good News
It's all we could find. Sorry.

Booming trees & plants

6.2%

Thanks to climate change. source: NASA 2006

National smoking bans

27

source: Wikipedia

Smokers quitting

4%

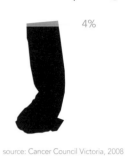

source: Cancer Council Victoria, 2008

Russian health spending

+200%

source: WHO 2006

The Good of Bush
Stuff that improved under Dubya

Artificial limb research funds

$7.2m

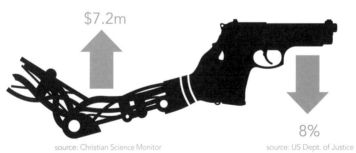

source: Christian Science Monitor

Violent crime

8%

source: US Dept. of Justice

Painkiller sales

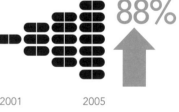

88%

2001 2005

source: Pharmatimes

Roads in Afghanistan

2793 km
1999

Mobile phones & cancer

SAFE

source: 20-year 420,000-person Danish study

CFC usage

96%

1986 2006

source: NASA

Gender pay gap

20%
2001

16%
2007

source: OECD

Shark attacks

2000

79

2007 62

source: University of Florida

Leaded fuel

2001

1% 2006

source: UN

Patients getting free anti-viral drugs in Africa

50,000 2001

1,300,000 2004

source: Independent newspaper

Education budget

29%

Racial gaps in results

20%

source: US Dept. of Education

12350 km
2008

source: USAID

Immortality

Biographies of the famously long-lived examined for clues to longevity

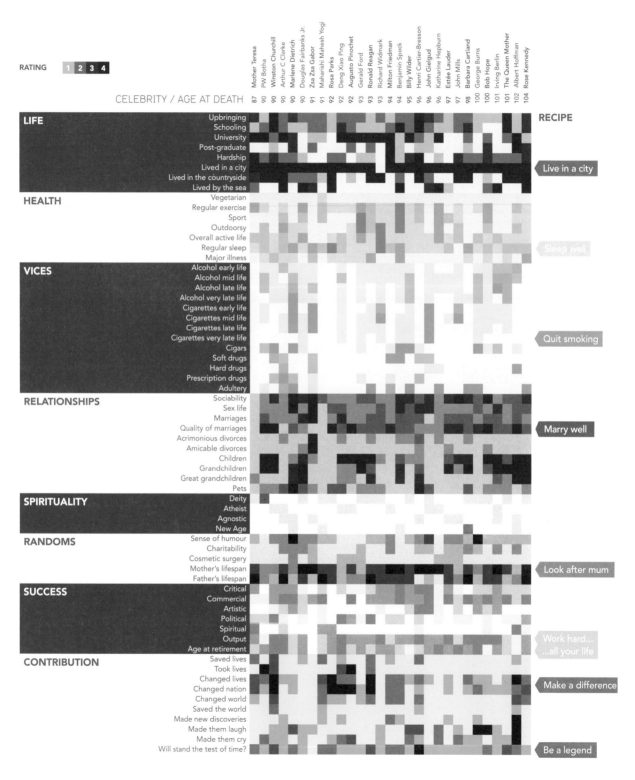

RATING 1 2 3 4

source: Wikipedia

War Chests

Who has the biggest military budget per year?

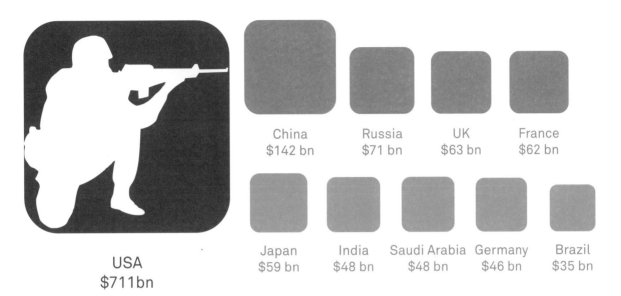

USA
$711bn

China
$142 bn

Russia
$71 bn

UK
$63 bn

France
$62 bn

Japan
$59 bn

India
$48 bn

Saudi Arabia
$48 bn

Germany
$46 bn

Brazil
$35 bn

War Chests II

Who has the biggest military budget as a % of GDP?

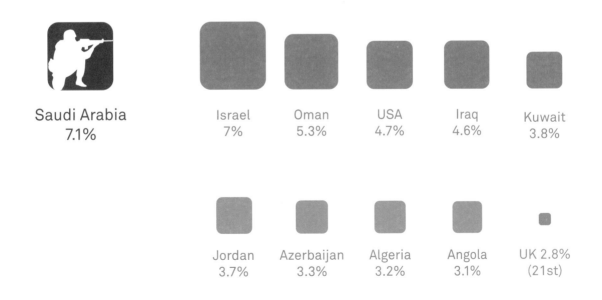

Saudi Arabia
7.1%

Israel
7%

Oman
5.3%

USA
4.7%

Iraq
4.6%

Kuwait
3.8%

Jordan
3.7%

Azerbaijan
3.3%

Algeria
3.2%

Angola
3.1%

UK 2.8%
(21st)

source: Stockholm International Peace Research Institute, sipri.org

2012: The End of the World?
Sceptics vs Believers

2012 BELIEVERS

We believe cataclysmic or transformative events will occur in the year 2012

Mayan archaeological, mythological, and numerological sources all point to December 21st 2012 as a momentous date in the history of humanity.

The planet and its inhabitants may undergo a positive physical or spiritual transformation. Or the date may mark the beginning of an apocalypse…

2012 SCEPTICS

We do not believe anything significant, transformative or apocalyptic will happen in the year 2012

The idea of a global event occurring in 2012 based on any interpretation of the Mayan calendar is rejected as pseudoscience by the scientific community.

It is also considered a misrepresentation of Mayan history by Mayanist scholars.

MAYAN PROPHECY?

2012

BELIEVERS

The ancient Mayans predicted the end of the world in 2012

The Mayan's longest calendar, The Long Count, lasts approximately 5,125 years (13 baktuns) and ends around December 21st 2012.
The end of the calendar signifies the end of a great cycle and the end of the world.

SCEPTICS

The Mayans did not predict the end of the world in 2012

Scholars disagree about the end date. Also different Mayan city states had different Long Counts. Some lasted 7,886 years (20 baktuns).

The end of the calendar did not mean the end of creation. Mayans celebrated the ends of cycles. Predictions were also made for events after the calendar ended.

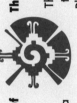

BELIEVERS

The Mayan's "Hunab Ku" symbol signifies their understanding of cosmic forces on humanity

This Hunab Ku, the name of Mayan diety, is a leading symbol of the 2012 movement. The Hunab Ku bears a resemblance to both a ying-yang symbol and a spiral galaxy. Just an amazing coincidence?

SCEPTICS

This isn't a Mayan symbol. It's Aztec and has no known association to "Hunab Ku" or the Mayans

This symbol was originally rectangular and used by the Aztecs, not the Mayans, as a ritual cloak design known as "The Mantle of Lip Plugs". It was turned into a circular symbol and associated with the Milky way by the New Age author Jose Arguelles in 1987.

THE MAYAN LONG COUNT CALENDAR

THE MAYANS COUNTED IN BASE 20 (fingers & toes) ◯ = 0 • = 1 ▬ = 5

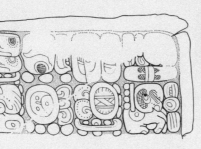

Image: S. Gronemeyer

mayan	3,200,000's	160,000's	8000's	400's	20s	1's
	●●●● ▬ ▬ *	●● ▬▬▬	●● ▬▬▬	◯	•	•
	◯	◯	◯	◯	◯	◯
	◯	◯	◯	◯	◯	
	◯	◯	◯	◯		
	◯	◯	◯	◯		

mayan						
	13 x baktuns	baktun	katun	tun	winal	kin
solar time	5125.36 years	394.3 years	19.7 years	360 days	20 days	1 day

*N.B. this final Mayan number may be incorrect

TORTUGUERO MONUMENT 6

SOME OF THE INSCRIPTION IS ILLEGIBLE

BELIEVERS

Mayan texts are full of references to 2012 (date 13.0.0.0.0 in Mayan).

Present-day Mayan elders believe that 2012 is the year of the transformational "shift".

SCEPTICS

The only reference to 2012 is carved in one single monument found in Tortuguero, Mexico. (And the long count calendar used in Tortuguero was a 7,886 year, 20 baktun, version.)

Very few modern day Mayans use the Long Count calendar. It was only recently discovered by archaeologists. "Apocalypse" is a Western concept that has little to do with Mayan belief.

CELESTIAL SIGNIFICANCE?

PRECESSION OF THE EQUINOXES

A wobble in the Earth's axis slowly traces out a cone over approximately 25,685 years. This means the constellations shift by 1 degree every 72 years. A full rotation is called a Precession.

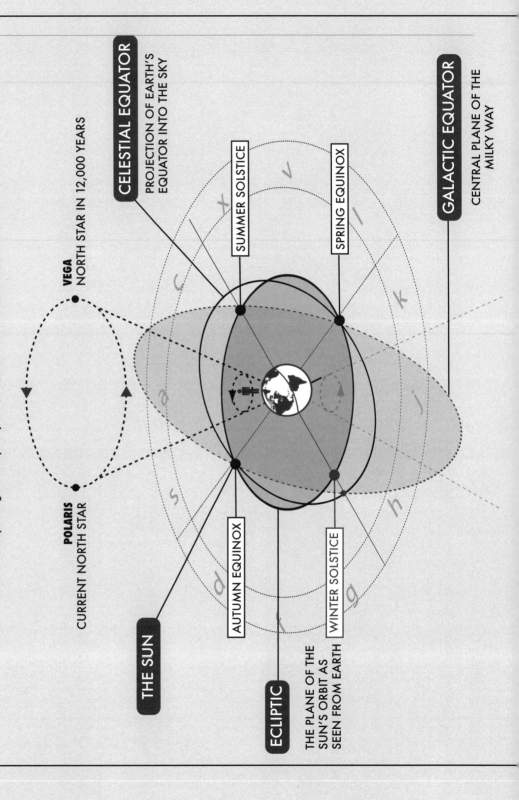

POLARIS
CURRENT NORTH STAR

VEGA
NORTH STAR IN 12,000 YEARS

CELESTIAL EQUATOR
PROJECTION OF EARTH'S
EQUATOR INTO THE SKY

SUMMER SOLSTICE

SPRING EQUINOX

AUTUMN EQUINOX

WINTER SOLSTICE

GALACTIC EQUATOR
CENTRAL PLANE OF THE
MILKY WAY

THE SUN

ECLIPTIC
THE PLANE OF THE
SUN'S ORBIT AS
SEEN FROM EARTH

BELIEVERS

December 21st 2012 is a significant celestial date

That date marks the completion of a 26,000 year celestial cycle: "The Precession of the Equinoxes"

December 21st 2012 is not massively significant

True. But such are the vast timespans involved, the "completion" actually occurs over 36 years, not a single day.

BELIEVERS

Galactic Alignment

The Winter solstice December 21st 2012 is a unique moment when the equators of the Earth, the Sun and the Milky Way all fall miraculously into alignment.

Galactic Non-Alignment

The most precise alignment already happened – in 1998

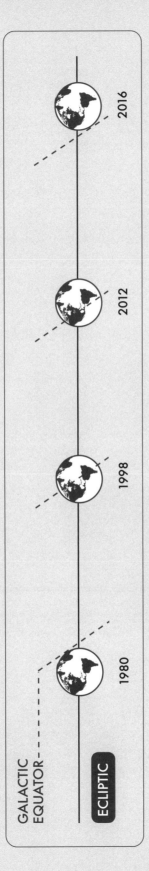

GALACTIC EQUATOR - - - -

ECLIPTIC

1980 1998 2012 2016

BELIEVERS

The Earth will pass through the Galactic plane

In 2012, the planet will physically move through the disk at the centre of the Milky Way and pass through to the other side.

The Earth is nowhere near the galactic plane

We are currently around 24 light years north of the plane. We won't cross it for around 27 million years.

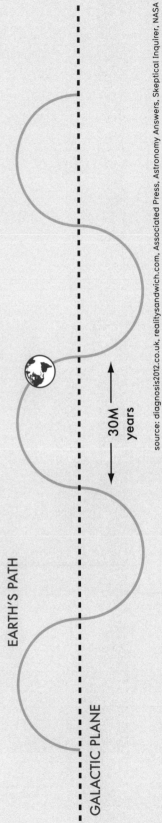

EARTH'S PATH

30M years

GALACTIC PLANE

source: diagnosis2012.co.uk, realitysandwich.com, Associated Press, Astronomy Answers, Skeptical Inquirer, NASA

Red vs Blue

Scientists have discovered that when two evenly matched teams compete, the team wearing red wins most often

American Football			American Football			Football			Football		
San Francisco 49ers	Denver Broncos		Kansas City Chiefs	Tennessee Titans/ Houston Oilers		Arsenal	Chelsea		Bayern Munich	Schalke	

Handball			Baseball			Ice Hockey			Rugby League		
Norway	France		LA Anaheim Angels	Toronto Blue Jays		Detroit Red Wings	Columbus Blue Jackets		Wigan Warriors	Leeds Rhinos	

Rugby Union			Ten Pin Bowling			Politics			Politics		
Gloucester	Bristol		USA	Europe		Republican	Democrats		Labour	Conservative	

Red

vs

Blue

win 8

draw 2

win 2

source: Hill & Barton, University of Durham, Journal of Sports Sciences [via Nature], Wikipedia

Man's Humanity to Man

Ah, that's better

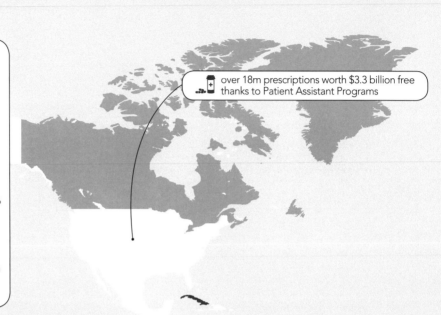

Wikipedia
$6.2m

9/11 concert
$35m

Live Aid
$283m

PHILANTHROPISTS

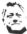 Bill Clinton supports over 31 charities.

 Warren Buffet, the US's richest man, donated $43.5bn in 2006.

 Bill Gates donates $1.5 bn yearly. He earns $2.1bn.

 George Soros gives 65% of his money to worthy causes.

 Michael Bloomberg, businessman mayor of New York, is the US's 7th biggest philanthropist.

over 18m prescriptions worth $3.3 billion free thanks to Patient Assistant Programs

● Free full education (inc. university)

● Free universal healthcare

● Both

MOST GENEROUS CELEBRITIES % of income given to charity

11%								
Oprah Winfrey	Nicolas Cage	Michael Jordan	Jerry Seinfeld	Sandra Bullock	Rush Limbaugh	Celine Dion	Paul McCartney	Steven Spielberg

MOST GENEROUS COUNTRIES % of national income given as overseas aid

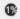 1%								
Norway	Sweden	Luxembourg	Denmark	Netherlands	Ireland	Austria	Belgium	Spain

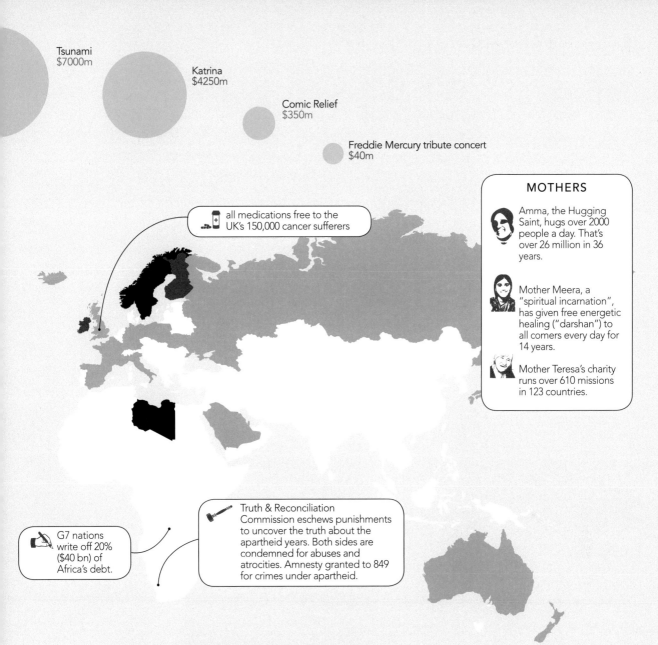

Tsunami
$7000m

Katrina
$4250m

Comic Relief
$350m

Freddie Mercury tribute concert
$40m

all medications free to the
UK's 150,000 cancer sufferers

MOTHERS

Amma, the Hugging
Saint, hugs over 2000
people a day. That's
over 26 million in 36
years.

Mother Meera, a
"spiritual incarnation",
has given free energetic
healing ("darshan") to
all comers every day for
14 years.

Mother Teresa's charity
runs over 610 missions
in 123 countries.

G7 nations
write off 20%
($40 bn) of
Africa's debt.

Truth & Reconciliation
Commission eschews punishments
to uncover the truth about the
apartheid years. Both sides are
condemned for abuses and
atrocities. Amnesty granted to 849
for crimes under apartheid.

PEOPLE POWER non-violent revolutions

● **Berlin Wall, Germany 1989** After weeks of civil unrest, the East German government
allowed its citizens to cross into West Germany. The wall was quickly dismantled.

● **Velvet Revolution, Czech Republic 1989** 500,000 took to the streets to overthrow the
communist government without a shot being fired.

● **Bulldozer Revolution, Serbia 2000** Slobodan Milosevic usurped. Named after a
bulldozer operator who charged the HQ of Serbian State Television.

● **Rose Revolution, Georgia 2003** A disputed election led to the peaceful overthrow of
president-elect Eduard Shevardnadze.

● **Orange Revolution, Ukraine 2004** Thousands protested against a presidential election
marred by fraud and corruption. Election annulled.

● **Blue Revolution, Kuwait 2005** Kuwaitis protested in support of giving women the vote. The
government gave in and women voted for the first time in 2007.

source: Wikipedia, Unicef.org, Forbes.com, Un.org

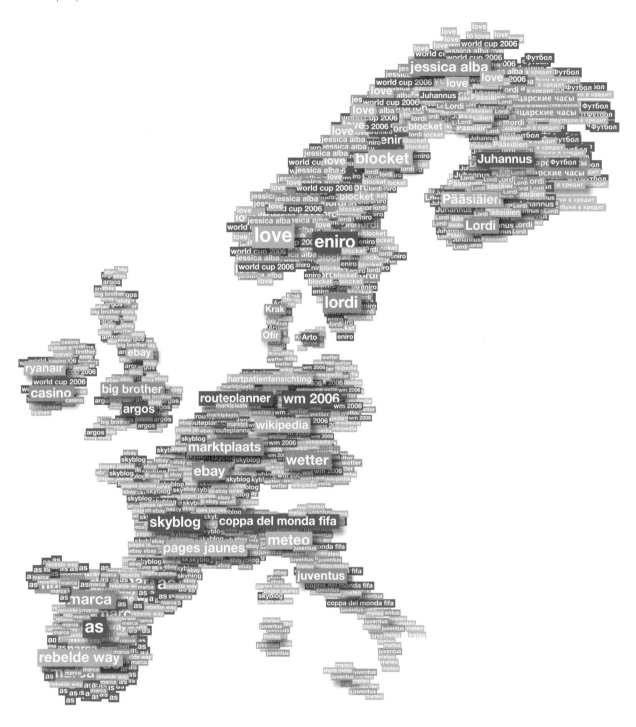

Most popular search terms 2008

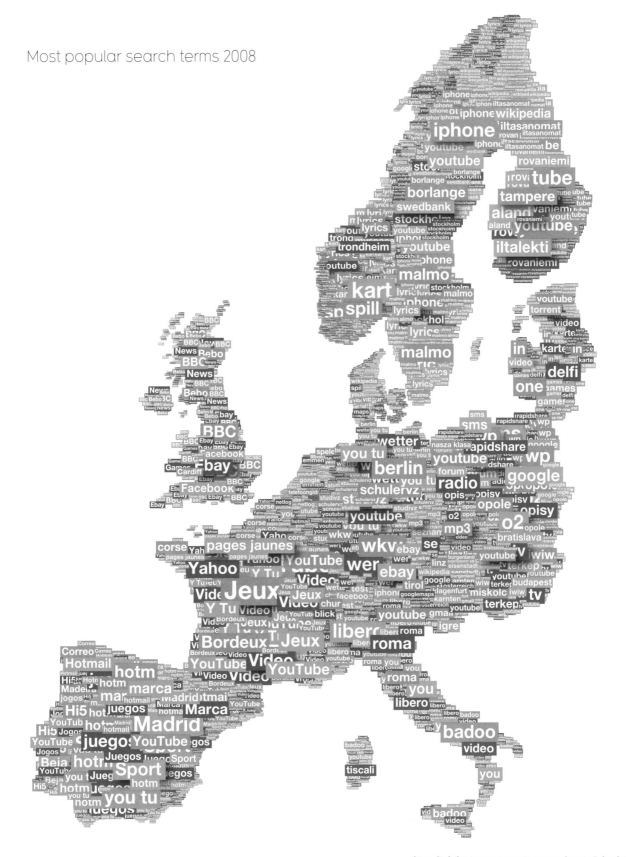

idea: Christian Lange coccu.de source: Google Zeitgeist.
Years after 2009 not plotted due to dominance of Facebook.

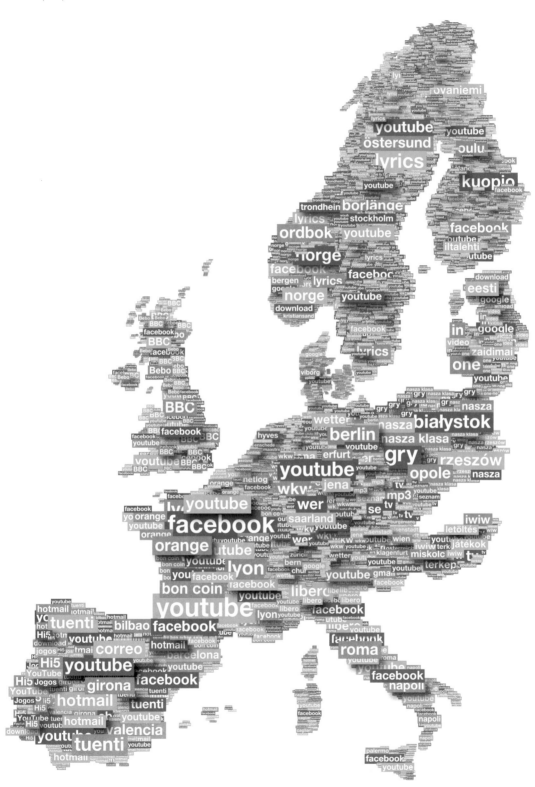

Most popular search terms 2006

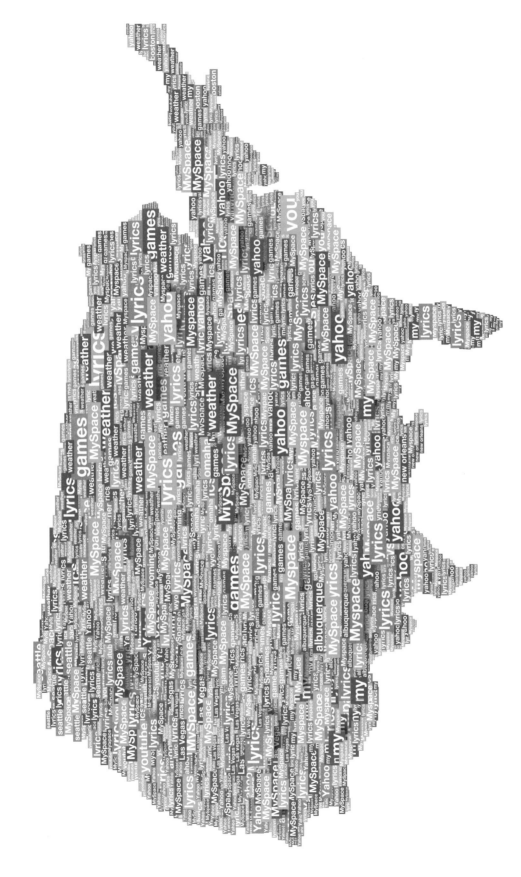

idea: Christian Lange coccu.de source: Google Zeitgeist.
Years after 2009 not plotted due to dominance of Facebook.

Simple Part II

Time to Get Away
Legally required paid annual leave in days per year

source: Centre for Economic & Policy Research, 2007

Lack of Conviction
Rape in England and Wales

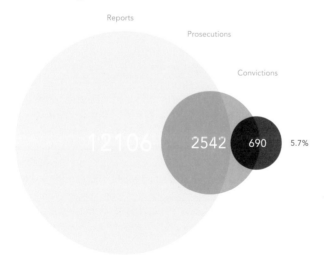

Reports

Prosecutions

Convictions

12106 2542 690 5.7%

source: UK Home Office

Trafficking
World internet bandwidth usage

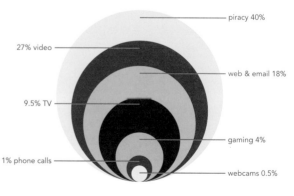

piracy 40%

27% video

web & email 18%

9.5% TV

gaming 4%

1% phone calls

webcams 0.5%

source: Cisco visual networking index

Fat Chance
Who has the most influence on your weight?

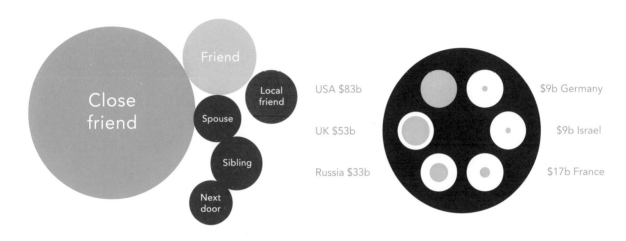

Shooting Stars
Worldwide yearly arms sales

USA $83b

UK $53b

Russia $33b

$9b Germany

$9b Israel

$17b France

source: N.Fowler, J.Christakis, N. England Journal of Medicine [via New Scientist]

source: Guardian.co.uk

Caused by Global Warming
according to media reports

CLIMATE CHANGE Alaska reshaping, oak deaths, ozone repair slowing, El Niño intensification, Gulf Stream failure, new islands, sinking islands, melting alps, mud slides, volcanic eruptions, subsidence, wildfires, earthquakes, tsunamis RANDOMS witchcraft executions, violin decline, killer cornflakes, tabasco tragedy, truffle shortage, tomato rot, fashion disasters, gingerbread house collapse, mammoth dung melt, UFO sightings, mango harvest failure ANIMALS cannibal polar bears, brain-eating amoebas, aggressive elephants, cougar attacks, stronger salmon, rampant robins, shark attacks, confused birds THE EARTH! light dimming, slowing down, spins faster, wobbling, exploding SOCIAL PROBLEMS floods of migrants, suicides, drop in brothel profits, civil unrest, increased taxes, teenage drinking, early marriages, crumbling roads, deformed railways, traffic jams FOOD soaring prices, sour grapes, shop closures, haggis threat, maple syrup shortage, rice shortage, beer shortage! THE TREES! growth increase, growth decline, more colourful, less colourful HEALTH PROBLEMS dog disease, cholera, bubonic plague, airport malaria, asthma, cataracts, smaller brains, HIV, heart disease, depression LESS moose, geese, ducks, puffins, koalas EVEN LESS krill, fish, glaciers, antarctic ice, ice sheets, avalanches, coral reef MOUNTAINS shrinking, taller, flowering, breaking up INVASIONS cat, crabgrass, wasp, beatle, midge, cockroach, stingrays, walrus, giant pythons, giant oysters, giant squid MORE HEALTH PROBLEMS salmonella, kidney stones, anxiety, childhood insomnia, frostbite, fainting, dermatitis, fever, encephalitis, declining circumcision, diarrhoea, fever, dengue, yellow, west nile, hay DISASTER! boredom, next ice age, cannibalism, societal collapse, release of ancient frozen viruses, rioting and nuclear war, computer models, terrorism, accelerated evolution, conflict with Russia, billions of deaths, the end of the world as we know it

source: UK and US media reports [via numberswatch.co.uk]

Life Times

How will you spend your 77.8 years?

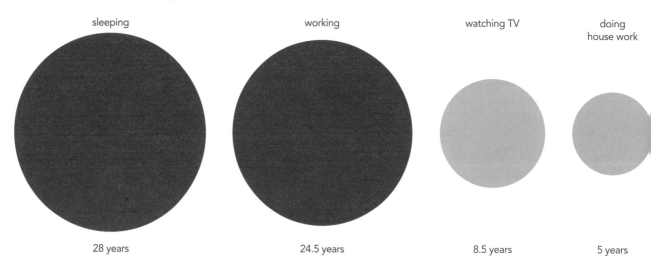

sleeping	working	watching TV	doing house work
28 years	24.5 years	8.5 years	5 years

Visible Spectrum

Current best guess for the composition of the universe Dark energy // Dark matter // Intergalactic gas // Normal matter

Invisible

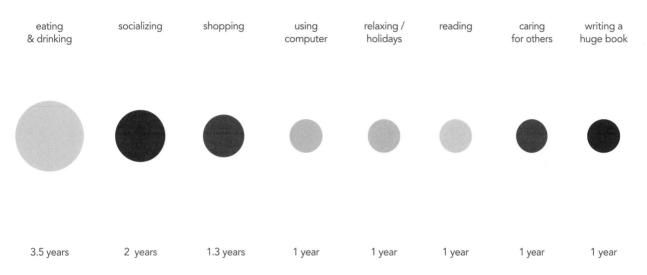

eating & drinking	socializing	shopping	using computer	relaxing / holidays	reading	caring for others	writing a huge book
3.5 years	2 years	1.3 years	1 year	1 year	1 year	1 year	1 year

source: American Bureau of Labor Statistics 2007

uns, planets, us etc)

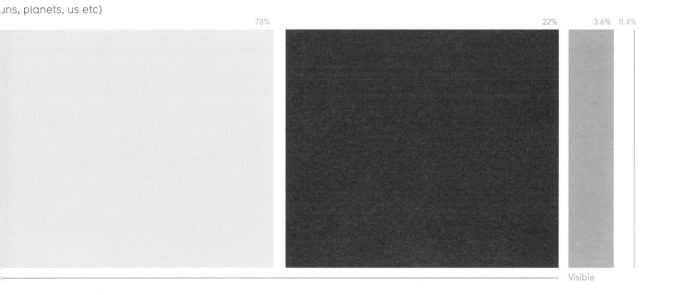

78% 22% 3.6% 0.4%

Visible

source: Wikipedia

Peters Projection
The true size of the continents

The standard "Mercator" world map inflates the size of nations depending on their distance from the equator. This means that many developing countries end up much smaller than they are in reality (i.e. most of Africa). The Peters Projection corrects this.

source: Wikipedia

Alternative Medicine
Scientific evidence for complementary therapies

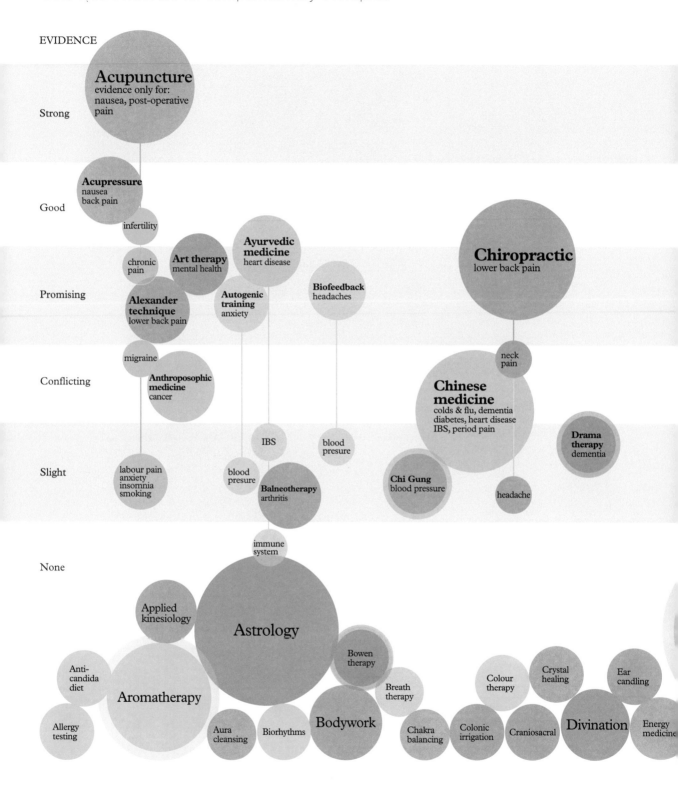

EVIDENCE

Strong

Acupuncture
evidence only for:
nausea, post-operative pain

Good

Acupressure
nausea
back pain

infertility

chronic pain

Art therapy
mental health

Ayurvedic medicine
heart disease

Biofeedback
headaches

Chiropractic
lower back pain

Promising

Alexander technique
lower back pain

Autogenic training
anxiety

migraine

neck pain

Conflicting

Anthroposophic medicine
cancer

Chinese medicine
colds & flu, dementia
diabetes, heart disease
IBS, period pain

Drama therapy
dementia

IBS

blood presure

Slight

labour pain
anxiety
insomnia
smoking

blood presure

Balneotherapy
arthritis

Chi Gung
blood pressure

headache

immune system

None

Applied kinesiology

Astrology

Bowen therapy

Breath therapy

Colour therapy

Crystal healing

Ear candling

Anti-candida diet

Aromatherapy

Bodywork

Divination

Energy medicine

Allergy testing

Aura cleansing

Biorhythms

Chakra balancing

Colonic irrigation

Craniosacral

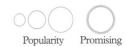

Popularity Promising

body energy expressive psyche mystical multiple natural substances

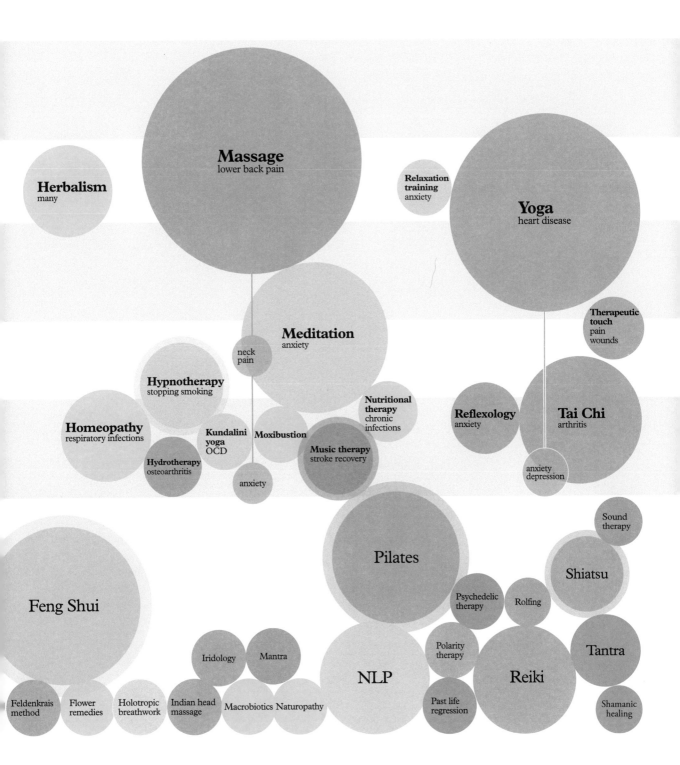

Herbalism
many

Massage
lower back pain

**Relaxation
training**
anxiety

Yoga
heart disease

Meditation
anxiety

neck
pain

**Therapeutic
touch**
pain
wounds

Hypnotherapy
stopping smoking

**Nutritional
therapy**
chronic
infections

Homeopathy
respiratory infections

**Kundalini
yoga**
OCD

Moxibustion

Reflexology
anxiety

Tai Chi
arthritis

Hydrotherapy
osteoarthritis

Music therapy
stroke recovery

anxiety

anxiety
depression

Sound
therapy

Pilates

Shiatsu

Feng Shui

Psychedelic
therapy

Rolfing

Iridology Mantra

Polarity
therapy

Tantra

NLP

Reiki

Feldenkrais
method

Flower
remedies

Holotropic
breathwork

Indian head
massage

Macrobiotics Naturopathy

Past life
regression

Shamanic
healing

source: Cochrane.org and other English-language meta-studies (via Pubmed.org)

Radiation Dosage

Risk of harm is dependent on both the **dose** and the **dose rate** (the time the body is exposed to that dose).

So a dose of 1,000 mSv over an hour is considerably more damaging than a dose of 1,000 mSv over a year.

Exposure Time

Dose	Instant	Hours	One Day	One Year
0.1 µSv	Airport security scan (backscatter X-ray) Eating a banana			
0.25	Airport security scan maximum permitted			
1.0				Using a cathode-ray computer monitor for a year
5.0	Dental X-ray			
7.5			Per day in Tokyo, 250km SW of Fukushima plant (+107 days after the disaster, 28 June 2011)	
10			Background dose received by an average person on an average day (varies wildly)	
40			Flight from New York to LA	
70				Living in a stone, brick or concrete building for a year
80				Average total dose per person within 10 miles of the Three Mile Island Accident (1979)
100	Chest X-ray	One hour dose 3km SW of Fukushima plant (+83 days after the disaster, 3 June 2011)		
250				Release limit for a nuclear power plant for a year
400				Yearly dose per person from food
1,000				

microsieverts (µSv)

US government yearly limit on artificial radiation exposure to a member of the public

Spinal X-ray Radiation per hour detected at Fukushima site (+1 day after the disaster)

1000 µSv
1,000 µSv = 1.0 millisieverts (1 mSv)
1.0 mSv

Average dose of natural background radiation per person per year (varies wildly)

Mammogram

Dose from spending one hour on the ground at Chernobyl in 2010

Average CT scan

Smoking 1.5 packs a day for a year

Maximum yearly dose permitted for US radiation workers

Lowest annual dose where increased lifetime risk of cancer is evident

Dose limit for US radiation workers in life-saving operations

Maximum radiation levels detected at Fukushima per hour

Slight decrease in blood-cell counts returning to normal in a few days

Highly targeted dose used in conventional radiotherapy (per single dose)

Temporary radiation sickness. Nausea, low blood-cell count. Not fatal. Per hour in surface water in tunnels outside Fukushima No.2 reactor (+17 days after the disaster, 28 March 2011)

Extremely severe dose – bleeding, hair loss – death possible within 4–6 weeks, especially if untreated.

Usually fatal within 2–4 weeks if untreated

Fatal dose, death within 2 weeks.

Seizures & tremors. Death within 48 hours.

10 mins exposure to the Chernobyl reactor core after meltdown

Dose values
2,000
2,400
4,000
6,000
10,000
36,000
50,000
100,000
250,000
400,000
500,000
1,000,000
2,000,000
4,000,000
6,000,000
10,000,000
30,000,000
50,000,000

10 mSv

100 mSv

1000 mSv

10,000 mSv

Exposure Time

Instant Hours One Day One Year

Dose

source: EPA, BBC, Guardian Datablog

Being Defensive
How psychotherapy sees you

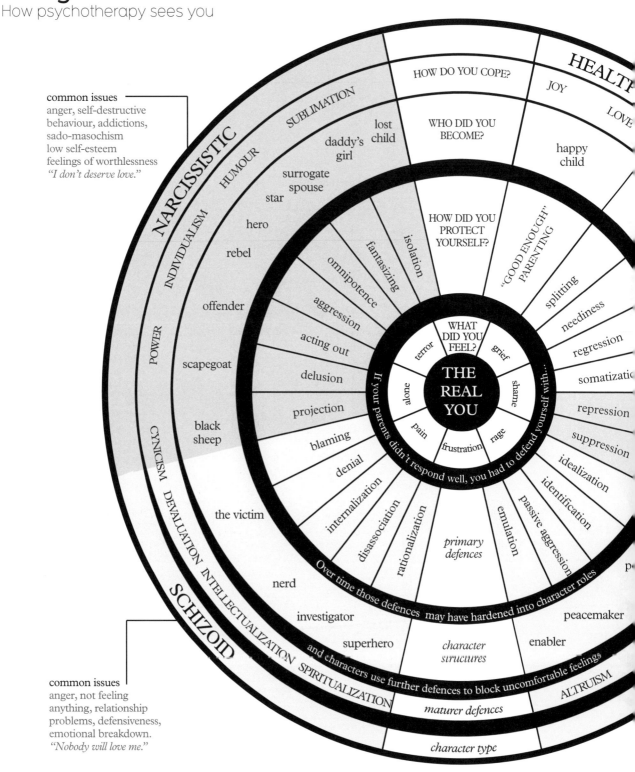

common issues
anger, self-destructive
behaviour, addictions,
sado-masochism
low self-esteem
feelings of worthlessness
"I don't deserve love."

common issues
anger, not feeling
anything, relationship
problems, defensiveness,
emotional breakdown.
"Nobody will love me."

NARCISSISTIC

SUBLIMATION

HUMOUR

INDIVIDUALISM

POWER

CYNICISM DEVALUATION INTELLECTUALIZATION SPIRITUALIZATION

SCHIZOID

lost
child

daddy's
girl

surrogate
spouse

star

hero

rebel

offender

scapegoat

black
sheep

the victim

nerd

investigator

superhero

HOW DO YOU COPE?

WHO DID YOU
BECOME?

HOW DID YOU
PROTECT
YOURSELF?

HEALTH

JOY

LOVE

happy
child

"GOOD ENOUGH"
PARENTING

splitting

neediness

regression

somatization

repression

suppression

idealization

identification

passive aggression

emulation

*primary
defences*

peacemaker

enabler

ALTRUISM

*character
structures*

maturer defences

character type

isolation

fantasizing

omnipotence

aggression

acting out

delusion

projection

blaming

denial

internalization

disassociation

rationalization

WHAT
DID YOU
FEEL?

**THE
REAL
YOU**

terror

grief

alone

shame

pain

rage

frustration

If your parents didn't respond well, you had to defend yourself with...

Over time those defences may have hardened into character roles

and characters use further defences to block uncomfortable feelings

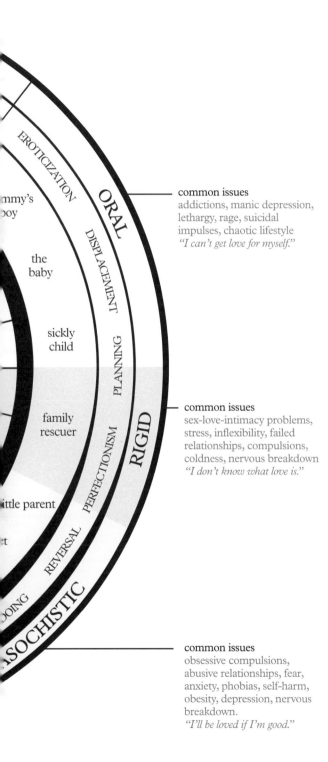

common issues
addictions, manic depression,
lethargy, rage, suicidal
impulses, chaotic lifestyle
"I can't get love for myself."

common issues
sex-love-intimacy problems,
stress, inflexibility, failed
relationships, compulsions,
coldness, nervous breakdown
"I don't know what love is."

common issues
obsessive compulsions,
abusive relationships, fear,
anxiety, phobias, self-harm,
obesity, depression, nervous
breakdown.
"I'll be loved if I'm good."

PRIMARY DEFENCES

acting out
turn it into behaviour

aggression
attacking

blaming
someone else's fault

delusion
lie to yourself & believe it

denial
it's not happening

disassociation
go numb

distortion
changing the story to fit

emulation
copy what you know

fantasizing
go into other worlds

idealization
over-regard for others

identification
forge an alliance

internalization
holding it all in

isolation
separate off feelings

neediness
over-dependence on another

omnipotence
all powerful, no weakness

passive aggression
indirect & concealed attacks

projection
put your feelings on someone

regression
revert back to immaturity

rationalization
a false but plausible excuse

repression
unconsciously burying it

somatization
turn it into a physical illness

splitting
good/bad, love/hatred

suppression
consciously burying it

MATURER DEFENCES

altruism
efface it with good deeds

cynicism
everything is false

devaluation
it doesn't matter

displacement
find a teddy bear

eroticization
safety in sex

humour
deflect with jokes

individualism
celebrate it

intellectualization
turn it into safe concepts

perfectionism
never slip up again

planning
safety in organization

power
control everyone

reversal
do the opposite of how you feel

spiritualization
it's all a divine purpose

sublimation
make art out of it

undoing
constant acts of compensation

source: the work of Freud, Heinz Kohut, John Bradshaw and A.H. Almaas

Being Defensive
How psychotherapy works

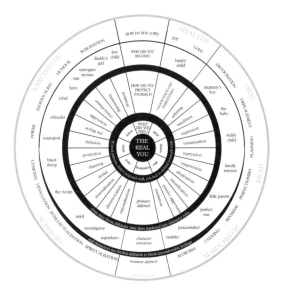

You slowly build a relationship of trust and intimacy with the therapist. That allows you to investigate, explore and ultimately learn to drop your outer defences without feeling threatened.

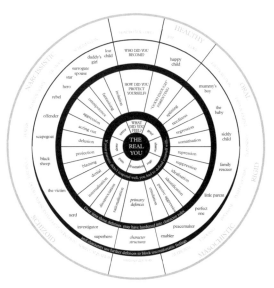

Exploring your life history, you re-experience situations and relationships from childhood in slow motion with the therapist. This way you can bring adult awareness and understanding to those experiences.

Some types of therapy and their target areas

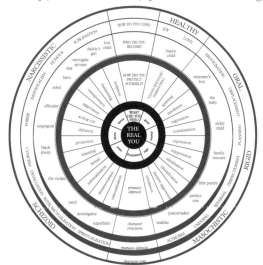

PSYCHOANALYSIS Explores the connection between (possibly "forgotten") events in early life and current disturbances and stress. Talking freely allows fantasies, feelings, dreams and memories to emerge more easily.

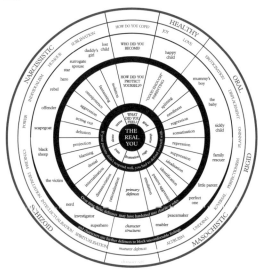

COGNITIVE-BEHAVIOURAL THERAPY Uncovering and understanding how inaccurate thoughts, beliefs and assumptions can lead to inaccurate interpretations of events and so to negative emotions and behaviours.

As those experiences are re-felt, digested, understood and perhaps resolved, the difficult and unbearable feelings you weren't able to feel at the time can also be felt. Deeper blocks and resistances may be revealed.

As those feelings are repeatedly felt, you learn to understand, tolerate and deal with them. The "real you", underneath all the defences, can be felt. Nothing really changes. All your defences are still there. You just feel less blocked and become more "transparent".

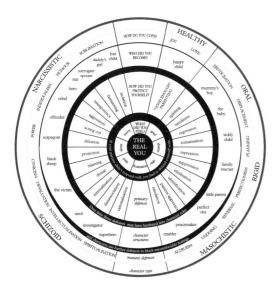

ANTI-DEPRESSANTS Reducing the intensity of symptoms of depression and anxiety and other symptoms of psychological disturbance and distress through regular use of psychiatric medicine.

source: Wikipedia, psychotherapy.org.uk

Most Popular US Girls' Names

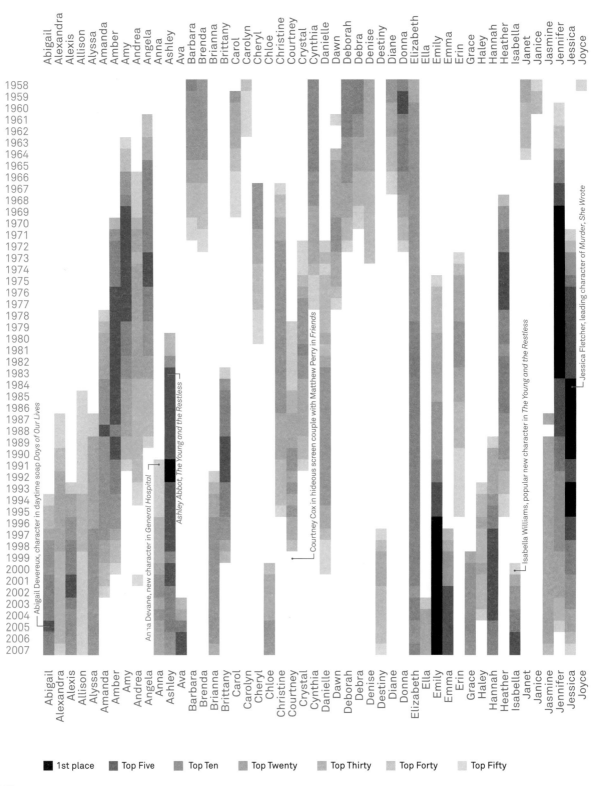

Abigail Devereux, character in daytime soap *Days of Our Lives*

An'na Devane, new character in *General Hospital*

Ashley Abbot, *The Young and the Restless*

Courtney Cox in hideous screen couple with Matthew Perry in *Friends*

Isabella Williams, popular new character in *The Young and the Restless*

Jessica Fletcher, leading character of *Murder, She Wrote*

Columns (left to right): Abigail, Alexandra, Alexis, Allison, Alyssa, Amanda, Amber, Amy, Andrea, Angela, Anna, Ashley, Ava, Barbara, Brenda, Brianna, Brittany, Carol, Carolyn, Cheryl, Chloe, Christine, Courtney, Crystal, Cynthia, Danielle, Dawn, Deborah, Debra, Denise, Destiny, Diane, Donna, Elizabeth, Ella, Emily, Emma, Erin, Grace, Haley, Hannah, Heather, Isabella, Janet, Janice, Jasmine, Jennifer, Jessica, Joyce

Rows (years): 1958–2007

■ 1st place	■ Top Five	■ Top Ten	Top Twenty	Top Thirty	Top Forty	Top Fifty

212 | 213

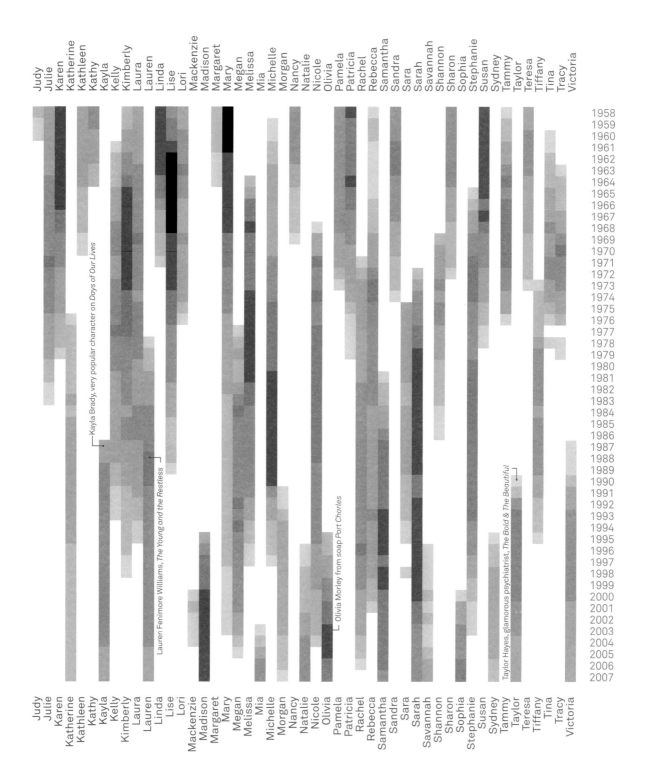

Judy Julie Karen Katherine Kathleen Kathy Kayla Kelly Kimberly Laura Lauren Linda Lise Lori Mackenzie Madison Margaret Mary Megan Melissa Mia Michelle Morgan Nancy Natalie Nicole Olivia Pamela Patricia Rachel Rebecca Samantha Sandra Sara Sarah Savannah Shannon Sharon Sophia Stephanie Susan Sydney Tammy Taylor Teresa Tiffany Tina Tracy Victoria

1958 1959 1960 1961 1962 1963 1964 1965 1966 1967 1968 1969 1970 1971 1972 1973 1974 1975 1976 1977 1978 1979 1980 1981 1982 1983 1984 1985 1986 1987 1988 1989 1990 1991 1992 1993 1994 1995 1996 1997 1998 1999 2000 2001 2002 2003 2004 2005 2006 2007

Kayla Brady, very popular character on *Days of Our Lives*

Lauren Fenimore Williams, *The Young and the Restless*

Olivia Morley from soap *Port Charles*

Taylor Hayes, glamorous psychiatrist, *The Bold & The Beautiful*

source: US Social Security Administration @ ssa.gov

Most Popular US Boys' Names

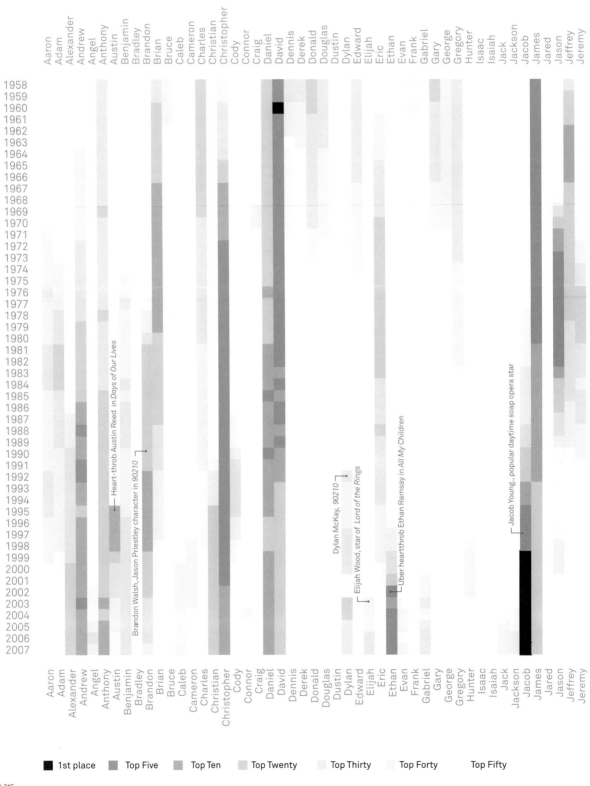

Heart-throb Austin Reed in *Days of Our Lives*

Brandon Walsh, Jason Priestley character in *90210*

Dylan McKay, *90210*

Elijah Wood, star of *Lord of the Rings*

Uber heartthrob Ethan Ramsay in *All My Children*

Jacob Young, popular daytime soap opera star

■ 1st place　　■ Top Five　　■ Top Ten　　■ Top Twenty　　Top Thirty　　Top Forty　　Top Fifty

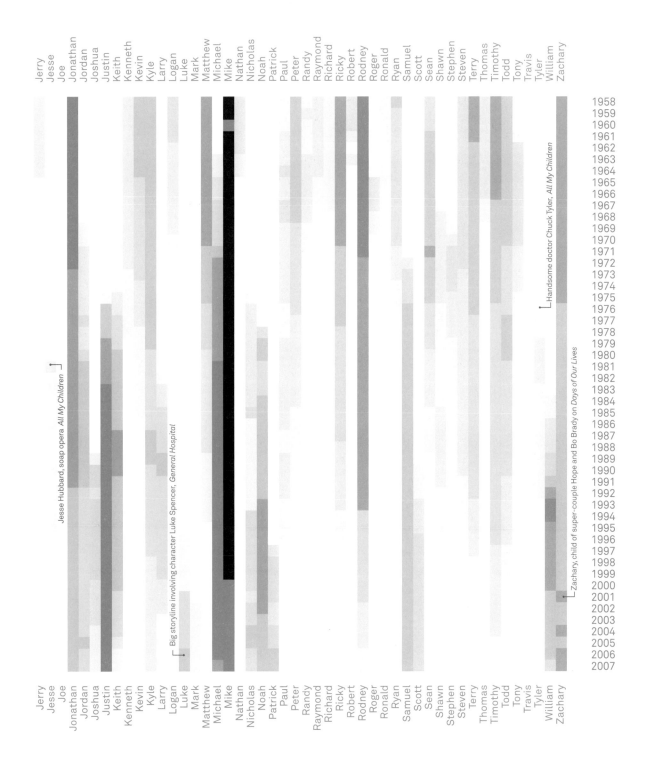

Jerry Jesse Joe Jonathan Jordan Joshua Justin Keith Kenneth Kevin Kyle Larry Logan Luke Mark Matthew Michael Mike Nathan Nicholas Noah Patrick Paul Peter Randy Raymond Richard Ricky Robert Rodney Roger Ronald Ryan Samuel Scott Sean Shawn Stephen Steven Terry Thomas Timothy Todd Tony Travis Tyler William Zachary

1958 1959 1960 1961 1962 1963 1964 1965 1966 1967 1968 1969 1970 1971 1972 1973 1974 1975 1976 1977 1978 1979 1980 1981 1982 1983 1984 1985 1986 1987 1988 1989 1990 1991 1992 1993 1994 1995 1996 1997 1998 1999 2000 2001 2002 2003 2004 2005 2006 2007

Jesse Hubbard, soap opera *All My Children*

Big storyline involving character Luke Spencer, *General Hospital*

Handsome doctor Chuck Tyler, *All My Children*

Zachary, child of super-couple Hope and Bo Brady on *Days of Our Lives*

source: US Social Security Administration @ ssa.gov

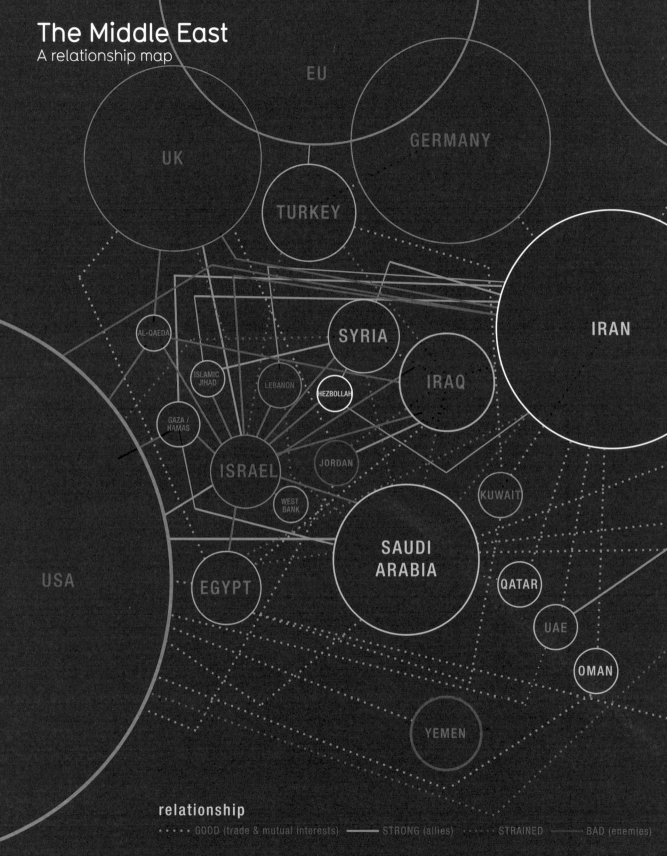

The Middle East
A relationship map

EU

UK

GERMANY

TURKEY

AL-QAEDA

ISLAMIC
JIHAD

SYRIA

LEBANON

HEZBOLLAH

IRAQ

IRAN

GAZA /
HAMAS

ISRAEL

JORDAN

KUWAIT

WEST
BANK

USA

EGYPT

SAUDI
ARABIA

QATAR

UAE

OMAN

YEMEN

relationship

•••••• GOOD (trade & mutual interests) ———— STRONG (allies) •••••• STRAINED ———— BAD (enemies)

RUSSIA

CHINA

PAKISTAN

INDIA

majority religions

○ SHIA ○ SUNNI ○ WAHHABI
(form of Sunni Islam) ○ OTHER RELIGION OR MIXED

source: Orgnet.com, New York Times

The Middle East: Some Context
Palestinian territories

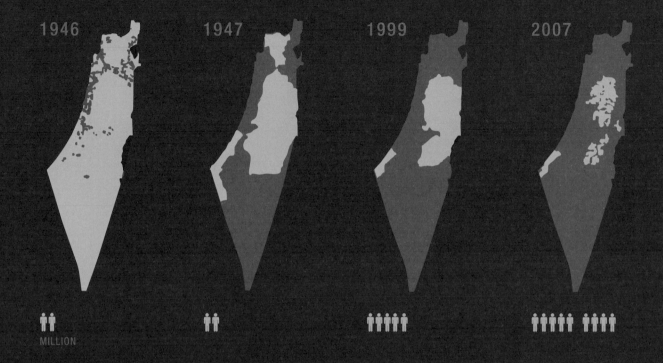

1946 1947 1999 2007

MILLION

Oil States
Who has the world's oil?

Oil States
Who'll have the world's oil?

2009 2020

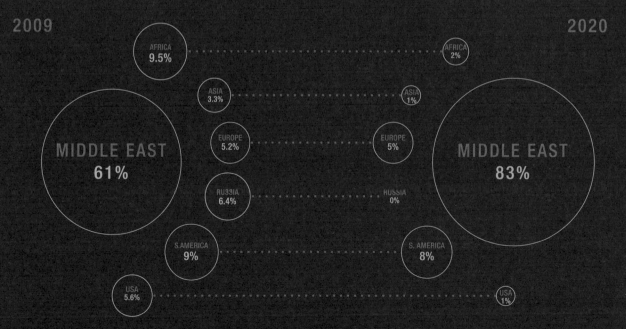

AFRICA 9.5% ····· AFRICA 2%

ASIA 3.3% ····· ASIA 1%

MIDDLE EAST 61% EUROPE 5.2% ····· EUROPE 5% MIDDLE EAST 83%

RUSSIA 6.4% ····· RUSSIA 0%

S.AMERICA 9% ····· S. AMERICA 8%

USA 5.6% ····· USA 1%

source: BP Statistical Review of the Year 2008, Wikipedia

The Future of Energy
Place your bets

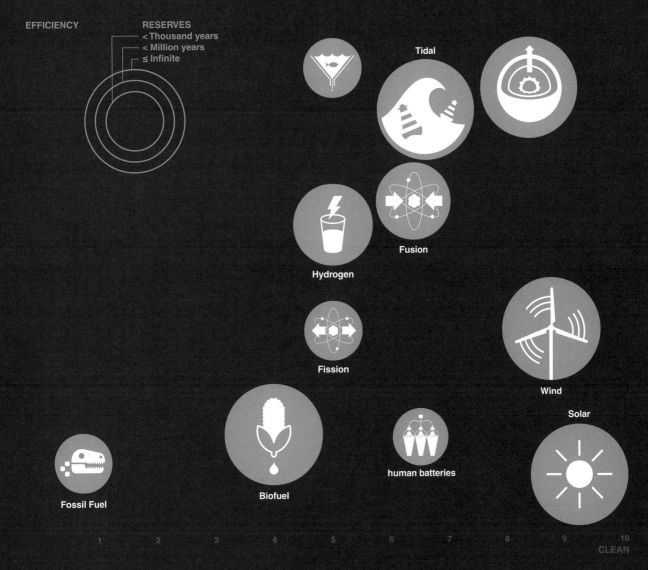

EFFICIENCY

RESERVES
< Thousand years
< Million years
≤ Infinite

Tidal

Hydrogen

Fusion

Fission

Wind

Solar

Fossil Fuel

Biofuel

human batteries

1 2 3 4 5 6 7 8 9 10
CLEAN

Biofuel – To replace all of America's petrol consumption with bio-fuel from plants would take three-quarters of all the cultivated land on the face of the Earth.

Fossil Fuel – By products: sulphur dioxide, carbon monoxide, methane, poisonous metals like lead, uranium and, of course, CO_2.

Geothermal – Drilling for free heat under the earth's surface has lots of advantages and is pollution-free. Iceland gets 20% of its energy this way. But watch out for earthquakes!

Human Batteries – The energy in the food needed to feed human power sources is greater than the energy generated. D'oh!

Hydroelectric – There's an unavoidable built-in limit to dams. There are only so many places you can put them. And space is running out...

Hydrogen – Currently 96% of hydrogen is made using fossil fuels.

Nuclear Fission – To meet the world's electricity needs from nuclear power would require 2230 more nuclear power stations. There are currently 439 in operation. They can take 5–10 years to build.

Nuclear Fusion – Recreates the temperatures at the heart of the sun. Generates much less nuclear waste than fission. But no one can work out how to do it. "At least 50 years away".

Solar – To replace all current electricity production in the US with solar power would take an area of approximately 3500 square miles (3% of Arizona's land area) covered in solar panels. In most areas of the world, solar panels would cover 85% of household water heating needs.

Tidal – Several question marks remain. Mostly related to its impact on environment and biodiversity.

Wind – Turbines covering about 0.5% of all US land would power the entire country. Around 73,000 to 144,000 5-megawatt wind turbines could power electric cars for every single American.

source: Wikipedia, USGS

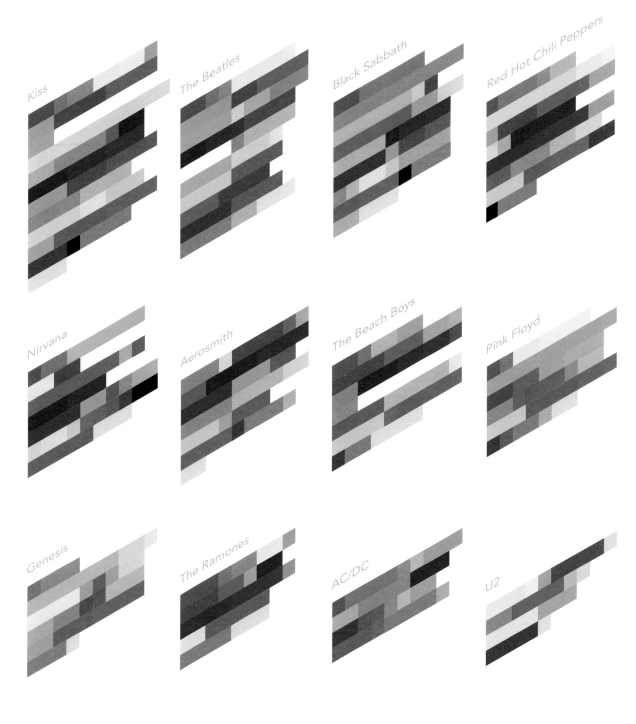

Kiss

The Beatles

Black Sabbath

Red Hot Chili Peppers

Nirvana

Aerosmith

The Beach Boys

Pink Floyd

Genesis

The Ramones

AC/DC

U2

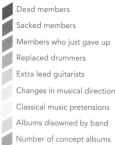

Dead members
Sacked members
Members who just gave up
Replaced drummers
Extra lead guitarists
Changes in musical direction
Classical music pretensions
Albums disowned by band
Number of concept albums

Most Successful Rock Bands
True rock success got nothin' to do with selling records

Metallica

The Rolling Stones

Fleetwood Mac

Led Zeppelin

Deep Purple

The Doors

The Who

Oasis

Status Quo

The Smiths

REM

Radiohead

Sex/drugs in album titles
Longest time to finish album
Offshoot groups
Solo albums
Disbanded and reformed
Severe musical differences
Largest single audience
Onstage breakdowns
Likelihood of cancelling gigs

Visits to rehab
Alcoholic members
Heavy drug-using members
Hotel room trashings
Own-vomit chokings
Religious/occult dabblings
God complex rating
Groupies
Divorces

Sexual tension in band
Supermodel relationships
Record company disputes
Court cases
Hits critically panned
Flops critically acclaimed
Sheer ardency of fans
Number of mansions
Number of islands

Number of estates
Glib political statements
Disastrous TV appearances
Feature films made
Tribute bands
Riffs heard in guitar shops
'"Greatest Hits" albums

source: Wikipedia

22 Stories
P=The Protagonist

Fish out of Water P tries to cope in a completely different place/time/world.
Mr Bean, Trading Places

Discovery Through a major upheaval, P discovers a truth about themselves and a better understanding of life.
Close Encounters, Ben-Hur

Escape P trapped by antagonistic forces and must escape. Pronto.
Poseidon Adventure, Saw

Journey & Return P goes on a physical journey and returns changed.
Wizard of Oz, Star Wars

Temptation P has to make a moral choice between right and wrong.
The Godfather, The Sting

Rags to Riches P is poor, then rich.
Trading Places, La Vie en rose

The Riddle P has to solve a puzzle or a crime.
The Da Vinci Code, Chinatown

Metamorphosis P literally changes into something else (i.e. a werewolf, hulk, giant cockroach).
Spiderman, Pinocchio

Rescue P must save someone who is trapped physically or emotionally.
The Golden Compass, Die Hard

Tragedy P is brought down by a fatal flaw in their character or by forces out of their control.
One Flew Over the Cuckoo's Nest, Atonement

Love A couple meet and overcome obstacles to discover true love. Or – tragically – don't.
Titanic, Grease

Monster Force A monster / alien / something scary and supernatural must be fought and overcome.
Jaws, The Exorcist

Revenge P retaliates against another for a real or imagined injury.
Batman, Kill Bill

Transformation P lives through a series of events that change them as a person.
Pretty Woman, Muriel's Wedding

Maturation P has an experience that matures them or starts a new stage of life, often adulthood.
The Graduate, Juno

Pursuit P has to chase somebody or something, usually in a hide-and-seek fashion.
Goldfinger, Bourne Ultimatum

Rivalry P must triumph over an adversary to attain an object or goal.
Rocky, The Outsiders

Underdog Total loser faces overwhelming odds but wins in the end.
Slumdog Millionaire, Forrest Gump

Comedy A series of complications leads P into ridiculous situations.
Ghostbusters, Airplane

Quest P searches for a person, place or thing, overcoming a number of challenges.
Raiders of the Lost Ark, Lord of the Rings

Sacrifice P must make a difficult choice between pleasing themselves or a higher purpose (e.g. love, honour).
300, 3:10 to Yuma

Wretched Excess P pushes the limits of acceptable behaviour, destroying themselves in the process.
There Will Be Blood, Citizen Kane

source: Tennesse Screenwriting Association, Robert McKee's *Story*

Most Profitable Hollywood Stories 2007

Average profitability: 301% Average quality: 51% Most common stories: ● Love ● Pursuit

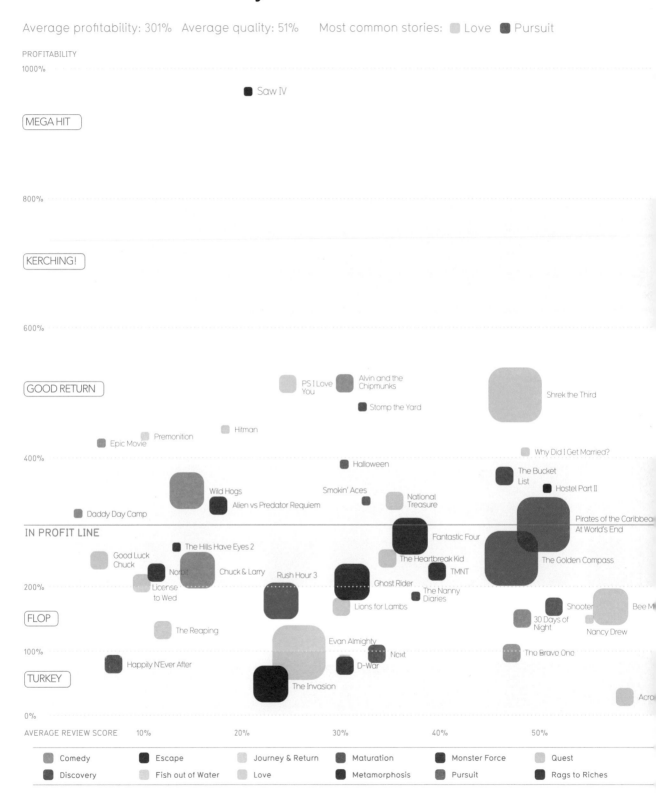

PROFITABILITY

1000%

● Saw IV

MEGA HIT

800%

KERCHING!

600%

GOOD RETURN

PS I Love You Alvin and the Chipmunks

Stomp the Yard

Shrek the Third

Premonition Hitman

Epic Movie

Why Did I Get Married?

400%

Halloween

Wild Hogs Smokin' Aces The Bucket List

Alien vs Predator Requiem National Treasure Hostel Part II

Daddy Day Camp

Pirates of the Caribbean At World's End

IN PROFIT LINE

The Hills Have Eyes 2 Fantastic Four

Good Luck Chuck The Heartbreak Kid The Golden Compass

Norbit Chuck & Larry Rush Hour 3 TMNT

200%

License to Wed Ghost Rider The Nanny Diaries Shooter Bee M

Lions for Lambs 30 Days of Night Nancy Drew

FLOP

The Reaping

100%

Evan Almighty Next The Brave One

Happily N'Ever After D-War

TURKEY

The Invasion Acro

0%

AVERAGE REVIEW SCORE 10% 20% 30% 40% 50%

● Comedy ● Escape ● Journey & Return ● Maturation ● Monster Force ● Quest
● Discovery ● Fish out of Water ● Love ● Metamorphosis ● Pursuit ● Rags to Riches

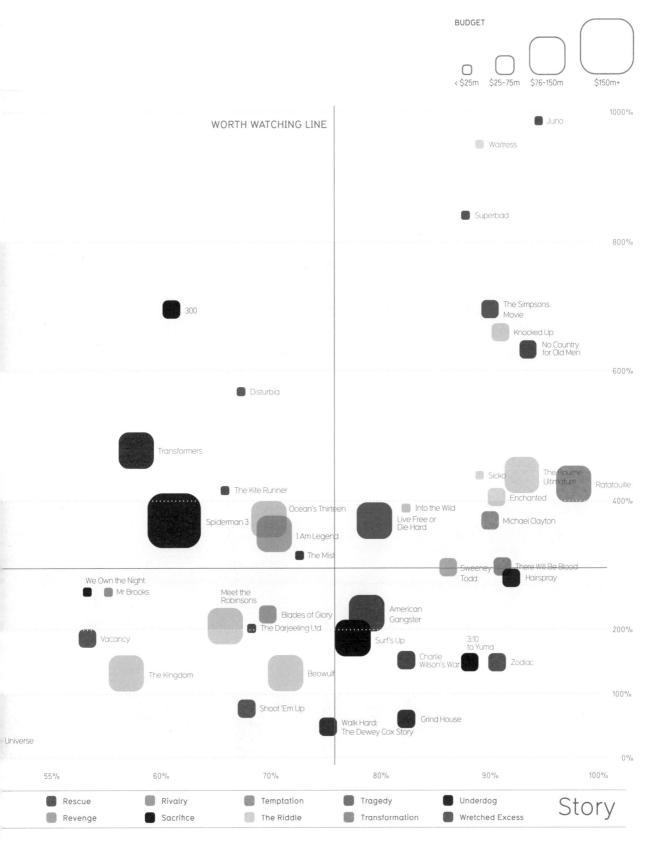

BUDGET

< $25m $25-75m $76-150m $150m+

WORTH WATCHING LINE

1000%

Juno

Waitress

Superbad

800%

The Simpsons Movie

Knocked Up

No Country for Old Men

600%

300

Disturbia

Transformers

Sicko The Bourne Ultimatum Ratatouille

The Kite Runner

Enchanted

Ocean's Thirteen Into the Wild 400%

Spiderman 3 I Am Legend Live Free or Die Hard Michael Clayton

The Mist

Sweeney Todd There Will Be Blood

Hairspray

We Own the Night

Mr Brooks

Meet the Robinsons

Blades of Glory American Gangster

The Darjeeling Ltd

Vacancy 200% Surf's Up 3:10 to Yuma

The Kingdom Beowulf Charlie Wilson's War Zodiac

100%

Shoot 'Em Up Walk Hard: The Dewey Cox Story Grind House

Universe

0%

55% 60% 70% 80% 90% 100%

Rescue Rivalry Temptation Tragedy Underdog

Revenge Sacrifice The Riddle Transformation Wretched Excess

Story

source: BoxOfficeMojo.com, The-Numbers.com, Wikipedia, IMDB.com & RottenTomatoes.com. Note: reported film budgets are notoriously unreliable (especially for flops)

Most Profitable Hollywood Stories 2008

Average profitability: 278% Average quality: 46% Most common stories: ▇ Love ■ Discovery

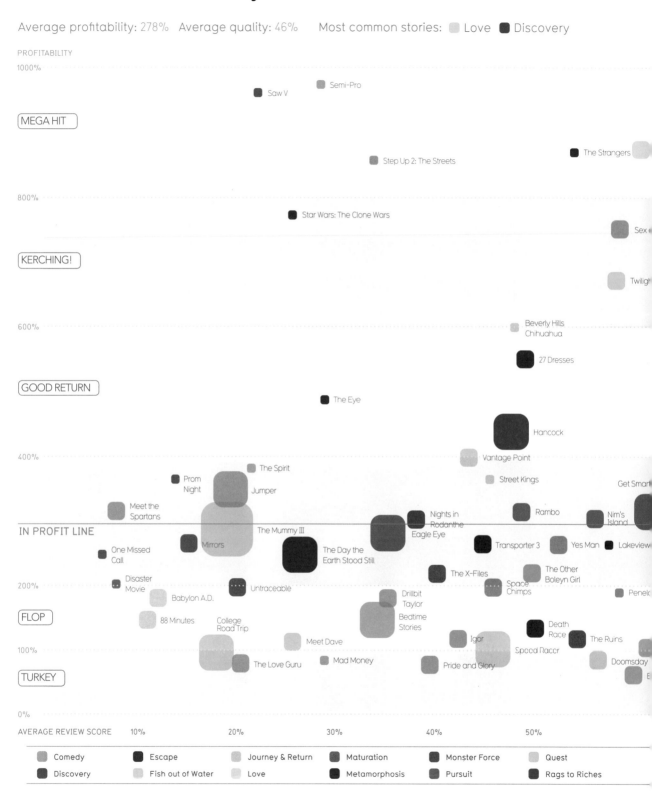

PROFITABILITY

1000%

Saw V Semi-Pro

MEGA HIT

The Strangers

Step Up 2: The Streets

800%

Star Wars: The Clone Wars

KERCHING!

Sex

Twilight

600% Beverly Hills
Chihuahua

27 Dresses

GOOD RETURN

The Eye

Hancock

400% Vantage Point

Street Kings Get Smart

The Spirit

Prom Jumper
Night

Nights in Rambo Nim's
Rodanthe Island

Meet the
Spartans

IN PROFIT LINE The Mummy III Eagle Eye

One Missed Mirrors The Day the Transporter 3 Yes Man Lakeview
Call Earth Stood Still

Disaster Untraceable The X-Files Space The Other
Movie Chimps Boleyn Girl

200% Babylon A.D. Penel

FLOP Drillbit
Taylor

88 Minutes College Bedtime Death The Ruins
Road Trip Stories Race

Meet Dave Igor Speed Racer Doomsday

100%

The Love Guru Mad Money Pride and Glory E

TURKEY

0%

AVERAGE REVIEW SCORE 10% 20% 30% 40% 50%

▇ Comedy ■ Escape ▇ Journey & Return ■ Maturation ■ Monster Force ▇ Quest

■ Discovery ▇ Fish out of Water ▇ Love ■ Metamorphosis ■ Pursuit ■ Rags to Riches

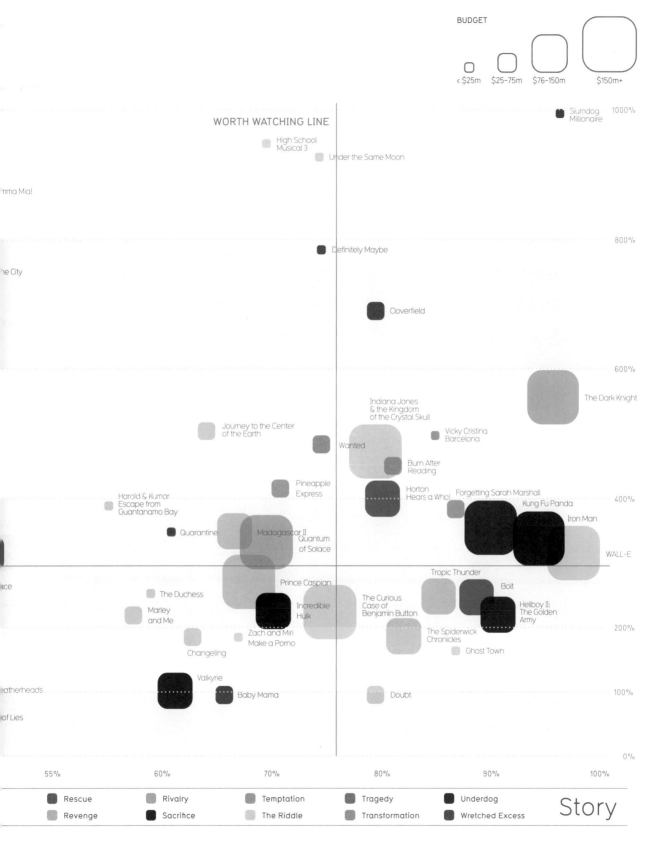

BUDGET

< $25m $25-75m $76-150m $150m+

WORTH WATCHING LINE

1000%
Slumdog
Millionaire

High School
Musical 3

Under the Same Moon

mma Mia!

800%
Definitely Maybe

he City

Cloverfield

600%

The Dark Knight

Indiana Jones
& the Kingdom
of the Crystal Skull

Journey to the Center
of the Earth

Vicky Cristina
Barcelona

Wanted

Burn After
Reading

Pineapple
Express

Horton
Hears a Who! Forgetting Sarah Marshall

400%

Harold & Kumar
Escape from
Guantanamo Bay

Kung Fu Panda

Iron Man

Quarantine Madagascar II

Quantum
of Solace

WALL-E

ace

Tropic Thunder

Prince Caspian

The Duchess

Bolt

Incredible
Hulk

The Curious
Case of
Benjamin Button

Hellboy II:
The Golden
Army

Marley
and Me

Zach and Miri
Make a Porno

The Spiderwick
Chronicles

200%

Changeling

Ghost Town

Valkyrie

eatherheads

Baby Mama

Doubt

100%

of Lies

0%

55% 60% 70% 80% 90% 100%

| Rescue | Rivalry | Temptation | Tragedy | Underdog | Story |
| Revenge | Sacrifice | The Riddle | Transformation | Wretched Excess | |

source: BoxOfficeMojo.com, The-Numbers.com, Wikipedia, IMDB.com & RottenTomatoes.com. Note: reported film budgets are notoriously unreliable
(especially for flops)

Most Profitable Hollywood Stories 2009

Average profitability: 308% Average quality: 47% Most common stories: ◼ Quest ◼ Comedy

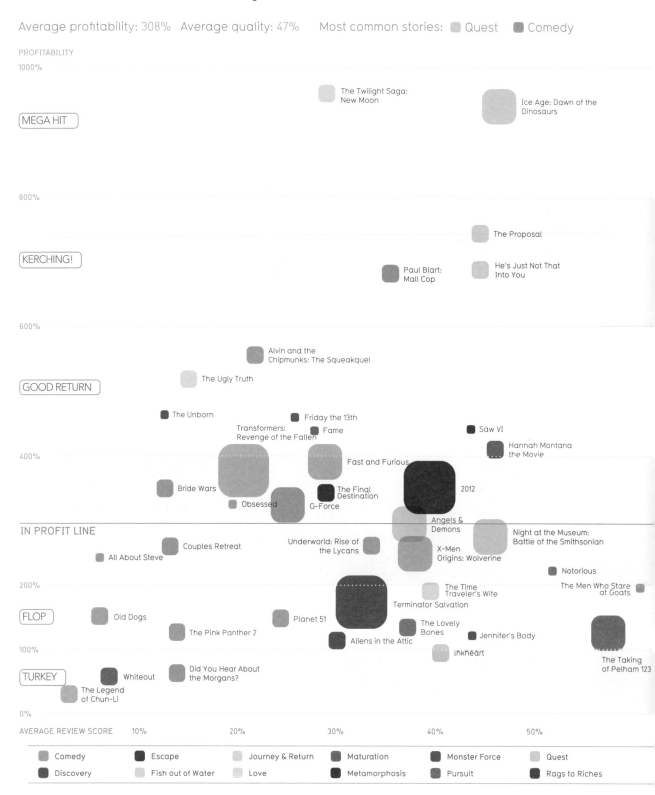

PROFITABILITY

1000%

MEGA HIT

The Twilight Saga: New Moon

Ice Age: Dawn of the Dinosaurs

800%

KERCHING!

The Proposal

Paul Blart: Mall Cop

He's Just Not That Into You

600%

GOOD RETURN

Alvin and the Chipmunks: The Squeakquel

The Ugly Truth

The Unborn

Friday the 13th

Transformers: Revenge of the Fallen

Fame

Saw VI

Hannah Montana the Movie

400%

Fast and Furious

Bride Wars

The Final Destination

2012

Obsessed

G-Force

IN PROFIT LINE

Angels & Demons

Night at the Museum: Battle of the Smithsonian

Couples Retreat

Underworld: Rise of the Lycans

X-Men Origins: Wolverine

All About Steve

Notorious

200%

The Time Traveler's Wife

The Men Who Stare at Goats

FLOP

Terminator Salvation

Old Dogs

Planet 51

The Lovely Bones

Jennifer's Body

The Pink Panther 2

Aliens in the Attic

Inkheart

100%

The Taking of Pelham 123

TURKEY

Did You Hear About the Morgans?

Whiteout

The Legend of Chun-Li

0%

AVERAGE REVIEW SCORE 10% 20% 30% 40% 50%

◼ Comedy ◼ Escape ◼ Journey & Return ◼ Maturation ◼ Monster Force ◼ Quest
◼ Discovery ◼ Fish out of Water ◼ Love ◼ Metamorphosis ◼ Pursuit ◼ Rags to Riches

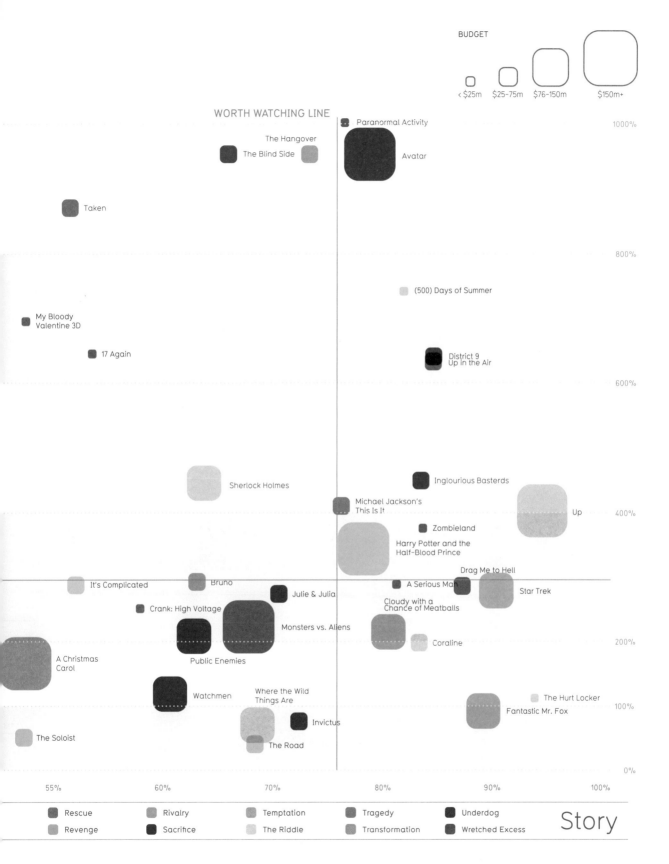

BUDGET

< $25m $25-75m $76-150m $150m+

WORTH WATCHING LINE

1000%

Paranormal Activity

The Hangover

The Blind Side Avatar

Taken

800%

(500) Days of Summer

My Bloody
Valentine 3D

17 Again District 9
 Up in the Air

600%

Sherlock Holmes Inglourious Basterds

Michael Jackson's
This Is It Up 400%

Zombieland

Harry Potter and the
Half-Blood Prince

Drag Me to Hell

It's Complicated Bruno A Serious Man Star Trek

Julie & Julia

Crank: High Voltage Cloudy with a
 Chance of Meatballs

Monsters vs. Aliens Coraline

200%

A Christmas
Carol Public Enemies

Watchmen Where the Wild
 Things Are The Hurt Locker

Fantastic Mr. Fox 100%

Invictus

The Soloist The Road

0%

55% 60% 70% 80% 90% 100%

Rescue Rivalry Temptation Tragedy Underdog

Revenge Sacrifice The Riddle Transformation Wretched Excess

Story

source: BoxOfficeMojo.com, The-Numbers.com, Wikipedia, IMDB.com & RottenTomatoes.com. Note: reported film budgets are notoriously unreliable
(especially for flops)

Most Profitable Hollywood Stories 2010

Average profitability: 277% Average quality: 49% Most common stories: ■ Love ■ Comedy

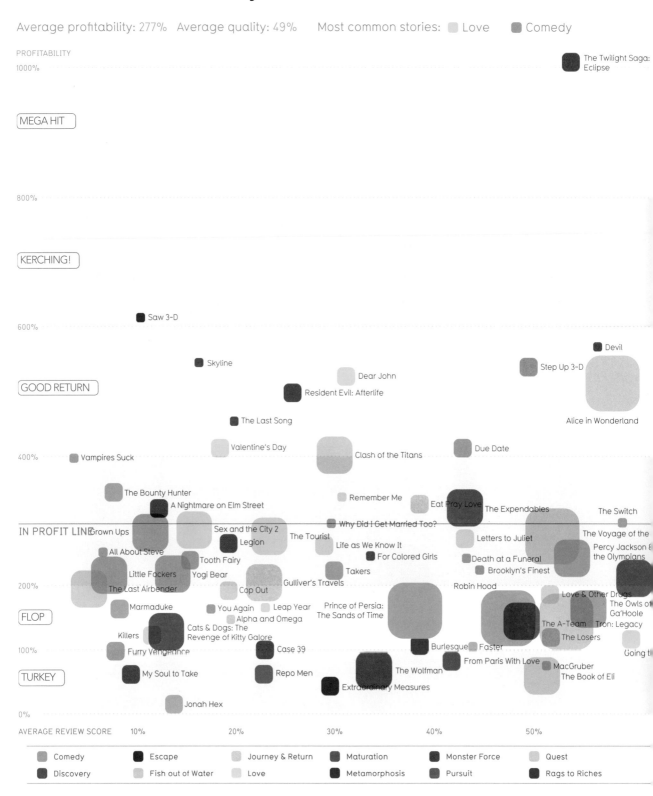

PROFITABILITY

1000%

MEGA HIT

The Twilight Saga: Eclipse

800%

KERCHING!

600% Saw 3-D

Skyline Devil

GOOD RETURN Resident Evil: Afterlife Dear John Step Up 3-D

The Last Song Alice in Wonderland

400% Vampires Suck Valentine's Day Clash of the Titans Due Date

The Bounty Hunter Remember Me Eat Pray Love The Expendables The Switch

A Nightmare on Elm Street Why Did I Get Married Too? The Voyage of the

IN PROFIT LINE Grown Ups Sex and the City 2 The Tourist Letters to Juliet Percy Jackson &
 Legion Life as We Know It the Olympians
All About Steve Tooth Fairy For Colored Girls Death at a Funeral

Little Fockers Yogi Bear Takers Brooklyn's Finest Love & Other Drugs
200% The Last Airbender Cop Out Gulliver's Travels The Owls of
 Robin Hood Ga'Hoole
Marmaduke You Again Leap Year Prince of Persia: The A-Team Tron: Legacy
 Alpha and Omega The Sands of Time The Losers
 Killers Cats & Dogs: The
FLOP Revenge of Kitty Galore Going t
100% Case 39 Burlesque Faster
 Furry Vengeance From Paris With Love MacGruber
 My Soul to Take Repo Men The Wolfman The Book of Eli
TURKEY Extraordinary Measures

0% Jonah Hex

AVERAGE REVIEW SCORE 10% 20% 30% 40% 50%

| ■ Comedy | ■ Escape | ■ Journey & Return | ■ Maturation | ■ Monster Force | ■ Quest |
| ■ Discovery | ■ Fish out of Water | ■ Love | ■ Metamorphosis | ■ Pursuit | ■ Rags to Riches |

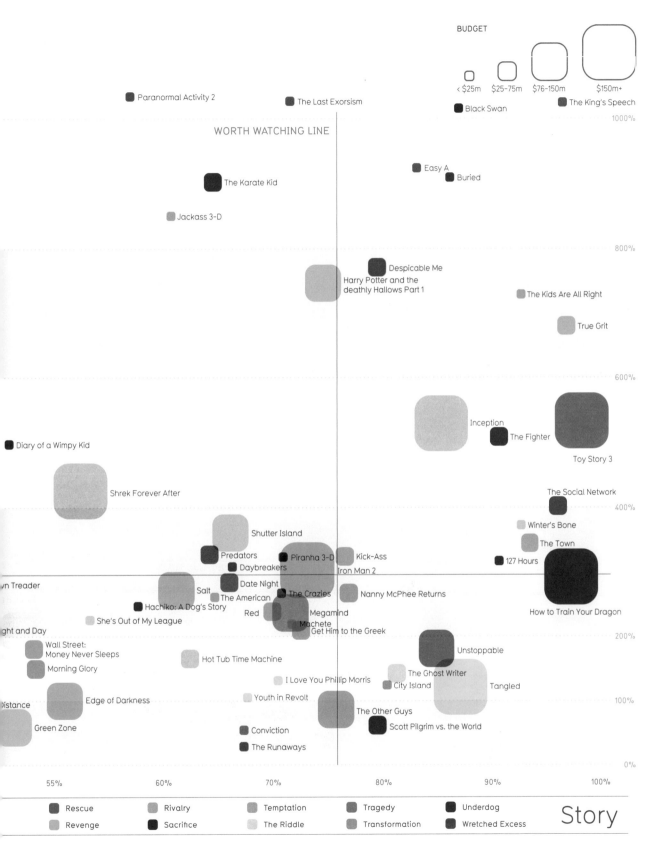

BUDGET

< $25m $25-75m $76-150m $150m+

1000%

Paranormal Activity 2 The Last Exorsism Black Swan The King's Speech

WORTH WATCHING LINE

Easy A
Buried

The Karate Kid

Jackass 3-D

800%

Despicable Me
Harry Potter and the
deathly Hallows Part 1 The Kids Are All Right

True Grit

600%

Inception
The Fighter

Diary of a Wimpy Kid Toy Story 3

The Social Network

Shrek Forever After 400%

Winter's Bone

Shutter Island The Town

Predators Piranha 3-D Kick-Ass 127 Hours
Daybreakers Iron Man 2

vn Treader Date Night How to Train Your Dragon
Salt The American The Crazies Nanny McPhee Returns
Hachiko: A Dog's Story Red Megamind
She's Out of My League Machete
ght and Day Get Him to the Greek 200%

Wall Street:
Money Never Sleeps Hot Tub Time Machine Unstoppable

Morning Glory
I Love You Phillip Morris The Ghost Writer
City Island Tangled

Distance Youth in Revolt
Edge of Darkness The Other Guys 100%

Green Zone Conviction Scott Pilgrim vs. the World

The Runaways

0%

55% 60% 70% 80% 90% 100%

Rescue Rivalry Temptation Tragedy Underdog Story

Revenge Sacrifice The Riddle Transformation Wretched Excess

source: BoxOfficeMojo.com, The-Numbers.com, Wikipedia, IMDB.com & RottenTomatoes.com. Note: reported film budgets are notoriously unreliable
(especially for flops)

Most Profitable Hollywood Stories 2011

Average profitability: 289% Average quality: 54% Most common stories: 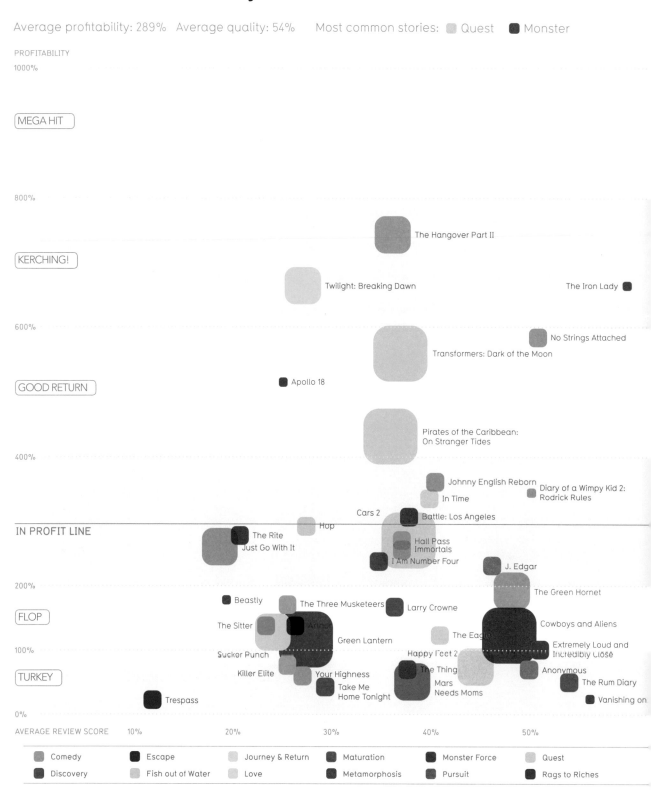 Quest ● Monster

PROFITABILITY

1000%

MEGA HIT

800%

KERCHING!

The Hangover Part II

Twilight: Breaking Dawn

The Iron Lady

600%

No Strings Attached

Transformers: Dark of the Moon

GOOD RETURN

Apollo 18

Pirates of the Caribbean:
On Stranger Tides

400%

Johnny English Reborn Diary of a Wimpy Kid 2:
 Rodrick Rules

In Time

Cars 2 Battle: Los Angeles

Hop

IN PROFIT LINE

The Rite Hall Pass
Just Go With It Immortals
 I Am Number Four

J. Edgar

200%

FLOP

Beastly The Green Hornet
 The Three Musketeers Larry Crowne

The Sitter Armor Cowboys and Aliens

 Green Lantern The Eagle Extremely Loud and
100% Incredibly Close

Suckor Punch Happy Feet 2 Anonymous

TURKEY Killer Elite The Thing The Rum Diary
 Your Highness Mars
 Take Me Needs Moms Vanishing on
 Home Tonight

0% Trespass

AVERAGE REVIEW SCORE 10% 20% 30% 40% 50%

| Comedy | Escape | Journey & Return | Maturation | Monster Force | Quest |
| Discovery | Fish out of Water | Love | Metamorphosis | Pursuit | Rags to Riches |

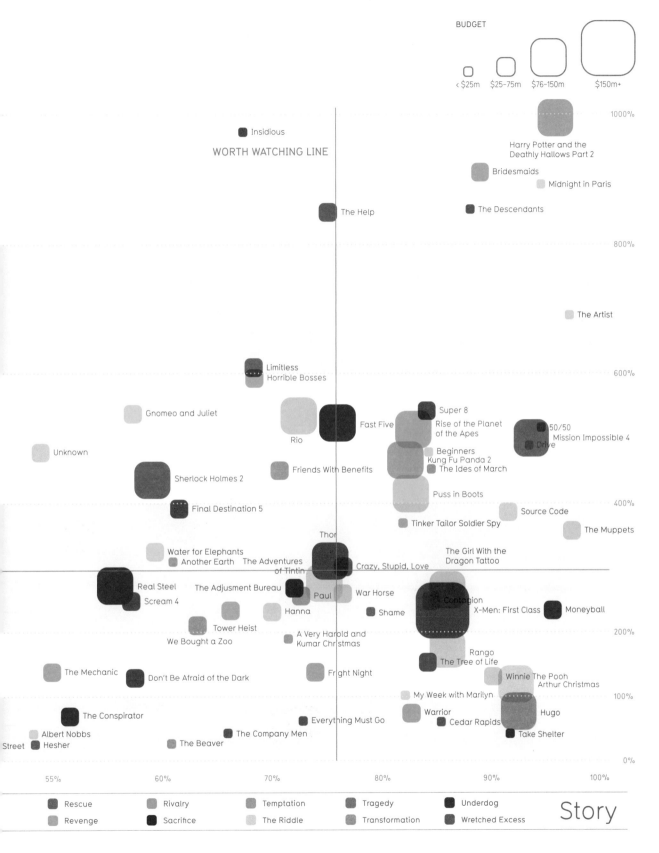

BUDGET

< $25m $25–75m $76–150m $150m+

1000%

Insidious

WORTH WATCHING LINE

Harry Potter and the
Deathly Hallows Part 2

Bridesmaids

Midnight in Paris

The Help

The Descendants

800%

The Artist

Limitless
Horrible Bosses 600%

Gnomeo and Juliet

Super 8

Fast Five Rise of the Planet
 of the Apes 50/50

Rio Mission Impossible 4
 Drive

Unknown Beginners
 Kung Fu Panda 2
Friends With Benefits The Ides of March

Sherlock Holmes 2

Puss in Boots 400%

Final Destination 5 Source Code

 Tinker Tailor Soldier Spy
 The Muppets

Thor

Water for Elephants The Girl With the
Another Earth Dragon Tattoo
The Adventures
of Tintin Crazy, Stupid, Love

Real Steel The Adjusment Bureau
Scream 4 Paul War Horse

 Hanna Shame Contagion X-Men: First Class Moneyball

Tower Heist 200%
We Bought a Zoo A Very Harold and
 Kumar Christmas

 Rango
The Mechanic The Tree of Life
 Don't Be Afraid of the Dark Fright Night Winnie The Pooh
 Arthur Christmas

 My Week with Marilyn 100%

The Conspirator
 Everything Must Go Warrior Hugo
Albert Nobbs Cedar Rapids
Street Hesher The Company Men Take Shelter
 The Beaver 0%

55% 60% 70% 80% 90% 100%

Rescue Rivalry Temptation Tragedy Underdog

Revenge Sacrifice The Riddle Transformation Wretched Excess Story

source: BoxOfficeMojo.com, The-Numbers.com, Wikipedia, IMDB.com & RottenTomatoes.com. Note: reported film budgets are notoriously unreliable
(especially for flops)

Most Profitable Stories of All Time

Average budget: 43m Average quality: 83% Most common stories: ■ Quest ■ Monster Force

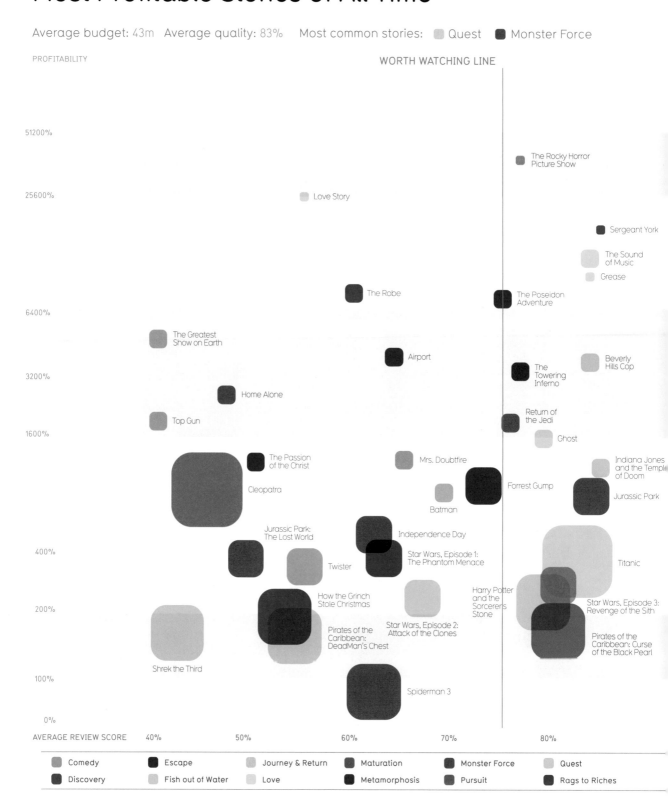

PROFITABILITY

WORTH WATCHING LINE

51200%

The Rocky Horror Picture Show

25600% Love Story

Sergeant York

The Sound of Music

Grease

The Robe The Poseidon Adventure

6400%

The Greatest Show on Earth

Airport Beverly Hills Cop

3200% The Towering Inferno

Home Alone

Return of the Jedi

Top Gun

1600% Ghost

The Passion of the Christ Indiana Jones and the Temple of Doom

Cleopatra Mrs. Doubtfire

Forrest Gump Jurassic Park

Jurassic Park: The Lost World Batman

Independence Day

400% Star Wars, Episode 1: The Phantom Menace Titanic

Twister

Harry Potter and the Sorcerer's Stone

How the Grinch Stole Christmas Star Wars, Episode 3: Revenge of the Sith

200% Star Wars, Episode 2: Attack of the Clones

Pirates of the Caribbean: DeadMan's Chest Pirates of the Caribbean: Curse of the Black Pearl

Shrek the Third

100% Spiderman 3

0%

AVERAGE REVIEW SCORE 40% 50% 60% 70% 80%

■ Comedy ■ Escape ■ Journey & Return ■ Maturation ■ Monster Force ■ Quest
■ Discovery ■ Fish out of Water ■ Love ■ Metamorphosis ■ Pursuit ■ Rags to Riches

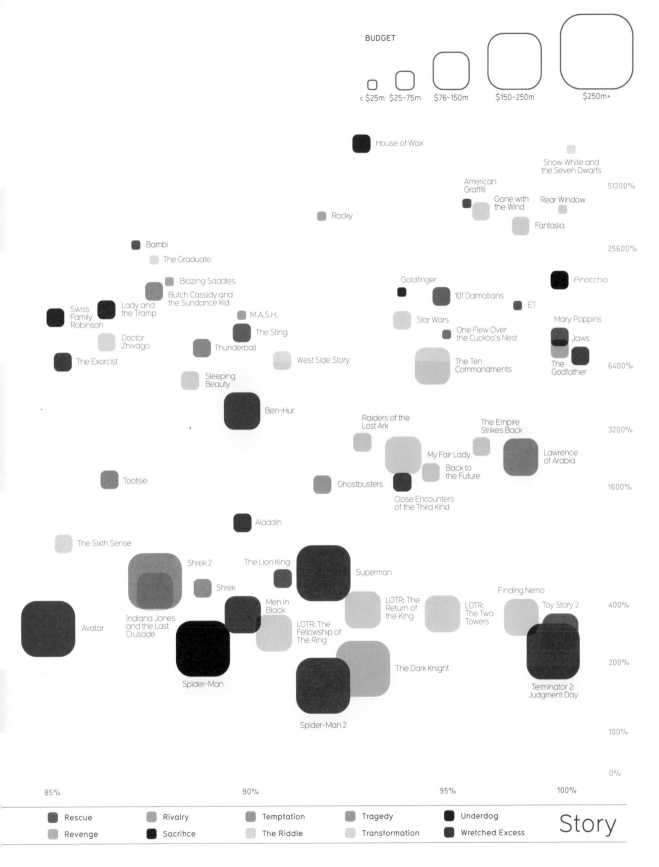

BUDGET

< $25m $25-75m $76-150m $150-250m $250m+

House of Wax

Snow White and the Seven Dwarfs

51200%

American Graffiti

Gone with the Wind

Rear Window

Rocky

Fantasia

Bambi

25600%

The Graduate

Blazing Saddles

Goldfinger

Pinocchio

Butch Cassidy and the Sundance Kid

101 Dalmatians

ET

Swiss Family Robinson

Lady and the Tramp

M.A.S.H.

Star Wars

One Flew Over the Cuckoo's Nest

Mary Poppins

Doctor Zhivago

The Sting

Jaws

The Exorcist

Thunderball

West Side Story

The Ten Commandments

The Godfather

6400%

Sleeping Beauty

Ben-Hur

Raiders of the Lost Ark

The Empire Strikes Back

3200%

My Fair Lady

Lawrence of Arabia

Tootsie

Back to the Future

Ghostbusters

1600%

Close Encounters of the Third Kind

Aladdin

The Sixth Sense

Shrek 2

The Lion King

Superman

Finding Nemo

Shrek

Men in Black

LOTR: The Return of the King

LOTR: The Two Towers

Toy Story 2

400%

Avatar

Indiana Jones and the Last Crusade

LOTR: The Fellowship of The Ring

The Dark Knight

Terminator 2: Judgment Day

200%

Spider-Man

Spider-Man 2

100%

0%

85% 90% 95% 100%

■ Rescue ■ Rivalry ■ Temptation ■ Tragedy ■ Underdog

■ Revenge ■ Sacrifice ■ The Riddle ■ Transformation ■ Wretched Excess

Story

source: BoxOfficeMojo.com, Wikipedia. Budgets inflation adjusted to 2010 dollars

Enneagram

A personality-type system based around an ancient symbol of perpetual motion. Each type is formed from a key defence against the world. Which one are you?

		I am...	I want to...	Virtue
1	**Reformer**	Reasonable and objective	Be good and have integrity	Serenity
2	**Helper**	Caring and loving	Feel love	Humility
3	**Achiever**	Outstanding and effective	Feel valuable	Honesty
4	**Individualist**	Intuitive and sensitive	Be myself	Balance
5	**Investigator**	Intelligent, perceptive	Be capable and competent	Detachment
6	**Loyalist**	Committed, dependable	Have support and guidance	Courage
7	**Enthusiast**	Reasonable and objective	Be satisfied and content	Sobriety
8	**Challenger**	Strong, assertive	Protect myself	Innocence
9	**Peacemaker**	Peaceful, easygoing	Have peace of mind	Action

Hidden complaint	I fear being...	Flaw	Saving grace
I am usually right. Others should listen to me.	Bad, wrong	Resentment	Sensible
I'm always loving. Others take me for granted.	Unloved	Flattery	Empathic
I am a superior person. Others are jealous	Worthless	Vanity	Eagerness
I don't really fit in. I am different from others.	Insignificant	Melancholy	Self-aware
I'm so smart. Others can't understand me.	Helpless or incompetent	Stinginess	No bullshit
I do what I'm told . Others don't	Without support	Worrying	Friendly
I'm happy. But others don't give me enough.	In pain	Over-Planning	Enthusiasm
I'm fighting to survive. Others take advantage.	Harmed or controlled	Vengeance	Strength
I am content. Others pressure me to change.	Lost and separated	Laziness	Fluidity

source: Wikipedia, EnneagramInstitute.com

Selling Your Soul

Workers on Amazon.com's Mechanical Turk asked to draw their souls

female

Amazon's Mechanical Turk is a "cloud workforce" of people happy to do microjobs for micropayments ($0.25 and up). 200 people were asked to draw a picture of their soul for the author's ongoing collection. Muhahahahahahahaha...

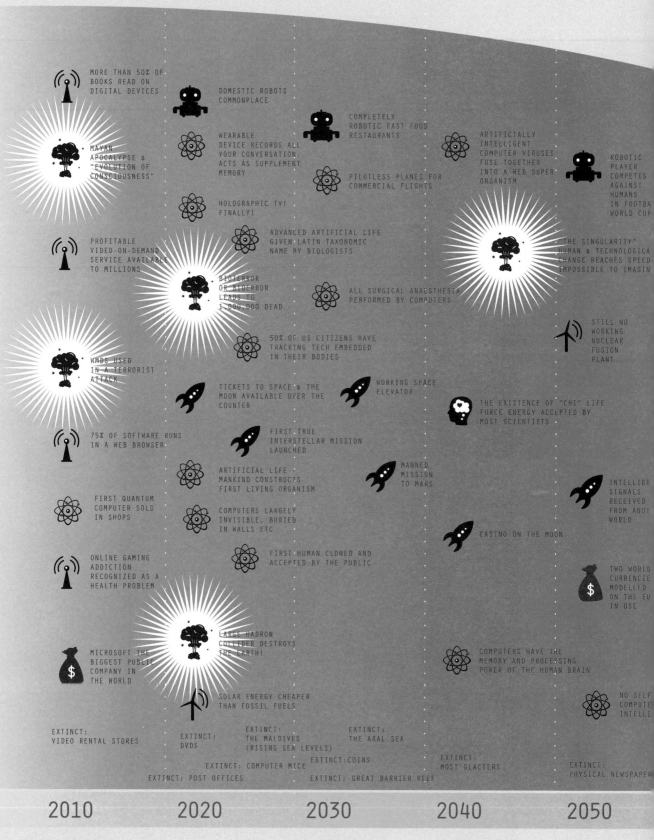

MORE THAN 50% OF BOOKS READ ON DIGITAL DEVICES

DOMESTIC ROBOTS COMMONPLACE

COMPLETELY ROBOTIC FAST FOOD RESTAURANTS

ARTIFICIALLY INTELLIGENT COMPUTER VIRUSES FUSE TOGETHER INTO A WEB SUPER ORGANISM

ROBOTIC PLAYER COMPETES AGAINST HUMANS IN FOOTBA WORLD CUP

MAYAN APOCALYPSE & "EVOLUTION OF CONSCIOUSNESS"

WEARABLE DEVICE RECORDS ALL YOUR CONVERSATION, ACTS AS SUPPLEMENT MEMORY

PILOTLESS PLANES FOR COMMERCIAL FLIGHTS

HOLOGRAPHIC TV! FINALLY!

"THE SINGULARITY" HUMAN & TECHNOLOGICA CHANGE REACHES SPEED IMPOSSIBLE TO IMAGIN

PROFITABLE VIDEO-ON-DEMAND SERVICE AVAILABLE TO MILLIONS

ADVANCED ARTIFICIAL LIFE GIVEN LATIN TAXONOMIC NAME BY BIOLOGISTS

BIOTERROR OR BIOERROR LEADS TO 1,000,000 DEAD

ALL SURGICAL ANAESTHESIA PERFORMED BY COMPUTERS

STILL NO WORKING NUCLEAR FUSION PLANT

WMDS USED IN A TERRORIST ATTACK

50% OF US CITIZENS HAVE TRACKING TECH EMBEDDED IN THEIR BODIES

TICKETS TO SPACE & THE MOON AVAILABLE OVER THE COUNTER

WORKING SPACE ELEVATOR

THE EXISTENCE OF "CHI" LIFE FORCE ENERGY ACCEPTED BY MOST SCIENTISTS

75% OF SOFTWARE RUNS IN A WEB BROWSER

FIRST TRUE INTERSTELLAR MISSION LAUNCHED

MANNED MISSION TO MARS

FIRST QUANTUM COMPUTER SOLD IN SHOPS

ARTIFICIAL LIFE MANKIND CONSTRUCTS FIRST LIVING ORGANISM

INTELLIGE SIGNALS RECEIVED FROM ANOT WORLD

COMPUTERS LARGELY INVISIBLE, BURIED IN WALLS ETC

CASINO ON THE MOON

ONLINE GAMING ADDICTION RECOGNIZED AS A HEALTH PROBLEM

FIRST HUMAN CLONED AND ACCEPTED BY THE PUBLIC

TWO WORLD CURRENCIE MODELLED ON THE EU IN USE

LARGE HADRON COLLIDER DESTROYS THE EARTH!

MICROSOFT THE BIGGEST PUBLIC COMPANY IN THE WORLD

COMPUTERS HAVE THE MEMORY AND PROCESSING POWER OF THE HUMAN BRAIN

SOLAR ENERGY CHEAPER THAN FOSSIL FUELS

NO SELF COMPUTE INTELLI

EXTINCT: VIDEO RENTAL STORES

EXTINCT: DVDS

EXTINCT: THE MALDIVES (RISING SEA LEVELS)

EXTINCT: THE ARAL SEA

EXTINCT: COMPUTER MICE

EXTINCT: COINS

EXTINCT: MOST GLACIERS

EXTINCT: PHYSICAL NEWSPAPER

EXTINCT: POST OFFICES

EXTINCT: GREAT BARRIER REEF

2010 2020 2030 2040 2050

The Future of the Future

At longbets.org leading thinkers gather to place bets on future predictions

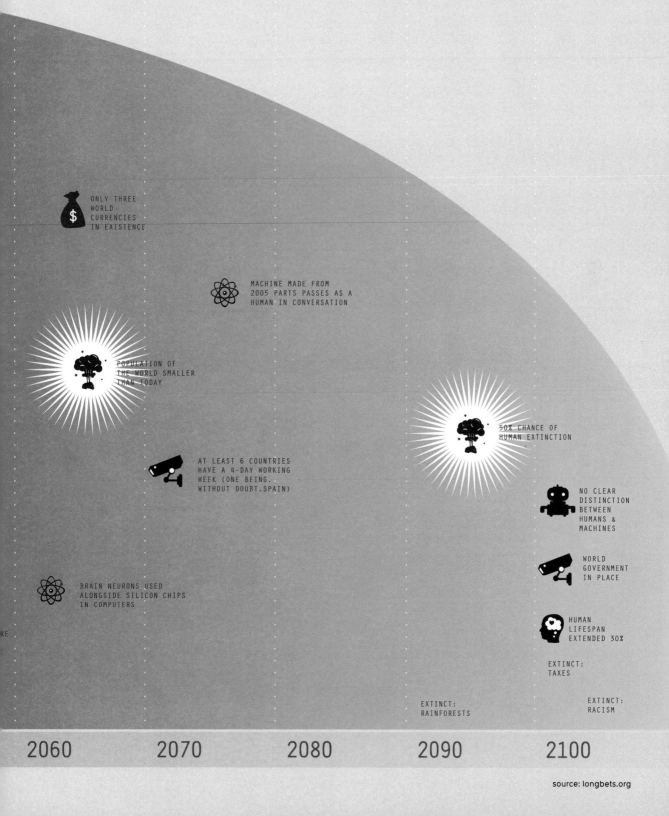

ONLY THREE WORLD CURRENCIES IN EXISTENCE

MACHINE MADE FROM 2005 PARTS PASSES AS A HUMAN IN CONVERSATION

POPULATION OF THE WORLD SMALLER THAN TODAY

AT LEAST 6 COUNTRIES HAVE A 4-DAY WORKING WEEK (ONE BEING, WITHOUT DOUBT, SPAIN)

50% CHANCE OF HUMAN EXTINCTION

NO CLEAR DISTINCTION BETWEEN HUMANS & MACHINES

WORLD GOVERNMENT IN PLACE

BRAIN NEURONS USED ALONGSIDE SILICON CHIPS IN COMPUTERS

HUMAN LIFESPAN EXTENDED 30%

EXTINCT: TAXES

EXTINCT: RAINFORESTS

EXTINCT: RACISM

2060 2070 2080 2090 2100

source: longbets.org

Making the Book
The first six months

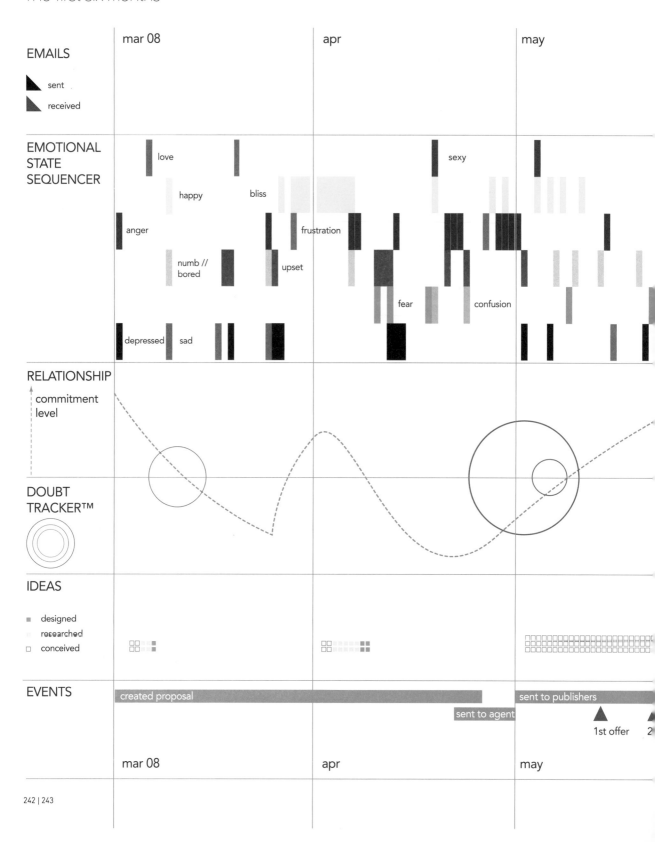

EMAILS

- ◤ sent
- ◣ received

EMOTIONAL STATE SEQUENCER

love · happy · bliss · sexy · anger · frustration · numb // bored · upset · fear · confusion · depressed · sad

RELATIONSHIP

commitment level

DOUBT TRACKER™

IDEAS

- ■ designed
- ▦ researched
- □ conceived

EVENTS

created proposal · sent to agent · sent to publishers · 1st offer · 2

mar 08 · apr · may

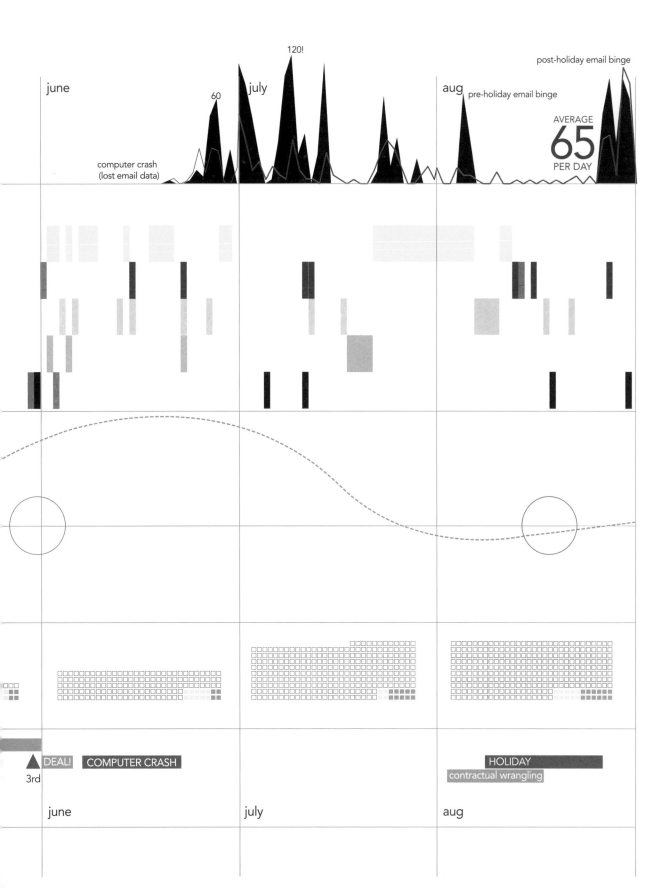

june

july

120!

60

aug pre-holiday email binge

post-holiday email binge

computer crash
(lost email data)

AVERAGE
65
PER DAY

3rd

▲ DEAL! COMPUTER CRASH

HOLIDAY
contractual wrangling

june

july

aug

Making the Book

The last six months

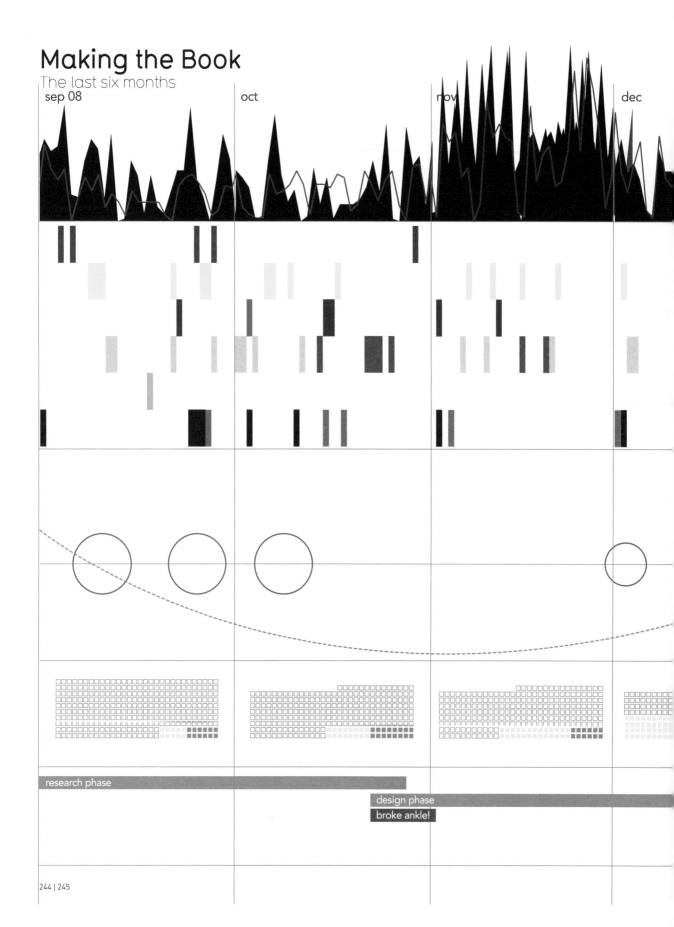

sep 08

oct

nov

dec

research phase

design phase

broke ankle!

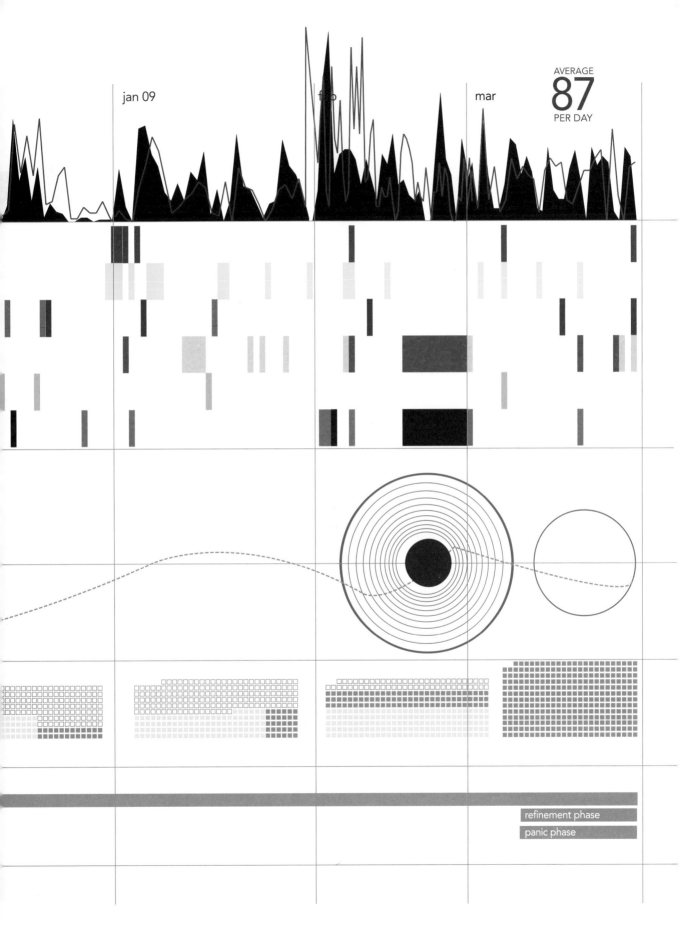

jan 09

feb

mar

AVERAGE
87
PER DAY

refinement phase
panic phase

Acknowledge Map
Thanks to all who helped and supported

MANY THANKS TO: Vincent Ahrend, Kathryn Ariel, Dr David Archer, Steve Beckett, Delfina Bottesini, Laura Brudenell, Candy Chang, Susanne Cook Greuter, Dave Cooper, Kesta Desmond, Robert Downes, Danielle Engelman, Edward Farmer, Richard Henry, Dr Phil Howard, Claudia Hofmeister, Aegir Hallmundur, Becky Jones, Dongwoo Kim, Jenny McIvor, Priscila Moura, Mark O'Connor, Kate O'Driscoll, Dr. Lori Plutchik, Laura Price, Richard Rogers, Miriam Quick Twitter Army, Mechanical Turkers.

Denise Bates　Claire Kingston　Lucie Jordan　Anna Martin　Stephanie Meyers

Airella Feiner

Simon Trewin

David　Christianne　Michelle　Holly

iMac 24"　MacBook Pro 17"　PB G4 12"

Google

Illustrator CS3

Wikipedia

InDesign CS3

Photoshop CS3　MacJournal 5

Amazon

Google Docs

Wordle

Twitter　iStockPhoto　Google Insights　Britannica　Ffffound　Google Reader　Decodeme

Design

Freelance design

Art direction

Research

Freelance Research

Interns

Programmer

HarperCollins

UnitedAgents

Family

Hardware

Software

Webware

Bibliograph
Inspiration and source material

Schott, Ben, *Schott's Almanac* 2007 (London: Bloomsbury Publishing Plc., 2007)

Tufte, Edward R., *Envisioning Information* (Cheshire, Connecticut: Graphics Press LLC, 2005)

Abrams, Janet and Peter Hall, *Else/Where: Mapping* (Minneapolis: University of Minneapolis Design Institute, 2006)

Fry, Ben, *Visualizing Data* (Sebastopol, CA: O'Reilly Media, Inc., 2008)

Bakhtiar, Laleh, *Sufi* (New York: Thames and Hudson Inc., 2004)

Tufte, Edward R., *The Visual Display of Quantitative Information* (Cheshire, Connecticut: Graphics Press LLC, 2006)

Levitt, Steven D. and Stephen J. Dubner, *Freakonomics* (London: Penguin Books, 2006)

Ayers, Ian, *Super Crunchers* (London: Random House, Inc., 2008)

Harmon, Katharine, *You Are Here* (New York: Princeton Architectural Press, 2004)

Solomon, Lawrence, *The Deniers* (Richard Vigilante Books, 2008)

Image Credits

InformationIsBeautiful.net

Visit the website for the book

discover more
our blog covers visual journalism, unusual infographics,
far-out data visualizations

be involved
crowdsource and help us investigate, research and
unearth facts and information for new designs

get animated
play with interactive visuals and animations

have a play
access the data and research used in this book
and find editable versions of some images

find extra stuff
tons of new diagrams, idea maps, bubble charts,
factoramas, knowledgescapes and infomaps...

twitter: @infobeautiful // facebook.com/pages/Information-Is-Beautiful

Can Drugs Make You Happy?

DRUGGIEST Largest % of population using illegal drugs (7% or more)

Argentina, Australia, Belize, Canada, Chile, Czech Rep, Denmark, England & Wales, Estonia, France, Ghana, Ireland, Israel, Italy, Jamaica, Kyrgyzstan, Latvia, Lebanon, Luxembourg, Madagascar, New Zealand, Nigeria, Spain, Switzerland, Uruguay, USA, Venezuela, Zambia, Zimbabwe

source: Guardian Data blog, UN

HAPPIEST by Happiness Index Rating (above 6.8/10)

Argentina, Australia, Austria, Belgium, Belize, Brazil, Canada, Chile, Colombia, Costa Rica, Cyprus, Denmark, El Salvador, England & Wales, Finland, Guatemala, Iceland, Ireland, Italy, Luxembourg, Malta, Mexico, Netherlands, New Zealand, Norway, Saudi Arabia, Singapore, Spain, Sweden, Switzerland, Thailand, Trinidad & Tobago, UAE, USA, Venezuela

source: Erasmus University Rotterdam, Worlddatabaseofhappiness.eur.nl

BLISSED OUT! where happiness strongly correlates with drug use

Argentina, Australia, Belize, Canada, Chile, Denmark, England & Wales, Ireland, Italy, Luxembourg, New Zealand, Spain, Switzerland, USA, Venezuela

42%

just for fun. correlation is not cause

Ain't Nothing Going On But The Rent
money and divorce in a co-dependent relationship?

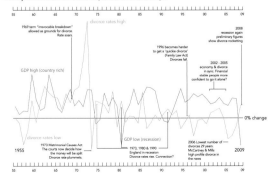

1969 term "irrevocable breakdown" allowed as grounds for divorce. Rate soars.

divorce rates high

2008 recession again preliminary figures show divorce rocketting

1996 becomes harder to get a 'quickie divorce' (Family Law Act) Divorces fall.

2002 - 2005 economy & divorce in sync. Financial stable people more confident to go it alone?

GDP high (country rich)

0% change

divorce rates low

GDP low (recession)

1955

1973 Matrimonial Causes Act. The courts now decide how the money will be split Divorce rate plummets.

1973, 1980 & 1990 Divorces in recession. Divorce rates rise. Connection?

2006 Lowest number of divorces 29 years. McCartney & Mills high profile divorce in the news

2009

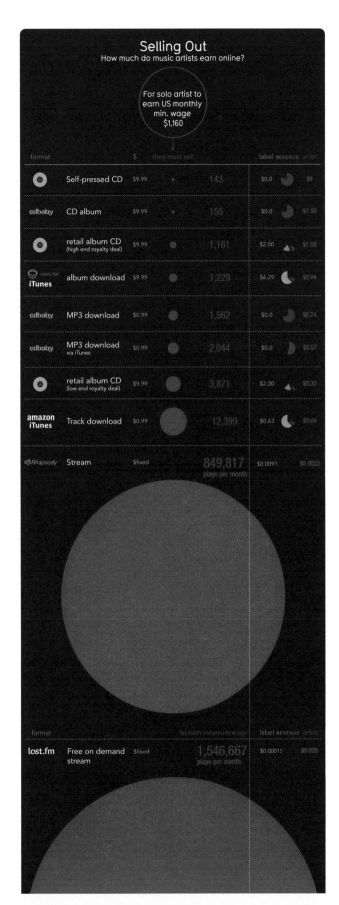

Selling Out
How much do music artists earn online?

For solo artist to earn US monthly min. wage $1,160

format		$	they must sell	label	REVENUE	artist
	Self-pressed CD	$9.99	143	$0.0		$0
cdbaby	CD album	$9.99	155	$0.0		$7.50
	retail album CD (high end royalty deal)	$9.99	1,161	$2.00		$1.00
NAPSTER iTunes	album download	$9.99	1,229	$6.29		$0.94
cdbaby	MP3 download	$0.99	1,562	$0.0		$0.74
cdbaby	MP3 download via iTunes	$0.99	2,044	$0.0		$0.57
	retail album CD (low end royalty deal)	$9.99	3,871	$2.00		$0.30
amazon iTunes	Track download	$0.99	12,399	$0.63		$0.09
Rhapsody	Stream	$fixed	849,817 plays per month	$0.0091		$0.0022

format			to earn minimum wage	label	REVENUE	artist
last.fm	Free on demand stream	$fixed	1,546,667 plays per month	$0.00015		$0.005

The Billion-Dollar-O-Gram
010

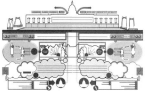

Left vs Right
014

Time Lines
016

Snake Oil?
018

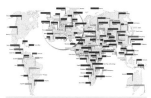

International Number Ones
020

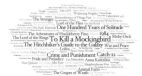

Mountains out of Molehills
022

X "is the new" Black
024

Small Carbon
026

Books Everyone Should Read
028

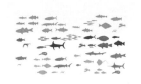

Which Fish are Okay to Eat?
030

The 'In' Colours
032

Three's a Magic Number
036

Who Runs the World?
038

Who *Really* Runs the World?
040

Stock Check
042

Amazon
044

Creation Myths
046

Dance Genre-ology
048

The Book of You
050

The Book of Me
052

Rock Genre-ology
058

Simple Part I
060

What is Consciousness?
066

Carbon Conscious
068

Reduce Your Chance of Dying in a Plane Crash 072

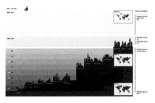

Rising Sea Levels 074

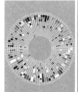

Colours & Culture 076

Stages of You 077

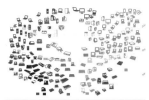

Personal Computer Evolution 084

The One Machine 086

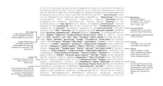

What Does China Censor Online? 092

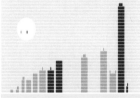

Water Towers 094

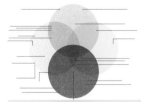

Drugs World 096

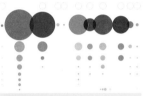

World Religions 098

Moral Matrix 100

The Carbon Dioxide Cycle 102

Low Resolution 104

Taste Buds 106

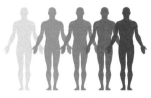

The Sunscreen Smokescreen Part 1 112

The Sunscreen Smokescreens Part 2 114

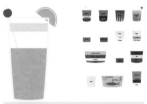

The Poison / The Remedy 116

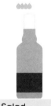

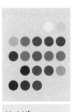

Salad Dressings 118

Not Nice

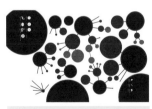

20th-Century Death 120

Climate Sceptics vs The Consensus 122

Behind Every Great Man... 126

Types of Info Viz 128

Pass the... 129

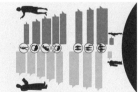

Nature vs Nuture 130

Postmodernism 132

Death Spiral 134

Google Insights
136

On Target?

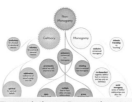

The Varieties of Romantic
Relationship 140

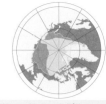

30 Years Makes a Difference
142

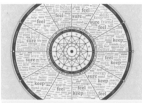

Horoscoped
144

Better than
Bacon 146

What are the
Chances? 147

Some Things You Can't Avoid
148

Body By
151

Microbes Most
Dangerous 152

Cosmetic
Ingredients 153

Things That'll Give You Cancer
154

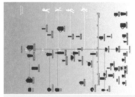

Types of Coffee
156

Big Carbon
158

Articles of War I
160

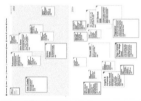

Articles of War II
162

Who Clever are You?
164

The Buzz vs The Bulge
166

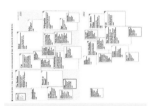

Daily Diets
168

Calories In, Calories Out
170

Types of Facial Hair
172

Scale of Devastation
174

Amphibian Extinction Rates
176

Motive, Timing & Delivery
178

Good News
180

Immortality
182

War Chests
183

2012: The End of the World?
Part 1 184

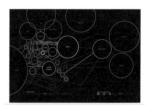

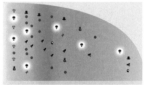
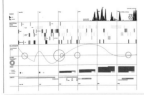